Praise for

❧ Special Museums of the Northeast ❧

"A delightful book. . . . Nancy Frazier describes the collections with an enthusiasm that is obvious—which makes this guide fun to read. . . ."
—**The Washington Post**

"If you like the off-the-beaten-path places, you'll get a kick out of this 'Guide to Uncommon Collections from Maine to Washington, D.C.' "
—**Northeast Outdoors**

"Reading this book whets the traveler's appetite to visit just one more museum, and one more, and one more. This book could be very useful to persons planning trips." —**Travel Writer's Journal**

"If you're traveling anywhere from Maine to Washington, this is just the thing to perk up an itinerary that's getting too predictable."
—**The Philadelphia Inquirer**

"A valuable museum guidebook." —**Library Journal**

"A marvelous guide to anyone who likes to go 'museum hopping.' "
—**Greenfield (MA) Recorder**

"There are museums dedicated to everything. . . . Includes an appendix of 188 additional specialized or well-known museums."
—**Aviso,** Association of American Museums Newsletter

"Each description mentions whether children will like the museum and how much time it takes to visit, so you can plan your itinerary with ease."
—**Country Living** magazine

"Will delight vacation planners looking for the offbeat, unusual, and entertaining." —**The Sunday Independent South**

SPECIAL MUSEUMS OF THE NORTHEAST

A Guide to Uncommon Collections
from Maine to Washington, D.C.

by
Nancy Frazier

The
Globe
Pequot
Press

Old Chester Road
Chester, Connecticut 06412

ᘒ About the Author ᘒ

Nancy Frazier, a reporter/researcher for *Newsweek* for five years, is currently editor of *Hampshire Life,* the award-winning weekly feature magazine supplement of the *Daily Hampshire Gazette* in Northampton, Massachusetts.

Updated Summer 1986

Cover photograph reprinted courtesy of the Margaret Woodbury Strong Museum
Cover design by Barbara Marks
Book design by K. A. Lynch

Library of Congress Cataloging in Publication Data

Frazier, Nancy.
 Special museums of the Northeast

 Includes index.
 1. Museums—New England—Directories. 2. Museums—Middle Atlantic States—Directories. I. Title.
AM12.N33F73 1985 069′.025′74 85-8027
ISBN 0-87106-869-9 (pbk.)

Manufactured in the Unites States of America
First Edition/Second Printing, August 1986

❧ CONTENTS ❧

ᏇᏇ ACKNOWLEDGMENTS ᏇᏇ

I am the editor of *Hampshire Life,* a weekly magazine supplement to the *Daily Hampshire Gazette,* in Northampton, Massachusetts. It is because of the support and encouragement of my editor, Edward K. Shanahan, and the good will of my publishers, Charles W. and Peter L. DeRose, that I was able to take a three-month leave of absence to travel and work on this book. Without that block of time, it would have taken me years to do the research. I don't know if they realize how grateful I am, but I hope so.

The opportunity to go on leave and the ability to do so don't necessarily come together. The person who really made it possible is my friend and associate, Debra Scherban. Debra worked hard to keep *Hampshire Life* going. While continually reassuring me that I was indispensable, she proved I wasn't and did an incredible job from week to week. Dan DeNicola, Lucy Pickett, and Doris Troy pitched in extra time and effort, which I appreciate enormously. In fact, I can't thank Doris enough. I have come to depend on her final reading of my work. The *Gazette* is a good place to work, and the *Hampshire Life* staff is a terrific team.

I also want to thank my husband, Jack, who, after some initial reluctance, shared the fun. He became as spirited a museum hopper as I am, and when the outings for this book were finished, he was quite downcast.

Finally, thanks to Linda Kennedy, Cary Hull, and Kate Bandos at the Globe Pequot Press for their enthusiasm.

*D*edicated to my mother, Shirley Margules

INTRODUCTION

People are incorrigible collectors. Why? Psychologists have no persuasive theories, and I can't tell you either. I do know, though, that accumulating treasures is a powerful drive, that being a collector becomes an organizing principle, gives a certain order to life. Excitement, too: "A passionate collector is like a hunter," as Arthur Sackler, one of the world's greatest contemporary collectors, has said. The thrill has less to do with actual acquisition than with what leads up to it, the pursuit.

I know a lot about pursuit. Between April and November 1984 I traveled close to 12,000 miles tracking down museums. I had more fun during those months than I've had in many years. And at some point I realized that, for the first time in the decades since I put my Story Book Dolls away for good, I, too, had become a collector.

I wasn't even a museum goer when I started this project. I might visit an art museum by choice and take my kids to science museums out of a sense of responsibility, but that was about it. Now I've been to everything from a cranberry museum to a whaling museum, seen collections of toy banks and airplanes, pathological specimens, quilts, and decoys. And I've found special collections of a single artist's works, like the Rodin Museum in Philadelphia, or the art of a particular region, such as the Hispanic collection in New York City. I went to so many maritime museums that I nearly got seasick. But I'm hooked. Tell me about a good museum I haven't been to, and I'll be on my way.

Don't think I'm undiscriminating. There were great disappointments, too. For instance, I drove from one end of Baltimore to the other (after being hopelessly lost just trying to get into the city) to find the Lacrosse Hall of Fame at Johns Hopkins University. When I

did, it was only a couple of cases of memorabilia. It is not included in this book. I was similarly discouraged by a playing-cards museum in Hawley, Pennsylvania, although the people who run it have high hopes for their project. There just wasn't enough to see to make a trip worthwhile. In Philadelphia I passed up a museum when I discovered it was isolated in an awful part of town. I would feel uneasy sending readers to places I wouldn't want to go myself. Many museums and collections were disqualified for such reasons, or because when I got there they were closed although they were not supposed to be.

But for every disappointment there were many pleasant surprises. They are all here. And there were wonderful connections. In Petersham, Massachusetts, a series of dioramas showed the evolution of a nearby landscape from virgin woodland to cultivated farmland and back to forest when New Englanders abandoned their land to join the westward migration. Then, at the Rockwell Museum in Corning, New York, I saw the settling of the West documented through works of art. I had been to the Saint-Gaudens National Historic Site in Cornish, New Hampshire, where I saw a small casting of the sculptor's statue of Diana. Then, there it was again in the dining room of Daniel Chester French's home in Stockbridge, Massachusetts. Finally, one day in the American wing of the Metropolitan Museum of Art in New York City, I saw it once again, this time in heroic proportions.

It is the genius of a good museum to draw you into its spell, to tell you of a world you hardly knew existed, to educate, certainly, but only through enthusiasm. Often it is the personality of the collector that flavors the collection. Sometimes it is the audiovisual presentations. I can tell you one thing: America is very, very big on audiovisuals these days. And a good measure of razzle-dazzle. When I descended to the Benjamin Franklin Museum in Philadelphia, I had a feeling I was going into the Benny discotheque. But a well-mounted exhibit is not necessarily an audiovisual extravaganza. Nothing could be further from that than the pre-Columbian wing at Dumbarton Oaks in Washington, D.C., and nothing could be more beautiful.

Most collections are still in someone's living room—or kitchen: I know a man who has hundreds of eggbeaters. Many of the museums I visited grew out of a single person's collection. Arthur Sackler's rare and unusual collection of Asian and pre-Columbian art will soon be installed in a museum in Washington, D.C.

I have become a collector of museums. But instead of arranging my treasures in glass cases, I have put them between the covers of this book. I hope you find them as fascinating as I do.

∾ Guidelines ∾

The first and most important guideline is that no museum has bought or could buy space in this book. That should go without saying, except I discovered that there are some books that commercial ventures can buy into. This is not one of them.

My self-imposed guidelines exclude historical society museums (almost every town seems to have one), except where they have a unique collection of, for instance, pincushions. (I haven't found a pincushion collection yet.) Also excluded are houses of famous people, unless there are important reasons for including them. For example, Daniel Chester French's home, Chesterwood, has the largest collection of his sculptures in a single place. General art and science museums are included only for their collections that have no equivalent, like the hummingbirds in the Fairbanks Museum of Saint Johnsbury, Vermont. Beyond those guidelines is eccentricity—of the museums and of the author.

I have personally chased down all the collections described at length in chapters 1 through 7. The listings in the appendix are either substantial, well-respected museums with membership in the American Association of Museums or specialized museums that could not be visited in time for the current review but that sound unique and interesting.

I welcome suggestions for special museums that might be included in future editions.

Although I've recorded the museum hours that were observed when I visited, those hours are subject to change. I recommend calling ahead before any visit. Assume that a museum is closed on major holidays.

Admission prices are also subject to change without notice, and for that reason I have listed them only when they are currently more than five dollars per adult. Such fees apply mainly in major complexes where you may well spend the whole day. Many museums that are listed as free "accept" if not require donations. For that reason I haven't listed places as free of charge.

I've tried to include explicit driving directions to museums, ex-

cept in cities where the streets are easy enough to find but parking is impossible; you'll probably get to those by foot, cab, or public transportation. Elsewhere, my rule of the road is: if you think you've lost your way, don't keep going because then you'll really get lost. Stop and ask directions as soon as possible.

Model of the *Nightingale* ▶
Penobscot Marine Museum, Searsport, Maine

MAINE,
NEW HAMPSHIRE,
& VERMONT

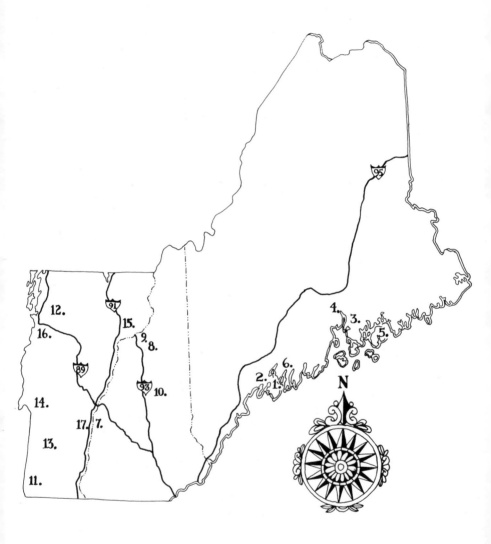

Numbers on map refer to towns numbered on opposite page.

✧ Maine ✧

✧ New Hampshire ✧

✧ Vermont ✧

∾ Boatyard ∾

MAINE MARITIME MUSEUM
963 Washington Street
Bath, Maine 04530
Phone: 207-443-6311
Director: John S. Carter
Hours: All museum sites are open mid-May through mid-October,
 10:00–5:00.
Directions: Bath is north of Portland. Take I-95 north to the exit for
 Route 1/Brunswick-Bath Coastal Route. Continue on Route 1
 to the Business District exit in Bath, turn right onto
 Washington Street, and continue about one and one-half miles
 to the Percy & Small Shipyard on your left.

To anyone interested in boats, especially old ones, this museum is
unquestionably the place to go. There are three Maine Maritime Mu-
seum sites in the city of Bath, and the most impressive and interest-
ing is the Percy & Small Shipyard. It is the only intact shipyard in
the United States where large wooden sailing vessels were built.

Percy & Small was active from 1897 to 1920, during which time
it built forty-one huge four-, five-, and six-masted schooners, includ-
ing the *Wyoming,* the largest wooden sailing vessel built in this coun-
try.

"Big schooners were used hard, and most came to violent ends,"
says a curatorial note. The explanation increases a sense of dismay as
you look at pictures of those beautiful craft, which had an average
life span of thirteen years before they "succumbed to coastal hazards,
economics or war." But consider the *Corce F. Creasy,* a five-master and
exceptionally attractive under sail. Between 1902 and 1929 she was
used mainly to transport coal. Then, in 1929, she was converted to a
gaudy nightclub with painted palms. Today she sits decaying in the
Medomak River in Bremen, Maine. The dishonor seems excessive;
she should have been lost in a storm.

There are a great many and a great variety of exhibits in several
buildings here. You can even walk around on a schooner and take a
boat trip to some other museum sites where marine art, ship models,
and life aboard some luxury liners are portrayed. This visit can be-
come a full-day trip that the whole family will enjoy.

ᘒᑫ Arctic Explorers ᘒᑫ

PEARY-MACMILLAN ARCTIC MUSEUM
Hubbard Hall
Bowdoin College
Brunswick, Maine 04011
Phone: 207-725-8731
Curator: Richard G. Condon
Hours: Tuesday through Friday 10:00–4:00, Saturday 10:00–5:00,
 Sunday 2:00–5:00. Guided tours can be scheduled during the
 academic year by calling the number above.
Directions: Take U.S. Route 1 to Brunswick and take the downtown
 exit. Follow signs to Bowdoin College. The museum is right in
 the middle of the campus, so you'll have to ask for specific
 directions when you get there.

When the temperature hits the nineties and the air is heavy, as it
is likely to be during midsummer in Maine, this is the place to cool
off.

Admirals Robert E. Peary and Donald B. MacMillan, both
Bowdoin alumni and both Arctic explorers, are honored by their
alma mater with a museum that documents their adventures and dis-
coveries. As you walk in, you encounter life-size photographic blow-
ups of the two men bundled head to toe in their fur snowsuits. Ex-
hibits around the corner show them breaking through the Arctic ice,
riding dog sleds across vast snowy wastelands, battling elements so
icy and harsh that the hot and humid air outside would seem to
bring relief.

Peary's early explorations in both the tropics and the Arctic are
the subject of the first exhibits: the odometer, telescope, and naviga-
tional instruments he used on his treks across the icecap of Green-
land are in the nature of mementos of those trips. Peary was a civil
engineer with the U.S. Navy, and he made many glass lantern slides,
especially during his 1908–9 expedition, when he became the first
man to reach the North Pole. In one case is a copy of the manual
Peary wrote for using a Kodak camera at the Pole. In another case is
the Winchester he used to kill polar bear, walrus, and musk ox for
food for the dogs and the men. Peary learned to eat, dress, and travel
as Eskimos did, which is the way he survived.

Donald MacMillan, who graduated from Bowdoin in 1898,

twenty-one years after Peary, went on that historic 1908 trip. It was MacMillan's first expedition, but it certainly whetted his appetite for adventure. He continued to explore unknown territories. He also collected Inuit carvings, implements, paintings, and artifacts, as well as Arctic birds and bird eggs, which can be seen at Bowdoin. One of the most beautiful things there is a woman's costume from South Greenland. It is made up of multicolored, patterned cottons, an enormous and elaborate beaded collar, white leather boots with embroidered ribbons. There are leggings that have fur strips alternating with strips of meticulously embroidered ribbon.

This isn't the largest, nor is it the most complete, collection of Arctic artifacts, but it is unique in that it is oriented only toward polar exploration and the Inuit culture of northern Greenland. It is also a nice place to escape the heat. There is no easy access for handicapped people, but with advance notice the staff is happy to help with wheelchairs. Children will enjoy it. Plan half an hour to an hour for a visit.

⋌ Steamship Memorabilia ⋋

ALLIE RYAN MARITIME COLLECTION
Quick Hall
Maine Maritime Academy
Castine, Maine 04421
Phone: 207-326-4311, extension 485
Assistant Curator: Kathryn L. Eisenhardt
The museum's hours of operation are currently under discussion. Be
 sure to call in advance of planning a visit.
Directions: Take U.S. Route 1 to Bucksport on the Penobscot River.
 A few miles beyond the bridge take Route 175 south. Stay on
 this two-lane road for ten miles—Route 175 bears sharply left
 but go straight ahead on Route 166 to Castine. As you enter the
 town, drive straight through to the Maine Maritime Academy
 campus. Go past the main gates to the second street on the left,
 turn left, and then enter the parking lot on the right-hand side.
 The museum is on the west side of the lot.

This is a small, quirky collection in a beautiful port town that would merit a visit even if there were no museum.

Allie Ryan, the collector, is as interesting as the collection. He's

a man now in his eighties, whose home is in South Brooksville, Maine. Ryan has made his living by picking blueberries, cutting ice, and digging clams. He didn't have electricity in his house until the 1960s and he still doesn't have plumbing or a telephone.

When he was young, Ryan began collecting relics of steam navigation, and he continued to collect when he was in the South Pacific during World War II. He put every cent he earned into his hobby, and what we see here is just a part of what he has accumulated: nameboards of steamers, timetables, menus, ships' telegraph equipment, paintings, lithographs. There are ship models made in the 1930s by Captain James Stinson of Stonington, who did not carve them but built his craft up from the keel. And there are wonderful prints of steamships under sail. It seems that when steamers were first being tested, about 1779, people were afraid the boilers would explode. To ease their fears steamships were rigged with sails. The museum also holds a phenomenal, huge, triple-expansion steam engine that was made about 1900. Students at the academy used it to develop their proficiency from about 1941 until the 1970s. It became a museum piece in the 1980s.

You can see this museum in thirty to forty-five minutes. Children might enjoy it.

∾ Downeasters ∾

PENOBSCOT MARINE MUSEUM
Church Street
Searsport, Maine 04974
Phone: 207-548-6634
Director: C. Gardner Lane
Hours: Memorial Day weekend through October 15, Monday
 through Saturday 9:30–5:00, Sunday 1:00–5:00
Directions: Go east on U.S. Route 1 through Belfast. Six miles
 beyond Belfast is Searsport. The museum is on the left-hand side
 at the east end of the main shopping area.

If language merits any credibility, it is ridiculous to talk about Maine as Down East anywhere but in Quebec and points north and west. But who among us doesn't recognize the term immediately (whether we've ever questioned it or not), and who doesn't also have a pretty good idea what a Downeaster is? It is (a) a person from

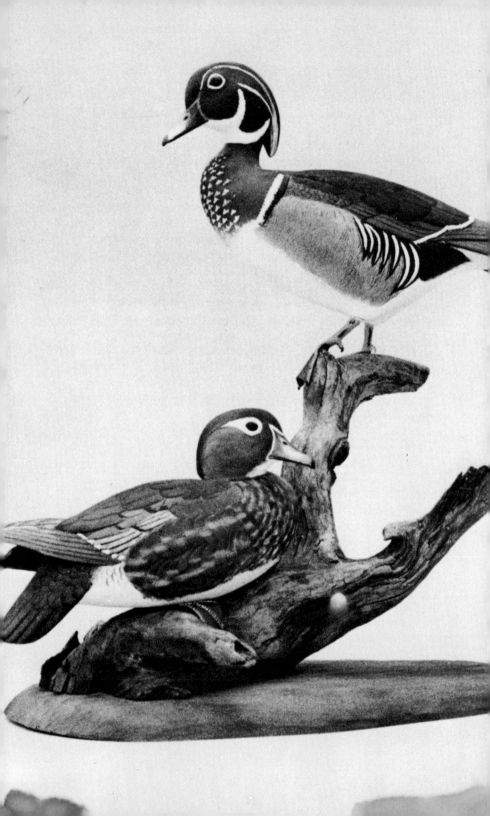

Maine and (b) a boat. About the latter you will understand a great deal after a visit to this museum, and as for the mysterious nomenclature, let's explain that right now.

"Down East" is a nautical term that can be traced back to the 1800s. Coastline schooners sailed from Boston to Maine setting their courses northeast. They sailed with the prevailing southwest wind, or downwind; hence they went down east. And the Downeaster, you will learn in this museum, was the "culmination of the American wooden shipbuilder's art," with the winning combination of speed, cargo capacity, hardiness, and low operating cost. It was built primarily in Maine.

Searsport, during the late nineteenth century, had a population of just two thousand, yet there issued from this town a full 10 percent of all American deepwater sea captains. Thus, it isn't all that surprising that three of these captains lived as close neighbors on a street that is now part of the museum. Seven buildings altogether contain a variety of exhibits, everything from a diorama of salmon fishing to a display of sugar bowls and butter dishes. The four hundred or so marine paintings include several by Thomas Butterworth and his son, James. Although the Penobscot doesn't have the largest or best collection of any particular object, it is nevertheless a very nice maritime museum.

Children should enjoy parts if not all of the exhibits. Give it from forty-five minutes to a couple of leisurely hours.

ᐤ Bird Carvings ᐤ

WENDELL GILLEY MUSEUM
Corner of Main Street (Route 102) and Herrick Road
Box 254
Southwest Harbor, Maine 04679
Phone: 207-244-7555
Curator: Nina Z. Gormley
Hours: The hours are irregular so it would be wise to check in advance. The museum is always closed on Monday, and from January to April; groups may make appointments. Check for hours during the rest of the year.
Directions: Take I-95 to the Bangor, Maine, bypass. Go east on route 395 to Route 1A. Follow 1A to Ellsworth, then continue straight through Ellsworth on Route 3 toward Mount Desert Island. Bear right onto Route 102 at the head of the island and remain on this route, which becomes Main Street in Southwest

◄ Life-sized wood duck
Wendell Gilley Museum, Southwest Harbor, Maine

Harbor. The Gilley museum is on the left side of the road at the corner of Main Street and Herrick Road, a few blocks before the town center.

In 1974 Wendell Gilley carved a life-size willet, a delicate and not very large shorebird with a long bill, an elegant curve of the neck, and soft-beige markings on its white chest. It isn't nearly as showy as his great horned owl or his bald eagles; it isn't as colorful as his brown, blue, gold, orange, and white wood ducks: it isn't as elaborate as the six Canada geese set upon a piece of driftwood, each of which is doing something different, from flying to reposing. But the willet is just right, holds its own among this collection of carvings by one of America's premier bird carvers.

Gilley was an oil-burner repair man and a taxidermist before he began whittling. But once he got started in the early 1960s, and once he was selling his birds to the classy New York store Abercrombie & Fitch, he didn't stop. He carved more than six thousand birds before he died in 1983. This museum in Gilley's hometown is an attractive, solar-heated building that opened to the public in 1981. Besides the more than two hundred birds of Gilley's at the museum, there are temporary exhibits of the works of other carvers. There is also a videotape of Gilley carving and talking about his work.

Children will enjoy this collection. There is a wheelchair ramp. About half an hour will give you enough time.

⌁ Mechanical Music ⌁

MUSICAL WONDER HOUSE
18 High Street
Wiscasset, Maine 04578
Phone: 207-882-7163
Director: Danilo Konvalinka
Hours: May 25 through October 15, daily 10:00–6:00. Guided tours
 until 5:00.
Directions: Follow Route 1 into Wiscasset and look for signs to the
 museum. A deluxe presentation tour of this museum, two hours
 long, costs $13.50. There are lesser tours: the three downstairs
 rooms for $5.50, seven rooms for $9.50. There are evening
 candlelight concerts, too, for which a ticket is $15. Or you can
 take a quick look around at a few of the musical wonders for
 free, but, oh, what you will be missing.

Musical Wonder House ▶
Wiscasset, Maine

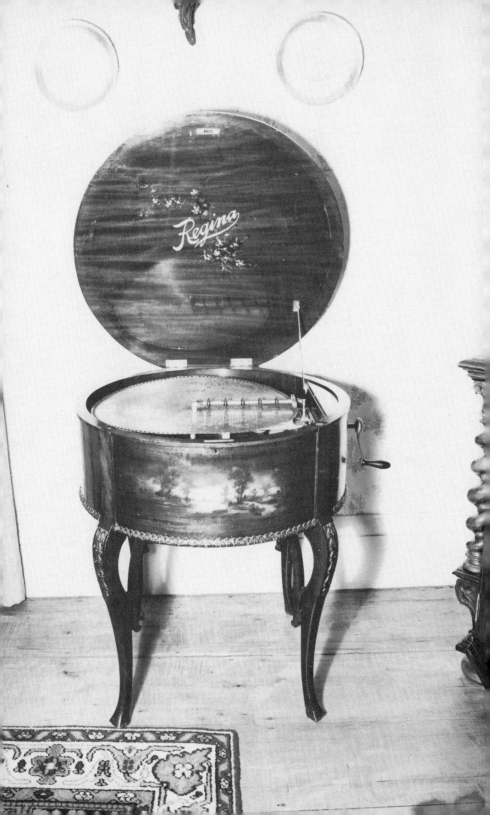

Remember dime-store crank toys that played a tune, the Swiss chalet Uncle George brought back from his trip to Europe, the jewelry box that played "Blue Danube," the musical cigarette box? *Où sont les boîtes à musique d'antan?* A lot of them are here. And there are musical trivets, devices that play a tune when a door is opened, musical snuff boxes, clocks, inkwells, tables. When you open the round top of an elegant Louis XV-style table handcrafted in Pennsylvania in 1895, you find a music box that plays twenty-inch metal discs. It has two sounding boards, so the timbre is deep and rich.

Danilo Konvalinka is the owner and maestro of this musical emporium, and when he sits down to either of his two Steinways, which he calls "reproducing expression players," he redefines player piano. He controls the temperament and pace as he plays Maria Careras playing Chopin on a piano roll, or a composition by his Austrian grandfather, Ferdinand Lang. He closes his eyes and works the pedal and becomes very much an interpretive pianist, without even using his hands.

The barrel and pin operating principle of a music box was used as early as the fourteenth century in the Netherlands, where it was applied to the carillon. Later the principle was adapted for harpsichords and organs and then, in the eighteenth century, for snuff boxes. In the music box, though, sound is produced not by bells, strings, or pipes but by metal teeth. These are plucked by pins that protrude at calculated intervals on a revolving drum or disc.

The Wiscasset collection is presented in rooms of an elegant Georgian-style house. The complete tour takes you up the flying staircase to a Victorian parlor, the Phonograph Room, where you'll find cylinder phonographs by Edison, Columbia, and Pathé that date from the turn of the century. In the adjoining Gramophone Room is a rare 1898 Berliner gramophone and the trademark for His Master's Voice, none other than the dog Nipper. In the wildly lavish Bird of Paradise Room are a bed and nightstand that, we're told, belonged to Archduke Franz Ferdinand, who was once heir to the Austrian throne. There are also mechanical singing birds and a "magic" mirror that, when its lights are turned on, reveals dancing dolls behind the glass.

On the ground-floor tour are, in the Red Room, player pianos; the Green and Gold Room has so-called musical automata, those wonderful small mechanical devices from jewelry boxes to bird cages. And The Great Music Room is devoted to music boxes: more than 125 cylinder models that can play more than 894 different tunes, and

about 15 antique disc musical boxes each of which has about 50 tune sheets.

Danilo Konvalinka came to the United States from his native city of Salzburg, Austria, in 1956. The Konvalinkas opened the Wonder House in 1963, and besides playing the reproducing pianos he is skilled at restoring music boxes. In fact, the Smithsonian Institution in Washington, D.C., has a few that he has repaired.

Although youngsters do love mechanical music, this collection is rather sophisticated for most small children. In any case, they should be carefully supervised. Unfortunately, there are no provisions for wheelchairs.

⚬⚬ Saint-Gaudens ⚬⚬

SAINT-GAUDENS NATIONAL HISTORIC SITE
RR 2
Cornish, New Hampshire 03745
Phone: 603-675-2175
Superintendent: John H. Dryfhout
Hours: From the last weekend in May through October. Buildings open 8:30–4:30 every day. Grounds open an hour earlier and remain open until dark.
Directions: The museum is just off New Hampshire Route 12A. Take I-89 to exit 20 (West Lebanon, New Hampshire) and go south on 12A. Or from I-91 take exit 8 (north toward Windsor, Vermont) or exit 9 (south toward Windsor) and cross the covered bridge. Then follow signs to the site.

This beautiful estate is tended lovingly by the National Park Service. It's the only site the NPS administers that is devoted to a visual artist, and it does a splendid job.

Augustus Saint-Gaudens, who lived from 1848 to 1907, was a sculptor whose public works may be familiar to most of us, although his name may not. Call to mind, though, an image of Abraham Lincoln standing in front of a chair with a contemplative expression on his face, one hand absently holding the lapel of his morning coat, the other behind his back. His deeply thoughtful eyes are fixed somewhere in front of his square-toed boots. He's younger, dreamier, than the seated president inside the Lincoln Memorial in Washington,

D.C.—that Lincoln is the work of Daniel Chester French (see page 83). Saint-Gaudens completed his Lincoln in 1887.

Or conjure up a naked, lithe Diana in bronze, her hair tucked into a chignon at the back of her head to reveal a perfect profile. With her right leg several inches above the ground, she appears to have leaped and landed gently as she is ready to release the arrow pulled back with what must be perfect form. (You will also see her in the new American wing of the Metropolitan Museum of Art in New York City.) There are the Pilgrim, a massive sculpture with a cape and a determined set to his face; Liberty blazing forth from the face of a twenty-dollar gold coin; General Sherman riding with the bronze beauty Victory by his side; Farragut, the statue whose completion in 1876 brought fame and a series of other commissions to the artist.

Some of these works are in the studio where Saint-Gaudens worked until he died, and where the books of his library, particularly a dictionary of Greek and Roman antiquities, still hold his page markers. Other pieces are placed around the grounds or in a gallery that was recently built at the site of a studio that burned down in 1944. Here is a fine exhibit of the artist's plaster working models of coin designs; here also are several of his portrait bas reliefs, a couple of comical, wonderful frogs spouting water into a reflecting pool. These creatures he designed for installation with his statue of the Puritan—which was, for a long time, without frogs—in Springfield, Massachusetts. The croakers were ceremoniously installed in the summer of 1984. And here, also, is a fabulous treasure that John Dryfhout, superintendent and museum curator, came upon entirely by accident. He was browsing in a gallery on Madison Avenue back in 1978 when he discovered something he realized was a Saint-Gaudens creation, although the gallery owners had no notion of what it really was. This piece is a mahogany wall panel depicting Ceres, one of twelve panels that were in the Vanderbilt House on Fifty-seventh Street and Fifth Avenue in New York City. None of the other eleven has yet surfaced.

At this historic site you can find more than a hundred works of Augustus Saint-Gaudens, but you can also find yourself in as idyllic a spot as you will ever hope to visit. There are the house, the gardens, a shrine to the artist; there are nature walks, weekend concerts. There is even a resident sculptor. In short, your visit can be a day-long outing for an entire family, or can be a shorter but no less enlightening visit for an admirer of heroic and elegant sculpture. Most of the exhibits, although not all of the grounds, are accessible to wheelchairs.

Santa Claus ▶
Annalee Doll Museum, Meredith, New Hampshire

⚭ Skis, Skiers, & Skiing ⚭

NEW ENGLAND SKI MUSEUM
Franconia Notch
P.O. Box 267
Franconia, New Hampshire 03580
Phone: 603-823-7177
Director and Curator: Arthur F. March, Jr.
Hours: December through March and June through October, daily
 10:00–4:00
Directions: Take I-93 and Route 3 to Cannon Mountain Tramway in
 Franconia Notch State Park.

A Northeasterner should probably sail all summer and ski all winter. But when you can't do the sport of your choice, it's nice to think about it, to delve into its history, and to learn about all its heroes.

Right smack in the jaws of ski country (beautiful and awesome in fall, I can testify, as it must be in winter), the ski museum is clearly a labor of love. It is also a well-conceived operation. Even a non-skier might be bitten by the bug while watching the ten-minute, extra-wide-screen film that gives a quick but dramatic rundown of the history of this sport.

The museum owns a huge collection of ski equipment, trophies, posters, memorabilia, and all those other objects that make up archives. But since exhibit themes change yearly, I can't predict what you will see when you decide to visit. Suffice it to say that if you love skiing, you will love it even more after a tour of the museum.

An inspiration to ski bums of all ages, this visit could take about half an hour. There are other ski museums in the country, but this is the only one in the Northeast.

⚭ Stuff ⚭

KELLEY'S MUSEUM
17 Bishop Street
Littleton, New Hampshire 03561
Phone: 603-444-5395
Hours: Call and make an appointment
Director: Charles W. Kelley

Directions: Littleton is just over the Vermont border. Take I-93 into town, and from the center go north on Route 116 (also called Union Street). Just before the elementary school turn left onto Bishop Street. Kelley's house, a yellow ranch, is on the right. There is a small sign in the front yard.

A category in which to fit this museum hasn't been devised yet. I would call it American Kitsch were it not for the negative connotations. Centuries from now Kelley's collection will probably be enshrined in a museum of cultural anthropology. We are probably too close to it now to put it in historical perspective.

Charles Kelley is a friendly man who was a florist before he retired in 1975. He has spent the years since enthusiastically collecting and creating things. He makes miniature furniture from tin cans and from milk cartons. He painstakingly curls threads of paper into snowflake designs and into bouquets. He uses coins to make designs in the shape of a horse's head; he builds tiny shells into large scenes; from two thousand popsicle sticks he has constructed two lamps on a single base. And he does all this with enormous gusto. His pleasure is to escort a visitor through the three basement rooms in which he displays his collection.

Scientific experiments that are written away for and built at home—he has written for and constructed them. A hologram, for instance, in which a woman's eyes follow you and she blows you a kiss as you move off to one side. A perpetual motion clock. Fluorescent rocks. The offbeat, the bizarre, the believe-it-or-not kinds of things are all set out and labeled in Kelley's own handwriting.

Charles Kelley doesn't charge a cent to show you his collection. In fact, you're more likely to walk out with a sample of his latest creation than to leave any money behind. "I just love doing it" is what he'll tell you. If you've a mind to tarry, you could spend more than an hour in Mr. Kelley's basement. It will fascinate children. It is, however, entirely inaccessible to handicapped people.

✺ Whimsical Dolls ✺

ANNALEE DOLL MUSEUM
Reservoir Road, Box 1137
Meredith, New Hampshire 03253
Phone: 603-279-4144

Directors: Annalee, Chip, Chuck, and Townsend Thorndike
Hours: Summer daily 9:00–5:00, winter 10:00–4:00. Closed in January.
Directions: Meredith is just above Laconia, on Lake Winnipesaukee.
 Take exit 23 from I-93 and follow Route 104 to Meredith. Look
 for signs to the museum, which is just off Route 104.

There is, apparently, quite a mystique connected with Annalee dolls.
I was not privy to it; in fact, I must confess I'd never even heard of
these dolls before the museum caught my attention.

 Annalee Thorndike, then Barbara Annalee Davis, made her first
doll way back in 1934. In the years since, she has designed a variety
of flexible-limbed people with faces painted on fabric. And the
armies of Annalee people have been joined by cute mice, ducks, deer,
rabbits, and a stork. Not to mention Santa and Mrs. Claus.

 In 1955 the New Hampshire Department of Parks and Recre-
ation really launched Annalee on the road to success when it com-
missioned a large number of dolls for display in its headquarters at
Rockefeller Plaza in New York City. These dolls, skiers in bright
outfits with wooden skis, were snowplowing, schussing, riding ski
tows, turning, and tumbling. There's a bevy of them at the museum
on a scene that is meant to represent the famous New Hampshire ski
slope called Tuckerman's Ravine.

 The museum, in a building with barnboard siding, is on the
grounds of the Thorndike complex. A slide presentation traces the
evolution of the dolls, shows how they are made, and also serves as a
sort of Thorndike family album. Although the founder is not so ac-
tively involved these days, her spirit pervades the entire operation.

 The whimsical spirit of Annalee dolls begins to grow on you, if
it hasn't already laid claim to your enthusiasm, as you look around
the museum. I think my favorite doll is one that was made in 1959.
It's a ten-inch-high fellow called O B Doctor. He's dressed in a white
scrub suit and he's holding an upside-down infant by its heels,
spanking it on the bottom.

 Children will like this museum. The visit is brief, although the
movie presentation might stretch it to half an hour. The museum is
not easily accessible.

⌘ Pottery, Glass, & Grandma ⌘

BENNINGTON MUSEUM
West Main Street
Bennington, Vermont 05201
Phone: 802-447-1571
Director: David Dangremond
Hours: 9:00–5:00 every day, including Sundays and holidays. Closed
 December, January, and February.
Directions: Bennington is in the southwestern corner of the state.
 The museum is on West Main Street (Route 9), one mile west
 of the intersection of Route 9 and U.S. Route 7.

If you've a mind to see it, the oldest stars and stripes known to exist is on display here. The flag's colors are faded and it is not particularly beautiful—but it sure is an important piece of fabric.

Bennington is a lively, impressive regional museum. While the flag is its most precious item, it has other outstanding exhibits. For instance, the largest collection of Bennington pottery is here. The untutored will be surprised by the great variety of styles and glazes that were made in Bennington. Those stoneware jugs and jars, with their blue designs on off-white backgrounds, are familiar enough, and the mottled brown enamel glazes are well known to the browser in antique stores. But the museum also shows Bennington Parian ware, fine, white unglazed porcelain, especially the white and blue kind that looks like an American version of Wedgwood. At the entryway to the Bennington pottery room of the museum is a ten-foot-high monumental sculpture, created for the 1853 Crystal Palace Exposition in New York. It is spectacular (if, once again, not necessarily beautiful) in concept and presentation. Made by Fenton's U.S. Pottery Company, it contains all the varieties of so-called Bennington pottery: base, pedestal, and columns are of different wares, the Madonna on top stands above a bust of none other than Mr. Fenton, and both he and she are fashioned in Parian.

The Bennington Museum has the largest collection of American glass *on display*. That is an important distinction. As Eugene Kosche, the museum's senior curator, pointed out, the museum may not own the largest number of pieces, but it has more available for visitors to see than even Corning in New York (see page 138). And, as he might have said, a larger collection is of little benefit to a visitor when it is in storage and can't be seen.

A wonderful innovation here is a hefty glass candlestick, a piece of American glass from 1850, that is left out for visitors to touch and hold. A diagram on the wall describes things to look for in the crafting of this glass; it is an informative and interesting lesson.

I was intrigued by the collection of glass salt dishes, of which about two hundred fifty are on view. And case after case with row after row of pressed glass goblets, a stunning parade, is another of my favorite displays here. In the newly exhibited art glass collection Kosche pointed out his favorite, an iridescent blue bowl in which color, shape, and the stretch marks along the rim embody a sense of design and balance that few objects can match.

Bennington has to its credit the largest collection on display (again that fine distinction) of Grandma Moses paintings. The sense of exuberance one has standing in a room among these joyful pictures is just right for a spirit that needs lifting. And another of Eugene Kosche's treasures—he himself is an antique car buff—is the six-cylinder 1925 vintage Wasp automobile, one of the two remaining of those built by the Martin-Wasp Corporation of Bennington.

Browsers who love museums such as this can spend an afternoon here. Bring young children at your own discretion.

ᕯᕧ Snowflakes ᕯᕧ

JERICHO HISTORICAL SOCIETY
Route 15, P.O. Box 35
Jericho, Vermont 05465
Phone: 802-899-3225
Director: Blair Williams
Hours: Monday through Saturday 10:00–5:00, Sunday 1:00–5:00, or
 call number above for appointment
Directions: The former mill in which the collection is kept is in
 Jericho Village on Route 15, about thirty minutes from
 Burlington. Take exit 15 from I-89 and follow Route 15
 through Essex Center. As soon as you enter Jericho, look for the
 mill on your left by the River Bridge.

As Newton was to the apple, as Andy Warhol was to Campbell soup, as Darwin was to evolution, and even as Columbus was to America—which was, after all, there before he found it—so is Wilson Alwyn Bentley to the snowflake.

"Snowflake" Bentley, as he is known, and even lionized by a

plaque in the center of the town where he was originally considered eccentric at best, was the first man ever to capture the snowflake on film. He was born in 1865 and spent his late boyhood and his entire adult life photographing, studying, and writing about snow, frost, dew, rain, and clouds. He made his own camera and devised his own process for making photomicrographs of snowflakes; once he got the knack, he made more than five thousand of them.

"The day that I developed the first negative made by this method and found it good, I felt almost like falling on my knees beside that apparatus and worshiping it! I knew then that what I had dreamed of doing was possible. It was the greatest moment of my life," Bentley said.

Bentley's wooden camera, a wooden tray painted black on which he collected snowflakes, a feather used to brush those snowflakes onto the glass slides on which they would be photographed, his pen knife—these are the main objects in this collection. They are, unfortunately, in the underground, lower level of the mill, along with the other museum pieces, which include milling machinery. I say "unfortunately" because anyone who has mold allergies, as I do, will get a headache here.

This is an underfunded collection that has undiscovered potential. The Jericho Historical Society, which owns not just what is on display but also many slides and writings of Bentley's, should and soon may be able to do better. The members have put together a slide show and they are coming into funds to improve the display. Bentley's story is one that could be told dramatically. You get a hint of that drama from the yellowed newspaper article on one wall: "Fame Comes to Snowflake Bentley after 35 Patient Years—even far-off China sends tributes" reads the headline in the January 2, 1921, *Boston Globe.*

Watch for this exhibit as a collection with a future. For now, you may want to make an appointment to explore the archives for scholarly purposes or, if you are passing by and you can't resist the extravagances of human nature at its devotional best, you can see the stuff in the basement in ten minutes or so.

⌘ Fly Fishing ⌘

AMERICAN MUSEUM OF FLY FISHING
Route 7A, Box 42
Manchester, Vermont 05254
Phone: 802-362-3300
Executive Director: John H. Merwin
Hours: Daily 10:00–4:00, May to October. Weekdays 10:00–4:00,
 November to April.
Directions: The museum is on the corner of Route 7A and Seminary
 Avenue, adjacent to the Equinox Hotel.

The paint was still fresh in the new quarters of this museum when I
visited—it had just moved from the nearby Orvis Company and is
now in its own building. Orvis is the direct mail-order company fa-
mous for its rod and reel manufacturing. Because the museum rented
space there, a lot of people mistakenly assumed it was part of Orvis.
It is independent although not entirely unconnected.

One fascinating display was put together by Mary Orvis Mar-
bury, daughter of C. W. Orvis, the company's founder. The author
of *Favorite Flies and Their Histories*, she was the first to name and stan-
dardize patterns of hundreds of different flies, and she prepared this
display for exhibit at the Columbian Exposition of 1893. Flies are
mounted in two-sided glass cases with wooden frames. The frames,
like leaves of a book, are attached to a spine that allows the frames to
be turned. Each page has a certain number of flies and wonderful old
tintypes of fishing scenes—some anglers proudly showing off their
catches, some landscapes of the kinds of places where the flies on that
page might be used.

John Merwin, the museum's executive director, provided a
quick primer: "There are two kinds of flies: those that look like the
insects fish eat and those that attract their attention." The latter,
called attractors, were, naturally enough, the ones that caught my at-
tention. Merwin described the materials used for one fly. The upper
portion of the fly, or wing, which was covered with polka dots, was
made from guinea-fowl feathers that had been dyed red. The lower
part, or hackle, was made from the neck feathers of a white rooster
and had been dyed orange. The body was wound with yellow silk
floss, the tail was a white goose-wing quill dyed red. Since this fly was
made in 1890, before the hooks had eyes, it had a loop that was fash-
ioned of Spanish silkworm gut. Say that again—Spanish silkworm

◀ Proctor, Vermont
 Vermont Marble Exhibit

gut—Merwin insisted, and he showed me, on one of the walls, a packet of the very product that fly tiers used.

The American Museum of Fly Fishing could turn a person into a fly fisherman, it's that engaging. There are the rods of some famous Americans who loved the sport: Winslow Homer (a "rabid angler"), Daniel Webster, Herbert Hoover, Ernest Hemingway, Dwight Eisenhower, Bing Crosby. There are also specimens of flies tied by America's best. A display shows the chronology of reels and documents the history of rod building.

What would Merwin save if the building had to be evacuated? He walked over to a case that held an old leather wallet packed full of fine metal loops with small feathers. It's a wallet full of flies, a "fly book" that can be dated back to 1835. Considering how easily flies deteriorate, this is a rare find, or, as Merwin said with quiet awe, "a real treasure."

The amount of time you spend in this museum may be in direct proportion to your interest in fly fishing. The nearby Battenkill River, a challenge to trout fishermen, is an extra incentive. This is probably not a museum for young children.

໑ Vermont Marble ໑

VERMONT MARBLE EXHIBIT
Route 3
Proctor, Vermont 05765
Phone: 802-459-3311
Exhibit Manager: Jean Peterson
Hours: Late May to late October daily 9:00–5:30
Directions: Proctor is a few miles northwest of Rutland, Vermont.
The museum is on Route 3, which is near the crossroads of
Routes 7 and 4 in Rutland. Just follow signs into town.

As you enter the town, the sign announcing Proctor is made of white marble veined with black. Around the bend is a handsome new fire station that is faced with marble. So are the library and enough other buildings to let you know that this little town is big on marble. Indeed, here in the Green Mountains of Vermont is, reputedly, the largest marble-production center on the North American continent.

The exhibit begins with a series of white marble bas-reliefs of American presidents. There are also a great many commercial dis-

plays of marble used as table tops, bathroom walls, lamp bases. A sculptor chisels away here in full view of visitors, and in a small gallery marble sculptures range from abstract and geometric to representative and realistic.

Photos and a film describe everything from the geology to quarrying to manufacturing. The displays show not only the local marble but also slabs from throughout the world. All marble considered, I think my favorite is one called Royal Red Vermont, a rich, rusty red flecked with grey.

One of the most interesting displays shows the effect of light coming through a wall of thin marble. In the exhibit this effect is demonstrated by means of incandescent light shining through a wall in a bathroom model—rather spectacular since the tub is a rich, deep red. The Vermont Marble Company provided 250 panels, 8-foot squares 1¼ inches thick, of Montclair Danby Marble for the Beinecke Library in New Haven, Connecticut. As wall panels these admit a unique, subdued light. Vermont Marble has also supplied the U.S. Supreme Court, the Thomas Jefferson Memorial in Washington, D.C., and the United Nations in New York City.

Redfield Proctor was the original marble mogul and a politician. He and three of his descendants served as governor of the state. But the Proctors no longer own the company; it is now a division of a Swiss-based company that specializes in quarrying operations around the world.

A tour through this museum requires about an hour. Parts of it, such as the artist at work, may interest small children. Without special provisions for the handicapped, it is still reasonably accessible.

∽ Hummingbirds ∽

FAIRBANKS MUSEUM AND PLANETARIUM
Main and Prospect Streets
Saint Johnsbury, Vermont 05819
Phone: 802-748-2372
Co-directors: Howard Reed, Jr. and Charles Browne
Hours: Daily 10:00–6:00 except Sunday 1:00–5:00
Directions: Saint Johnsbury is in northeastern Vermont close to the
 New Hampshire line. I-91 and I-93 will take you there, as will
 U.S. Route 2. Follow Route 2, which becomes Main Street, into
 the center of town, and you will find the museum.

I went to the Fairbanks Museum in Saint Johnsbury because I'd learned about its hummingbirds, but I never expected to be so completely charmed. The moment I walked into this handsome red stone building—in a style called Richardson Romanesque after the American architect, H. H. Richardson, who made it popular—I knew that if ever I imagined the perfect natural sciences museum, this would be it. There's a harmonious combination of the collection and the design of the building. For instance, a great sense of space is provided by a thirty-foot-high, wood-paneled, barrel-vaulted ceiling. To get from the first floor to the second, which is a mezzanine, you climb an enclosed spiral staircase in which the walls are wood-paneled and the risers between the stair treads are an elaborate jigsaw design. Arched windows with a discrete geometric pattern were designed by none other than Louis Tiffany.

We have all this thanks to Thaddeus Fairbanks, who invented the platform scale in the early nineteenth century and later set about manufacturing scales in Saint Johnsbury. By 1882 more than eighty thousand Fairbanks scales were being produced annually, and by 1897 the E. & T. Fairbanks Company held 113 patents for improvements and inventions in weighing. The company offered two thousand standard varieties of scales, as they put it, and made as many as ten thousand models and custom systems. (Why Saint Johnsbury doesn't have a scale museum I can't tell you.)

The Fairbanks Museum has a renowned collection of more than eighteen hundred birds from all parts of the world. Colonel Franklin Fairbanks, nephew of Thaddeus, was the naturalist whose collection and generosity led to the establishment of the museum in 1891.

Among a shelf of birds from South America sits Junior, a Mexican double yellow head parrot. He lived at the museum from 1966 until his death in 1974, according to a curatorial note. I would like to amend that note by saying that he lives there still, wings half spread, next to Le Valliant's Amazon parrot on one side and a branch full of trogons on the other.

On the mezzanine is an unusual collection of netsukes. These are tiny little carvings, most less than two inches high, in bone and in wood. They are often humorous creatures. There is a snake coiled around a monkey, which has a look of dismay on its face, wrestlers entwined around each other, Buddhas, puppies playing, and all sorts of miniature sculptures. Netsukes are clasplike devices that were used like toggles on Japanese men's purses.

But the hummingbirds! This museum probably has the largest collection of hummingbirds in the world. A friend of mine said

when I told her this, "As far as I'm concerned, one stuffed hummingbird is the world's largest collection."

Still, there are probably close to three hundred here. They are all smaller than the average bird, but it is interesting to note the great variety in both size and coloration, especially in their throat feathers, which range from iridescent yellow to iridescent blue. Hummingbirds are found only in the New World, and of more than three hundred species identified, only eight penetrate any distance from the Mexican border. And only the ruby throat, one of the smallest, is regularly found east of the Mississippi.

This is a wonderful museum for both children and adults. You could easily spend an hour here. Unfortunately there is currently only limited access for handicapped visitors.

ᘓᕊ A Circus Parade, Decoys, Quilts ᘓᕊ

SHELBURNE MUSEUM
Route 7
Shelburne, Vermont 05482
Phone: 802-985-3344
Director: Benjamin L. Mason
Hours: Mid-May through late October, daily 9:00–5:00; winter
 months limited, usually Sunday 11:00–4:00, but phone in
 advance.
Admission: Adults $9.00; ages six to seventeen $3.50; under six free.
 Special rates and provisions for late arrivals and second-day
 tickets.
Directions: The Shelburne Museum is on Route 7, seven miles south
 of the I-89 Burlington interchange.

Electra Havemeyer was a rebellious young woman—fortunately for us. The Havemeyers were one of those American families who had new wealth at the turn of the century and went, for the most part, to Europe to spend their dollars on treasures. (See, for instance, the Popes of Hill-Stead, page 105.) Havemeyer money came, incidentally, from the vast and monopolistic American Sugar Refining Company during the late nineteenth century. Although her parents accumulated great works of art from Europe—which are now at the Metropolitan Museum of Art—Electra insisted upon collecting the things she liked best: cigar-store Indians, weather vanes, quilts, figureheads, carriages, sleighs, and even a ship.

Electra Havemeyer married a handsome polo player, J. Watson Webb (son of Commodore Vanderbilt's granddaughter), whose father had a summer place (a 110-room summer place) near Shelburne. That provides the Vermont connection. The Webbs also maintained a 17-room apartment on Park Avenue in New York City. After Electra Webb died (in 1960), the contents of that apartment—a fabulous collection of works by Rembrandt, Degas, Corot, and Manet, as well as antique furniture, elegant paneling, and china objects—were moved to a specially constructed Greek revival building at the Shelburne Museum. Family photographs here and there add to the illusion that the Webbs have only stepped out for a moment. Portraits of the family, incidentally, reveal that Electra was a lovely woman both in her youth and in her later years.

In the Webb Gallery, too, is a notable collection of works of art, all American paintings and prints. The legend of Rip Van Winkle is told in a series of five paintings by Albertus Browere and four of them are here—although for some reason they aren't hung according to the plot sequence. There are primitive portraits by Erastus Salisbury Field and scenes by Grandma Moses; there are landscapes by Edmund C. Coates and Fitz Hugh Lane. In short, there's a great deal here to interest the connoisseur.

But it is the folk art, the bold collection of everything from hat boxes (yes, it's hard to believe, but the old hat boxes are as pretty as the hats) to blankets that draws attention to the Shelburne Museum. Some of the holdings here—decoys, for instance—constitute the largest and best collections of their kind.

In Dorset House (Building 33 in a complex that totals forty-three buildings) are more than a thousand early wildfowl decoys. Room after room, upstairs and downstairs, contain everything from tiny birds to huge carvings. A particular display irresistible to anyone interested in this craft shows the works of one of the country's foremost carvers, A. Elmer Crowell.

The finest collection of quilts to be found, a collection that quiltmakers study and that dazzles everyone, is here. Many of the quilts are mounted as if they were pages in a giant notebook. They can be turned and seen in their full beauty. From a distance the colors and designs are magnificent. At close range the tiny stitches and careful detail are astonishing.

In a building that is 525 feet long, the walls are hung with old circus posters. There are wonderful carousel animals, including an ostrich and a lion, and a circus parade that was carved by a man named Roy Arnold of West Springfield, Massachusetts, and four as-

Shelburne Museum ▶
Shelburne, Vermont

sistants. The parade was started in 1925 and completed in 1951. Teams of horses pull wagons with lions and tigers, giraffes and seals, and an "American Tableau" wagon in which Liberty (painted gold all over) holds her torch high; Knights wear armor, elephants parade. The scale is one foot to a mile, and if the scale were human, this parade would be two miles long.

Here is the S.S. *Ticonderoga,* a 220-foot-long steel-hulled side-wheeler that cruised up and down nearby Lake Champlain from 1906 to 1954 carrying passengers. She now sits, surrounded not by blue water but by green grass, on the grounds of this museum.

The Shelburne Museum is a real blockbuster. It is Eclectic with a capital E. In fact, it is all capitals and an exclamation point: ECLECTIC! It is also ENORMOUS! You could easily spend the entire day wandering around. Children will find a great deal to amuse themselves, not the least of which is a sort of bus-taxi that makes the rounds. This conveyance is also nice for older visitors who may weary of walking. A few wheelchairs are available and some, but not all, of the exhibits have ramps. Call to make advance arrangements for special-needs visitors.

↬ American System ↫

AMERICAN PRECISION MUSEUM
South Main Street
Windsor, Vermont 05089
Director: Edwin A. Battison
Phone: 802-674-5781
Hours: May 30 to November 1, 9:00–5:00 weekdays, 10:30–4:00
 weekends and holidays
Directions: This museum is just across the border from the
 Saint-Gaudens Museum in Cornish, New Hampshire. On I-91 or
 I-89 take the Windsor exit and follow the route into town. The
 museum is right at the Route 5 and Route 44 junction.

Standing before a particularly attractive hunk of heavy-duty machinery that was about fifteen feet long, I wondered why it sported such an elaborate bridgelike framework—it seemed an extravagant part of a utilitarian mammoth. Unlike all its neighbors, this piece had lost its label. Still, right next to it, patented in August 1856 by G. Van Horn (that he was proud was demonstrated by the promi-

nence of his name), was something that resembled it and that made me believe it was also an iron planer.

This museum is in a fabulous old brick factory built beside a waterfall in 1846 by Robbins, Kendall & Lawrence as an armory and machine shop. The company pioneered in making rifles with interchangeable parts, a practice that became known as the American system of manufacture.

Some of the machines here are self-explanatory, some have the objects they carve, mold, or hone sitting next to them. A gunstock, for instance, is inside the jaws of the machine that shapes it; a vintage toy banjo and a toy gun are both next to the molds in which they were created.

There are hand tools we have seen in grandparents' and parents' workshops, and some we may even use ourselves. And of course there are the gargantuan tools that grew up with industrialization and then disappeared: a twenty-foot-long wood planer patented on December 23, 1834, in Worcester, for example.

My favorite object was the "Physical Testing Machine" from about 1890. It was used to measure the breaking strength or resistance to deflection of materials. It could approximate a load or force up to two and a half tons by means of a hand wheel. The pressure was brought to bear on a sample of whatever material needed testing.

Another work of engineering art I can't resist mentioning is a cylindrical slide rule in a wooden box "for performing the greatest variety of useful calculations with unexampled rapidity and accuracy," according to the cover of the accompanying instruction booklet. Someday, perhaps, computers will look as antique.

Children will enjoy this museum if someone can provide background. It can take from thirty to forty-five minutes. It is just across the river from Cornish, New Hampshire, where Saint-Gaudens National Historic Site is located. A great part of the adventure is to get from one place to the other by crossing the river via the longest covered bridge in the United States.

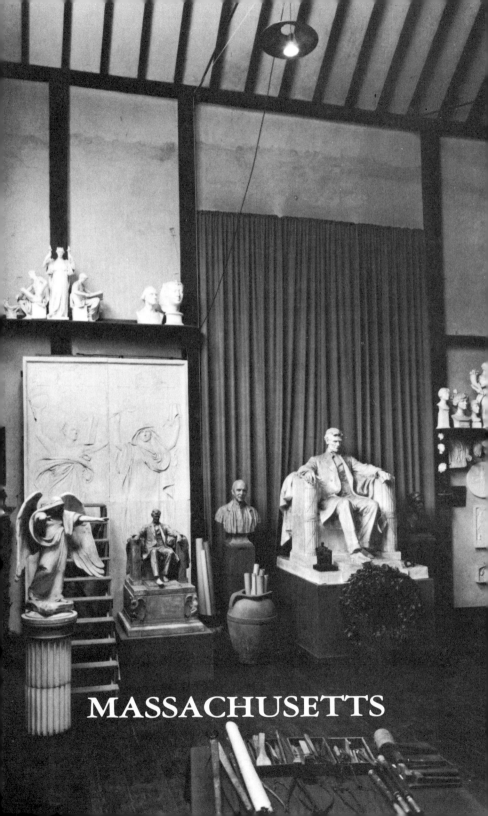

MASSACHUSETTS

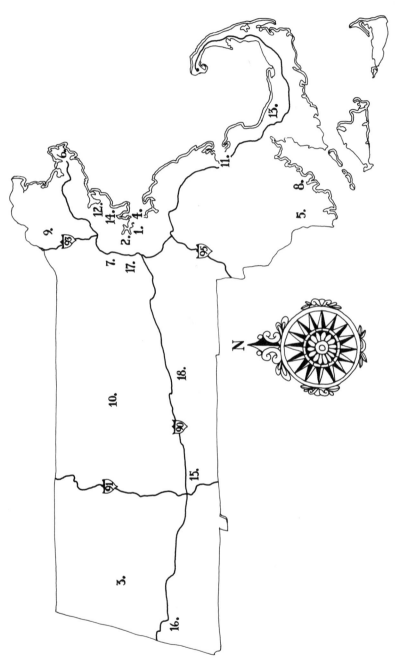

Numbers on map refer to towns numbered on opposite page.

ᘒ Massachusetts ᘒ

୧୬ Computing History ୧୬

COMPUTER MUSEUM
300 Congress Street
Museum Wharf
Boston, Massachusetts 02210
Phone: 617-426-2800
Director: Gwen Bell
Hours: Monday, Tuesday, Wednesday, Saturday, Sunday 10:00–6:00.
 Thursday, Friday 10:00–9:00. Closed Mondays September
 through June.
Directions: Take Route 3 to Atlantic Avenue/Northern Avenue.
 Follow the milk bottle sign to Museum Wharf.

There will be no doubt at all about the speed with which computer technology has advanced after a visit to this museum. But even before that visit, the ascent to the museum in a large elevator is an unusual experience: the outside walls of the elevator are glass and, as it rises, the city of Boston seems to fall into place below and around you.

What you see when you leave the elevator is hardly less impressive. The exhibits begin with the largest computer ever built, the SAGE air defense computer of the U.S. Air Force, which was in operation during the 1950s. It fills the entire top floor and spills downstairs, where the display terminals are installed. This could be a scene straight out of the movie *Doctor Strangelove,* except, as my guide pointed out, the movie had to approximate the design since SAGE was probably still top secret when the film was produced.

Most of the equipment in the museum is operating, although since SAGE used power enough to light up a town of fifteen thousand, it is not plugged in. But through a combination of audio, visual, hardware, and software displays, the workings and uses of computers are traced. Moreover, as often as possible, the exhibit designers try to give visitors actual hands-on experience. They even plan to create a setting that will make you feel as if you were walking through a computer-manufacturing plant.

The Computer Museum began in 1979 as a private museum sponsored by Digital Equipment Corporation. In June 1982 it became a nonprofit institution to which the major computer companies have contributed their products and a hefty financial endowment. It is the only such museum in the world, and when I visited, it was still in the process of moving from its first home else-

where in the state to downtown Boston. The building it shares with the Boston Children's Museum was originally a wool warehouse built in 1888.

The visit should take about an hour. Children old enough to be interested in computers will enjoy it. It is accessible to handicapped people.

໑ German Art ໑

HARVARD UNIVERSITY BUSCH-REISINGER MUSEUM
29 Kirkland Street
Cambridge, Massachusetts 02138
Phone: 617-495-2317
Curator: Peter Nisbet
Hours: Monday through Saturday 10:00–4:45
Directions: Seven museums at Harvard University are open to the
 public. They range from art to zoology. Three of the specialized
 Harvard museums are described in this book (another is listed
 in the appendix), and all are an easy walk from one another.
 Cambridge is just west of Boston, bordered on the south
 by the Charles River. From all directions take I-90 to the
 Allston-Cambridge exits (marked 18, 19, and 20.) Cross the
 Charles River on Cambridge Street and go left on Memorial
 Drive. Follow Memorial to the second bridge and turn right on
 Boylston Street. Boylston intersects Massachusetts Avenue at
 Harvard Square. Bear left on Massachusetts Avenue for a short
 distance beyond the Harvard Yard gate and bear sharply right
 through the underpass. Go left on Quincy Street one block,
 then left on Kirkland. For general information about the
 museums call 617-495-1910.
 The Busch-Reisinger Museum is located at the corner of
 Divinity Avenue and Kirkland Street.

A woman who went to college at Radcliffe during the 1950s remembers that when she was feeling dramatically gloomy she would stop in at the Busch-Reisinger to have her mood enhanced. This collection, begun in 1903 and moved into its own building in 1921, is the only one in America devoted to Central and Northern European art. You particularly absorb, as you go through, a strong sense of the Germanic spirit.

The first room has the feeling of a church. There are rows of

chairs, and in place of one whole wall is a ceiling-high plaster cast of the Golden Gate of the Cathedral of Freiberg, a thirteenth-century marvel of statuary and architecture. The room also houses an internationally famous organ, the Flentrop, which is played in concert weekly.

The holdings of this museum, according to its brochure, include the largest collection of Bauhaus materials outside Germany. Unhappily, only small parts of it are on display at any one time. In one alcove, however, several of Laszlo Moholy-Nagy's stark, linear paintings were hung and, on a stand, one of his light and motion machines stood. When it works (which it did not when I was there), it is a mechanized three-dimensional construction of reflecting metals and transparent plastics. If the curators get it back into operation, and a small note says they plan to do so, it will be a wonderful thing to see.

In clear contrast to the Bauhaus material is the museum's collection of eighteenth-century porcelain. On one shelf of the display case is a figure called *Winter,* a small porcelain sculpture of a naked old man straining against the wind, his long beard blowing, eyes dark in deep sockets. There is an amazing force in this work, which is no more than eight inches high. On a shelf below it is *A Pair of Gardeners*—one of them a maiden resplendent with flowers carried in her apron, on her hat, and in her hands—in Frankenthal china modeled in 1770.

The pieces in this museum, ranging from cubist paintings to religious icons, are linked by geographic and cultural bonds. The spirit of the place is definitely absorbing, and it is not entirely without a light touch—as you walk in, you are greeted by a bronze sculpture of the donkey, dog, cat, and rooster from the Grimms' fairy tale "The Bremen Town Musicians."

You could see the collection in under an hour, but you may want to linger. Children interested in art might enjoy it.

᧐᧐ Rocks & Gemstones ᧐᧐

HARVARD UNIVERSITY MINERALOGICAL AND
 GEOLOGICAL MUSEUM
University Museum Building
24 Oxford Street
Cambridge, Massachusetts 02138
Phone: 617-495-3045

Curator: Carl Francis
Hours: Monday through Saturday 9:00–4:30, Sunday 1:00–4:30
Directions (see page 49.): From Kirkland go right onto Oxford
 Street. The museum entrance is at 24 Oxford Street.

Footsteps echo and the radiators ping in this quintessential old museum. You expect to bump into a professor with his thumbs tucked in his vest and a monocle in his eye. Here reside the full weight and dignity of a traditional museum, a walk-softly-do-not-touch museum. But what treasures there are! Some say this collection is second only to the British Museum's. The curator, Carl Francis, says simply that it is "world class."

This museum is just across the hall from the botanical collection (see page 53) and has probably been overshadowed by the famous glass flowers next door. Still, besides ranking among the finest and largest mineral collections, it is also the oldest university collection in the country. More than six thousand mineral specimens are on exhibit, and a breathtaking 3,040-carat topaz gem stops visitors in their tracks. Despite its traditional atmosphere, there is much that is lighthearted here, too. For instance, tucked inside a case full of quartz specimens—smoky quartz, rock crystals, amethyst—is a brass rabbit with a good-sized crystal ball resting on its back.

The special strength of this collection is in the group of New England minerals, and the most unusual treasure among them is a hunk of quartz, label number 119779, an enormous purple rock that was found on Mount Apatite, in Auburn, Maine, in the 1780s.

Still, one's attention will probably be engaged by less historic and more fanciful pieces: among tourmaline specimens sits a 1½-inch-high Buddha carved from a piece of tourmaline that changes from black on top to pink on the bottom. Such displays reveal that part of the beauty of minerals is in the domain of human artistry, for the carved and cut gems are wonderful. But the raw beauty of some specimens is also intense. A piece of quartz from the French Alps is said to contain more than twelve hundred separate crystals of quartz. The specimen that lingers in my mind looked like a patch of rough grass that had crystallized in milk-white stone with occasional jet-black blades, and set upon it is a chunk of translucent cherry-red rock with smooth sides and sharp edges—a surrealistic landscape.

In a display tucked out of the way are various rough stones; next to each, a beaded necklace made from such a stone. How many moonstones might you have accidentally kicked aside in the drive-

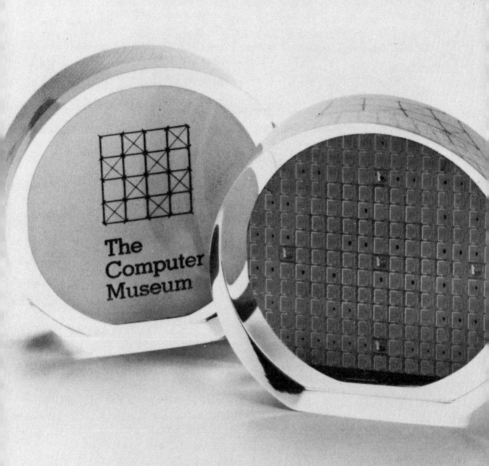

way? But you'd never have passed by a hunk of lapis lazuli or of rose
quartz.

This is a good museum for children. Plan about half an hour.

ᕲᕗ Glass Flowers ᕲᕗ

HARVARD UNIVERSITY WARE COLLECTION OF
 BLASCHKA GLASS MODELS OF PLANTS
Botanical Museum
University Museum Building
24 Oxford Street
Cambridge, Massachusetts 02138
Phone: 617-495-2326
Curator: Andrew Knoll
Hours: Monday through Saturday 9:00–4:30, Sunday 1:00–4:30
Directions: The museum entrance is at 24 Oxford Street.

Most of the plants are true to size: wild leeks and onions close by a
multitude of lilies; elegant, delicate white dog's tooth violet, also
called white adder's tooth; a wild hyacinth. Next to each plant are
sections of its ovary, its pistil, sometimes its seed. Probably the most
exquisite flower is the blue flag iris, its color rich and vibrant. But
sometimes there is a sense of unreality. A plant is magnified five hun-
dred times; a hive bee invades a sprig of sage but the bee is terrify-
ingly huge.

These are all glass—the flowers, the plants, the insects, the
fruits. Even those that look rotted and destroyed by disease are
created out of glass.

Seventy-five years ago, before photography was a means of docu-
mentation, these botanical specimens were commissioned for study
purposes. They comprise the only such collection in the world, and
they are astonishing. It is clear that the artisans did their work with
one eye on the microscope, and it is almost certain that their work
will never be duplicated. The artists were Leopold Blaschka and his
son, Rudolph, who worked in their studio near Dresden, Germany.
The first models were made in 1887 and the last in 1936. Most of the
parts were shaped by hand after the glass was softened by heat. And,
yes, they are entirely made of glass, although it is very difficult to be-
lieve in many models. With the 847 different species of plants and
the separate models of parts, there are, altogether, more than three
thousand models. They are still used extensively for teaching.

◀ Silicon wafer in lucite
 Computer Museum, Boston, Massachusetts

Although you are constantly reminding yourself as you go along that these objects are not real and certainly not plastic, there is one quite vivid external reminder. A plant with broken leaves has a note beside it that reads, "This model damaged by sonic boom."

A cassette player with an informative tape can be rented at the desk. A tour should take about forty-five minutes. This really isn't a museum for young children.

❧ Technology ❧

MIT MUSEUM
265 Massachusetts Avenue
Cambridge, Massachusetts 02139
Phone: 617-253-4444
Director: Warren Seamans
Hours: Monday through Friday 9:00–5:00, Saturday 10:00–4:00
Directions: The museum is on Massachusetts Avenue in Cambridge, north of Boston, but south of Harvard Square.

If they tried very hard, the people in charge of the MIT Museum couldn't do a better job of discouraging visitors. The outside of the building looks like an old warehouse, and when you open the front door, you face another door that is locked and warns against trying to enter. The museum is on the second floor, where you are likely to surprise a guard on duty—even though he does have a television screen to monitor who is coming and going.

But if you persist in spite of the discouraging facade, you are in for a treat. Since MIT was founded in 1861 to advance the needs of an industrializing country, the emphasis of the museum, founded in 1972, reflects the aim of the school. Steam engines, slide rules, antique globes of the world, man-powered flight implements, electricity displays, all sorts of mechanical devices fill the entirely inelegant gallery spaces.

Still, there is much that is elaborately elegant. One display entitled "Math in 3D" will strike you first as a bevy of colorful mobiles hanging by threads from the ceiling. These objects of harmonious tones are based upon geometric principles and scientifically scaled colors. And since the beaver—engineer of the animal world, don't forget—is the mascot of MIT, there will always be a beaver in some shape or form at the museum. The display I saw used a beaver to demonstrate the lost-wax process of molding. The museum also

holds one of the four major whaling collections in the country, but
it was on tour when I there.

(Part of MIT's collection is not in this building but is at 77
Massachusetts Avenue, one of the main buildings. This location
houses the Hart Nautical Galleries, a fine display of seaworthy
models, from sampans to steamships.)

Plan to spend half an hour to an hour at the main museum.
Children may enjoy it. There is access provided for handicapped visi-
tors.

⚭ Papermaking ⚭

CRANE MUSEUM
Off Route 9
Dalton, Massachusetts 01226
Phone: The museum has no telephone, but the number for the Crane
 Company is 413-648-2600
Director: John McGarry
Hours: Monday through Friday 2:00–5:00 during June, July, August,
 and September
Directions: Dalton is five miles east of Pittsfield on Route 9. You
 may pass a couple of Crane manufacturing plants on the way,
 but keep a lookout for the one that announces the museum.
 Then follow the signs past factory buildings to the small brick
 building.

John McGarry has worked for four years at the Crane Museum, fol-
lowing forty-five years with the company, first as a research chemist
and then as head of water pollution control. He is a helpful guide to
the museum, which is, as far as he knows and as far as I've been able
to determine, unique in the Northeast if not in the entire country.

The history of papermaking is traced here, especially as it relates
to the company founded by one Zenas Crane in 1801. Crane first
learned the trade from his older brother (who had a factory in New-
ton Lower Falls on the Charles River in Massachusetts), then furth-
ered his apprenticeship in Worcester. In 1799, when he was
twenty-two, he ventured forth on horseback to find for himself a
spot where the headwaters of a river would grant him fresh water
and abundant power. The source of the Housatonic River in the
lovely setting of Dalton provided the ideal spot, and the community
for miles around provided the rags he needed to make his product.

He even went door-to-door inquiring for those rags, but later he persuaded households to save their castoff cottons. In fact, fancy rag bags became parlor furnishings for a time during Zenas Crane's era. The company has remained in the Crane family to the present, and anyone who knows paper today will recognize the Crane trademark.

Displays trace both the development of the company and the manufacture of paper in general. Especially interesting is the fact that about 1850 Crane was responsible for the term "bond" as it relates to fine paper. It came about because, when the president of a New York bank-note company wanted a new supply of the Crane paper on which his bonds were printed, he ordered "some more of that bond paper."

Cyrus Field was the Crane Company's principal wholesaler in New York City and built up a million-dollar business. He went on to finance the laying of the first transatlantic telegraph cable.

A scale model here shows the vat house of the first Crane papermill. The model is a fine one, made by paper historian Dard Hunter, about 1930, when the museum was opened. The building housing the museum was once the rag room of the original mill, most of which was torn down in 1890. To provide an unobstructed floor space for the work going on here, the supports for the roof are in the shape of an upside-down ship's keel.

Among the objects on display that will catch your attention are presidential and first family cards and invitations. Strange to come upon are the engraved cards of gratitude for expressions of sympathy after the death of President John F. Kennedy. McGarry thinks that all presidents of this century have had cards of some kind printed on Crane paper. Also intriguing are the description and illustration of how counterfeiting is spotted (if not foiled) by means of confettilike colored paper in American Express Traveler's checks and silk threads woven into paper for U.S. currency.

Plan to spend half an hour and bring the children.

✧ John Fitzgerald Kennedy ✧

MUSEUM AT THE JOHN F. KENNEDY LIBRARY
Columbia Point
Off Morrissey Boulevard
Dorchester, Massachusetts 02125
Phone: 617-929-4523
Director: Dan H. Fenn, Jr.

Hours: Daily 9:00–5:00

Directions: Dorchester is five minutes south of Boston. Take the
Southeast Expressway to exit 17 and follow the signs for the
JFK Library.

In mid-June the sweet scent of wild beach roses envelops a visitor to
this library and museum; it is a fragrance that, as you discover when
you leave the building if not before, has deep symbolism.

This museum may be the most stirring that those of us who
lived through the era of John Fitzgerald Kennedy's presidency will
ever visit. Handsome, wealthy, brave—certainly he was all of that.
But he was also witty and, most important, driven by a devotion to
justice and to humanity. He was brilliant, and he was eloquent, not
only in his speeches, but extemporaneously, too. Among the displays
is a videotape of moments from press conferences. Kennedy was the
first president to permit Washington press conferences to be broad-
cast live; moreover, he held one every ten days on the average. It was
during these live conferences that he made some of his memorable
off-the-cuff comments.

"Mr. President, how is your aching back?" he was asked during
one televised conference. "It depends on the weather," he answered
and added with a grin, "political and otherwise."

The exhibition begins by putting John Kennedy's life into a his-
torical and ancestral perspective. Displays proceed along a time line,
rather like a ruler. On top are the significant moments in American
or world history, and below are moments in the Kennedy family his-
tory. JFK's youth is touched upon; for example, a photo journal kept
by his friend K. LeMoyne Billings records adventures the two young
men had on a trip through Europe in 1937. Kennedy's naval and po-
litical careers are followed; his marriage and family life are illustrated
through photographs and memorabilia. In the center of one large
section is a replica of his White House desk and next to it is the
rocking chair that helped to ease the pain in his back. As you study
this scene, you also hear taped conversations his brother, Robert, and
JFK himself had with Governor Ross Barnett of Mississippi during
the integration crisis.

A combination of recordings, tapes of events such as the cam-
paigns, conventions, and press conferences, a movie that runs every
half hour, and, also powerfully moving, a section devoted to Robert
Kennedy after his brother's death, all give a sense of the era and the
man. As you leave the museum, you exit through a nine-story-high
glass pavilion that overlooks Massachusetts Bay. You also pass a

wall-sized photograph of John Kennedy absorbed in thought and alone, walking along the beach of Cape Cod. He seems somehow removed from day-to-day troubles as he travels a sandy path through the wild beach roses.

Certainly children should see this museum. It is entirely accessible to handicapped visitors. It is a place to visit not just once, but again and again.

∾ Lizzie Borden ∾

FALL RIVER HISTORICAL SOCIETY
451 Rock Street
Fall River, Massachusetts 02722
Phone: 617-679-1071
Curator: Florence Brigham
Hours: March through December, Tuesday through Friday 9:00–4:30
 (also, April through November, Saturday and Sunday
 2:00–4:00); closed January and February
Directions: From Route I-195 exit onto Route 24 north and follow
 Route 24 to the first exit: Route 6 (Somerset). Pass two traffic
 lights, go down the hill on President Avenue. Before the third
 traffic light you will see a school on the right, Rock Street on
 the left. Turn left on Rock and follow it about seven blocks.
 The museum is a granite building with an unusual wrought-iron
 fence.

It's all a little bit incongruous and came about quite unintentionally and one curator was heard to say that she wished *that woman* had never been born, that woman to whom she referred being Lizzie Borden.

But there it all is, the Lizzie Borden collection, in two cases at the Fall River Historical Society, which is a whole lot prouder of its building (constructed of Fall River granite in 1843 and moved to this lofty site in 1870), which was used as a station of the Underground Railroad. It contains sixteen rooms filled with portraits, furniture, china, glass, and all manner of old things pertinent to the town. And that Lizzie woman.

There is the braid Mrs. Borden wore—not her real hair, which is also there, but an embellishment. And her dusting cap. And the photo of her as she was found when her head was, yes, well . . . And the photo of Mister so peculiarly stretched out on the ornate Victo-

John Fitzgerald Kennedy Library ▶
Dorchester, Massachusetts

rian sofa with his head also . . . In the corner of the picture is something that seems to be a ghost. Spooky. It's the plainclothes policeman who was left to guard the body because of the gold watch and the possibility of foul play. (An extravagance, considering.) This fellow was the only policeman on duty that day as the rest had all gone to Rocky Point Amusement Park. His likeness is fading out of the photo through time rather than witchcraft, but still . . . There's the billy club of the marshal who arrested Lizzie. And a photo of Lizzie, of course. A photo of the first jurors (June 8–18, 1896), and the stenographic records. And tags that were attached to some police exhibits of tests of the stomachs of Mr. & Mrs. Oh, gross! But, oh, no, that's not caked blood on the labels, it's red sealing wax. And in a corner of one of the cases, where it could go unnoticed—the hatchet. It's awfully small and the handle is broken off. It wasn't one of those hefty, substantial axes but was the sort that was used to split cedar shingles.

Why do you suppose all this is in the kitchen of the mansion, along with stove, sink, all manner of tinware, and other cooking items? Well, it happened that the first things the society was given (entirely unsolicited, one must realize) were the tin dinner pail that Lizzie used when she was in jail and the wooden stool she sat on there. The society didn't quite know what to do with these items, but they certainly didn't belong in the parlor. That's how the whole collection, which thereafter grew but is still modest, ended up here.

The society also owns a large collection of newspaper stories and a few of Lizzie's letters. Members of the historical society have thought of unburdening themselves of this rather unseemly collection, but it does, after all, bring in visitors. And, once there, they do look around at the other fine things.

How long should you stay? Well, that depends a lot upon your interest and imagination. You can look at the Lizzie display in five minutes. Should you bring small children? No, no, no. Yet . . . an interesting notice at the entrance announces that minors are not admitted during school hours. No special provisions for handicapped visitors.

∞ Gloucester: Artist & Industry ∞

MUSEUM OF CAPE ANN HISTORY
27 Pleasant Street
Gloucester, Massachusetts 01930
Phone: 617-283-0455
Administrator: Ellen Story
Hours: Tuesday through Saturday 10:00–5:00
Directions: Gloucester is north of Boston and at the end of Route
 128. The museum is in the center of downtown Gloucester, one
 block north from Main Street and a short block east of City
 Hall.

This is a great surprise and a wonderful museum. Two particularly
fine collections make it unique.

Fitz Hugh Lane (1804–65) lived in Gloucester. He painted har-
bor scenes and seascapes so lovingly you'd guess he was a sailor. In
fact, his legs were paralyzed and getting around was difficult. For the
most part he sketched the scenes he would later paint at home.

Lane's paintings are full of luminous light, glowing sunsets, and
gleaming dawns. He studied and painted sailing ships of every vari-
ety, becalmed and in rough seas, alone on the canvas and surrounded
by many others. He seemed to enjoy the juxtaposition of ships as
much as he delighted in the play of light on the water.

The Cape Ann Historical Society has the largest collection of
Lane's works and, fittingly, shows them in the very town that was his
inspiration for so many years. Moreover, it is an interesting idea to
look at Lane's renderings of Gloucester harbor and then to visit the
harbor these 130-odd years later.

In addition to the Lane collection, this museum has one of the
best fisheries and maritime exhibits. That's not because it has either
more or better objects than any of the many other maritime exhibits
I've seen; rather it's because of the variety and most of all the spirit
of the collection. That spirit is well represented by the curatorial
notes, which often tell a story briefly but well. There is a model
(made in 1890) with an explanation of a breeches buoy, an inge-
nious device that was set up on the beach to rescue mariners from
vessels stranded offshore. There are a portrait and biographical sketch
of a local hero, Howard Blackburn, whose tale is nearly told in the
title of a book—*The Fearful Experience of a Gloucester Halibut Fisher-
man Astray in a Dory in a Gale off the Newfoundland Coast in Midwin-*

ter. Along with a collection of mackerel plows is a description of how these blades were used to cut a fish so that it looked plumper than it actually was. There are ship models—it's just a fine exhibit. Whether or not children spend much time studying the Fitz Hugh Lane paintings, I'm sure they will enjoy the nautical themes and especially the fisheries exhibit. There are no particular accommodations for handicapped visitors. Plan to spend at least an hour here.

∾ American History ∾

MUSEUM OF OUR NATIONAL HERITAGE
33 Marrett Road
Lexington, Massachusetts 02173
Phone: 617-861-6559
Director: Clement M. Silvestro
Hours: April through October, Monday through Saturday 10:00–5:00;
 November through March, Monday through Saturday
 10:00–4:00, Sunday, all year, 12:00–5:00
Directions: The museum is right on Route 2A. From Route 2 take
 the 2A branch through Lexington. From Route 128 take exit
 45A and go about one and a half miles east on Marrett Road.
 From Boston follow Route 2, and take exit 4/225 to Lexington.

In 1934 the United States was in the grip of the Great Depression. In 1935 Jews were persecuted in Germany under the Nuremberg laws, Mussolini invaded Ethiopia, Senator Huey P. Long of Louisiana was shot and killed, and the Dionne quintuplets reached their first birthday. The quintuplets held the country in thrall. Their progress was monitored and their lives were watched as they grew to adulthood. Dolls were fashioned after them, and they advertised everything from soap to white bread. They were a national obsession. And then they were forgotten.

At the Museum of Our National Heritage the Dionne quintuplets were the focus of an exhibition in one of the four galleries that are devoted to the history and decorative arts of the United States. In the other galleries were exhibits on pewter in American life from 1635 to 1875; the work of Charles M. Russell, an artist who painted and sculpted American Indians and cowboys; and the archaeological ceramic evidence of New England's past. Although these displays are all temporary, they do reflect the variety of interests that will be satisfied at any particular time.

This museum was founded in 1975 by the Scottish Rite Masons of the northern jurisdiction of the United States as a bicentennial project. It is in a handsome, contemporary red-brick building, and the layout of galleries gives each exhibit a discrete and very pleasant space. Although specific exhibits cannot be predicted at this writing, this museum is worth checking. It is likely that at least one of the four current exhibits will entice not only adults but children, too. The time you'll want to spend here will depend upon what is on display. The museum is accessible to handicapped visitors.

❧ Whales, Whaleships, Whalemen ❧

WHALING MUSEUM
18 Johnny Cake Hill
New Bedford, Massachusetts 02740
Phone: 617-997-0046
Director: Richard C. Kugler
Hours: Monday through Saturday 9:00–5:00, Sunday 1:00–5:00
Directions: New Bedford is on the southern coast of Massachusetts.
 From I-195 take exit 15 and follow the downtown connector to
 Elm Street. Turn right and then left onto Johnny Cake Hill.

The Whaling Museum sits at the top of a hill, on a street paved in cobblestone. It overlooks the historic New Bedford waterfront, is across the street from the Seamen's Bethel (where Herman Melville once worshiped), and is an entirely wonderful and exciting place. If you haven't read *Moby Dick,* you'll want to do so after a visit. And if you manage to be shown around by Polly Lissak, one of the volunteer docents, you will be lucky indeed.

The first thing you see upon entering the museum is—a whaling ship. It is a giant replica on which you can walk around. "It is half-size," said Mrs. Lissak, "which is just fine since many of our visitors are half-size." Nearby is a full-size whaleboat, a thirty-foot-long cedar craft that six men would row off in when the lookout on the masthead called, "She blo-o-ws!" These boats, we learn by pictures later on, were often smashed by the whale's tail or crushed in its jaws.

Galleries here have excellent art, including sculpture, prints, paintings (William Bradford's 1886 *Sealers Crushed by Icebergs* is one outstanding example), and ship figureheads. Melville fans make a beeline for the room where the crew list of the *Acushnet* in January

1841 is posted. Both his name and that of his buddy Richard Greene are underlined. "We think the captain must have underlined them since they both jumped ship," Mrs. Lissak said.

In the same large room as the Melville exhibit is something I had never seen before and am unlikely to see anywhere else. It is called "Purrington & Russell's Original Panorama of a Whaling Voyage Round the World." (It was touted as being a mile long but it measures just a quarter of a mile.) It is a long, long canvas on which whaling scenes are painted. This panorama is the nineteenth-century version of the movies, but instead of a film reeling through a projector, the painting was marched across the stage. It is full of adventures, danger, and delight. Of course, just a modest part of it is visible here.

There is exquisite scrimshaw. One elaborate three-tiered carving looks like a cathedral with ivory spires, figures, windows, and as many ornate details as the sailor could dream up. Its modest purpose was to hold someone's watch. What did the building represent? According to Mrs. Lissak, "It represents 'I've got a lot of time until the next whale.'"

In an extensive library, which contains ship logs that docents, among others, love to read and exchange information about, there are more beautiful and storied objects. The entire museum is an adventure of discovery.

Certainly take children to the New Bedford Whaling Museum and plan to spend at least an hour there.

∽ Carding, Spinning, & Weaving ∽

MUSEUM OF AMERICAN TEXTILE HISTORY
800 Massachusetts Avenue
North Andover, Massachusetts 01845
Phone: 617-686-0191
Director: Thomas W. Leavett
Hours: Tuesday through Friday 9:00–5:00, tours 10:30, 1:00, 3:00.
 Saturday and Sunday 1:00–5:00, tours 1:30, 3:30.
Directions: From I-495 take exit 3 at North Andover. Follow
 Massachusetts Avenue, pass two sets of traffic lights and you will
 see the town common. The museum is on the left facing it.

What was it like to work in a textile factory during the nineteenth century? Guides start up mechanized cotton pickers, carders, spinners and looms, and your imagination multiplies the deafening noise

of one machine to conjure up the atmosphere of mills like those that turned the Merrimack Valley into an industrialized area a hundred years ago.

This collection differs from the Textile Museum in Washington, D.C. (see page 248) in that here the manufacturing process is traced while in the Capital the history and examples of fabric, from earliest times, are the focus.

Also, as the Fogg Museum in Boston is to the restoration and repair of art objects, the Museum of American Textile History is to the conservation of fabric. Its laboratory for conserving textiles takes on everything from fourteenth-century tapestries to twentieth-century quilts. The museum also boasts of owning the largest textile library in the country.

The exhibits begin with a chronology that includes preindustrial technology. There are primitive, rough-hewn looms made by the weavers who used them as well as huge industrial models. The fascination of this collection depends a lot on the ingenuity of the installations. The museum combines watching the machinery in operation with information about the era in which these power looms were revolutionizing industry. One display is a great cast-iron bell made in 1802 by Revere & Son of Boston. It hung first in a church in Maine but was bought for the Stevens mill in North Andover in 1831. It was rung to call the mill girls to work.

Besides the machinery on permanent display, the museum mounts changing exhibits. Young children may not appreciate these displays, but those who are interested should save at least an hour and a half for a leisurely visit.

০৵৩ Forests behind Glass ৵৩

HARVARD UNIVERSITY FISHER MUSEUM OF FORESTRY
Petersham, Massachusetts 01366
Phone: 617-724-3302
Director: John G. Torrey
Hours: Weekdays 9:00–5:00
Directions: Petersham is northwest of Worcester. On Route 2 take
 the Athol/Petersham exit. Go south on Route 32, about three
 miles.

The sky gives them away. These scientific, teaching models don't have to be artistic, after all. They were designed to show the history of central New England forests and to demonstrate the silvicultural

(that is, forestry) practices developed at the Harvard Forest, as well as to demonstrate certain useful fire-control and wildlife-management procedures. The director and members of the staff of the Harvard Forest designed most of the models, which were completed in 1941. If all you saw were black-and-white photographs of the twenty-plus dioramas, you might think they were simply outdoor snapshots. But they are works of tremendous care and, I believe, devotion. The variety of skies, from vivid sunsets to peaceful clear blue canopies, confirmed my suspicion that the designers had as much concern with beauty as with accuracy.

The historical sequence is compelling. The first diorama portrays the forest as it would have looked when white settlers arrived—the would-be civilizer is dwarfed beneath gigantic trees. By 1740 the intrepid fellow has cleared about an acre for subsistence farming and has built a modest farmhouse. By 1830 the farm is at the peak of its cultivation and production. The farmhouse has become a mansion, and the land, defined by brick walls, rolls pleasantly in all directions. Change continues—abandonment, new growth, logging—until finally the 1930 diorama updates the new terrain as far as a hardwood stand that has reached cordwood size. In the background the house, which grew from modest to mansion to abandoned to nothing but a chimney in the snow, adds to the sense that you are looking at an ancestral album. To complete the biography, you can walk outdoors and follow a trail that will bring the history up to date, for the area documented is based upon this museum's own locale.

The other dioramas are more practical but no less thoughtfully assembled. The museum has made a tape to walk you through the displays, and you might want to find out whether player and tape are available. This is a good place to bring children since the dioramas will interest them and a walk in the woods can burn some stored-up energy. You could see all the dioramas in thirty or forty-five minutes and walk as long as you like.

ᔕᔕ Glorious Cranberry ᔕᔕ

CRANBERRY WORLD VISITORS CENTER
225 Water Street
Plymouth, Massachusetts 02360
Phone: 617-747-1000 or 617-747-2350
Director: Herbert N. Colcord
Hours: April 1 through November 30, daily 9:30–5:30

◄ "Girl Winding Shuttle Bobbins," by Winslow Homer
 Museum of American Textile History, North Andover, Massachusetts

Directions: Plymouth is on the coast, south of Boston. From Route 3
take Route 44 to the Plymouth waterfront and turn left on
Water Street.

"Of all the pleasures which ornamented my installation as president
of Harvard in 1708, none exceeded in delight the serving of beaute-
ous cranberries." So spoke President Leverett of the esteemed univer-
sity in Cambridge. You, too, will raise the lowly cranberry to heights
you never imagined after a visit to this museum. The exhibit is so
well conceived and constructed that you find yourself surprised at
how very interesting the cranberry—its cultivation, history, harvest-
ing, processing, and even advertising—actually is.

You will learn, to begin with, that this beauteous red berry is
one of only three native American fruits. (The other two are the
blueberry and the Concord grape.) You will also see a 2½-minute
filmed interview with Domingo Fernandes, a cranberry-bog owner
whose father came to Plymouth from Cape Verde. He tells a won-
derful story that has all the earmarks of folklore: An immigrant
wanted a job harvesting berries so much that when he was pushing a
full wheelbarrow up a plank and it fell off into the sand, he contin-
ued pushing it through the sand with every ounce of strength he
possessed. Seeing how earnest this newcomer was, the boss said,
"OK, you can stop now, you've got the job." The character may not
be as familiar as the old steel-driving John Henry, but he has the
same heroic fabric.

The museum is in an attractive contemporary building by the
ocean. In front of one large window that looks onto the water a col-
lection of cranberry scoops hangs from the ceiling on individual
threads. You get the impression that you are looking at sculptures or
mobiles. Further along is a machine that bounces berries. Bounces
berries? "We've been bouncing cranberries for a hundred years and
haven't found a better way to separate and grade them yet," said a
guide in a you-can-guess-what-color suit. "The best grades bounce
the highest."

The Cranberry World Visitors Center is sponsored by the Ocean
Spray Company, which gives free samples and sells a few of its prod-
ucts here. It is a short visit, perhaps half an hour, but it is a delight.
Children will enjoy it.

❧ Captains' Collections ❧

PEABODY MUSEUM OF SALEM
East India Square
Salem, Massachusetts 01970
Phone: 617-745-9500 (recorded information) or 617-745-1876
 (complete information)
Director: Peter Fetchko
Hours: Monday through Saturday 10:00–5:00, Sundays and holidays
 1:00–5:00. Guided tours at 2:00.
Directions: Salem, north of Boston, can be reached by Route 128.
 Take the Salem exit and follow the signs into town on Route
 114. Go left on Lynde Street, cross Washington Street to
 Church. Park behind the Essex Street Mall, which is closed to
 automobile traffic. The museum is in the mall on East India
 Square.

A woman who now works at Salem's Peabody Museum remembers
her father taking her to the museum many years ago. The exhibit
that stands out most vividly in her mind from those childhood years
is a room in which the main cabin of an 1816 brig, *Cleopatra's Barge,*
is reconstructed. She remembers not the elegant furnishing of the
cabin, but rather the peek allowed through the door to the adjacent
bedroom or berth. Fast asleep on the floral bedspread is a curled-up
cat. It hasn't moved in all those years, since it is, she now realizes, a
ceramic passenger.

It's hard to know what images children will carry away from a
museum, but I'm sure that many others have a vivid recollection of
Kukailimoku, a seven-foot-tall figure whose stand sets him a good
deal higher than that. Kukailimoku is a war god from a Hawaiian
temple. Huge and fearsome, he is one of only three such wooden
sculptures in existence.

There is a wonderful diversity in this museum, among the finest
in the country, yet there is a unifying principle behind the exhibits.
The collections date back to 1799, when a group of American sea
captains formed the East India Marine Society. Among the purposes
stated in their charter was the intention "to form a Museum of natu-
ral and artificial curiosities" with the objects that they brought back
from voyages.

Outstanding and unique is the collection of Japanese household
arts and crafts—items of everyday life, perhaps, but no less stunning

for their domesticity. These objects range from a household shrine—a cabinet that opens up to reveal a fully equipped place of worship with carved gold icons, bowls, and incense burners—to a model of a Japanese garden with stepping stones set in patterned sand, a place that exemplifies calm and simplicity.

The Peabody is a spectacular, major museum. It will take at least an hour, and children can certainly be brought along. There are provisions for handicapped visitors. Recently the China Trade Museum of Milton was combined with the Peabody. I visited the Milton museum before the move and, as we go to press, the new wing of the Peabody that will merge the two collections is not yet open. The following are my notes from the collection in Milton.

Two hundred years ago American ships began sailing to China. Great fortunes were made by merchants and seamen whose quest for Chinese products—tea, silk, and porcelain, mainly—opened a new and exciting market in this country. Captain Robert Bennet Forbes was an adventurer who went to sea at the age of thirteen. With the wealth he amassed in the China trade, in 1833 he settled in a mansion overlooking Massachusetts Bay. His home was furnished and decorated with the objects he had collected during his travels and afterward as a Boston merchant. In 1964 his great-grandson, H. A. Crosby Forbes, turned the mansion into a museum. Among the exquisite objects is a tea table with an enameled top. The elaborate and colorful design represents a Chinese palace garden scene. An absolutely intriguing bamboo chair on wheels with an adjustable back and extendable leg rest, which looks more like a praying mantis than a piece of furniture, was, the guide pointed out with little further explanation, a drunk's chair. But then, little further explanation was needed.

Much of what was exported from China was made to order, and Chinese artisans were, to a certain extent, absorbed with the job of reproduction of American art. An extraordinary example is a copy of the famous painting *The Apotheosis of George Washington,* in which the president, clothed in white and gleaming in a shaft of celestial light, is being carried heavenward by angels. This work, a reverse painting on glass, was made in Canton about 1800 and copied an engraved print.

[Although this collection has now been moved to Salem, there are plans to reopen the Forbes mansion.]

ᔢ Salem's Witches ᔢ

SALEM WITCH MUSEUM
19½ Washington Square North
Salem, Massachusetts 01970
Phone: 617-744-1692
Director: Patricia McLeod
Hours: Daily 10:00–4:30; July and August 10:00–6:30.
Directions: Salem is north of Boston. From Route 128 take the Salem
 exit and follow Route 114 into town. The museum is located
 across from the common in the heart of Salem.

Salem and witches are synonymous. The strange story of the witch-craft trials and the ignominious events that took place here is revealed interestingly in this museum. Every half hour in a darkened hall a series of tableaux and a voice-over narration trace the origin of the frenzy that gripped the town in 1692.

This place is not a museum in our standard context—it has no collection to boast of—but it is an enlightening exhibit and a dramatic explanation of Salem's witchcraft hysteria.

Because the audience must stand in the dark for half an hour, and because young or sensitive children may be frightened, it's wise to think twice about taking them to this museum.

ᔢ Cars, Soldiers, Prints, & More ᔢ

HERITAGE PLANTATION OF SANDWICH
Grove and Pine Streets, P.O. Box 566
Sandwich, Massachusetts 02563
Phone: 617-888-3300
Director: Gene A. Schott
Hours: Mid-May to mid-October, every day 10:00–5:00
Directions: Heritage Plantation is three miles from the Cape Cod
 Sagamore Bridge. Once you are on Cape Cod, take Route 6A to
 Route 130 going into Sandwich. Then take Pine Street. There
 will be signs.
Admission: $5 adults, $2 children under twelve

"When I started working here, I thought I'd died and gone to heaven," said Judith Selleck as she showed me around Heritage

Plantation. She had begun her public relations job in spring, when the rhododendrons are in full bloom and the colors were magnificent. (The area was owned by a rhododendron breeder, who developed between five and ten thousand seedlings per year over a twenty-one year period.) I was there in July, well after the season was over, but I was bowled over by the daylilies, huge and multicolored, in more than five hundred varieties. But this book is about museums, not flowers, so suffice it to say that the seventy-six acres on which this museum is located are among the most beautifully landscaped and manicured of any I've seen.

As for the collections, these are estimable and there is plenty to see. Three separate museums occupy the grounds.

The Automobile Museum is a knockout. Antique cars are displayed in a circular barn that is modeled after the round Shaker barn in Hancock, Massachusetts. The automobile bodies gleam and the chrome and brass shine: the scene is breathtaking. Moreover, the cars are not roped off, and hoods are open for inspection by appointment. One star of the show is a 1931 Duesenberg that Gary Cooper owned and reportedly raced against Clark Gable's Duesie. It's a two-tone, primrose yellow and mint green, with dark green leather upholstery. Very snazzy. With the exception of a white Rolls Royce of 1962 vintage, all the cars, including a blue Rolls that was made in Springfield, Massachusetts, are American made and date from 1899 to 1937.

The Military Museum is also well thought out and fascinating. Particularly appealing are the two thousand hand-painted miniature soldiers in small wall cases that light up as you approach. From the Revolutionary to the Spanish-American War, the color guards of each unit have been carefully researched and reproduced. Colonel Frederick Todd, an army historian and former director of the West Point Museum, designed the display and wrote the notes for the dioramas. These notes go beyond simple names. For instance, the Louisiana Zouave Battalion, Confederate States of America 1861–65, is shown on parade wearing red pants and blue jackets, and we learn that they were noted for "fine drill and bad discipline."

In the arts and crafts building is a good collection of folk art. I was particularly taken with a grasshopper weather vane, and the working carousel that everyone gets to ride is delightful. A collection of Currier and Ives—believed to be the largest exhibition of their lithographs available to the general public—includes *The Life of a Hunter—"A Tight Fix"*, in which a hand-to-hand battle in the

Salem Witch Museum ▶
Salem, Massachusetts

blood-spattered snow between bear and man is about to be ended by a third party with a rifle. One can only hope his aim is good.

The minimum time it will take to see all the exhibits here is an hour and a half, but you could well and enjoyably spend an entire day. There is a picnic area (no food is sold) and the setting is inviting for strolls. Children will love it here, too. For those with limited mobility, transportation is provided between museum buildings.

๛ Boston & Sandwich Glass ๛

SANDWICH GLASS MUSEUM
Sandwich Historical Society
Route 130, P.O. Box 103
Sandwich, Massachusetts 02563
Phone: 617-888-0251
Director: Barbara M. Rockefeller
Hours: April 1 through October 31, daily 9:00–4:30. Check with
 museum for winter hours.
Directions: On Cape Cod take Route 6A to Route 130, which takes
 you into Sandwich and right to the museum. Or from Route
 6(Mid-Cape Highway), take exit 2 to Route 130.

In one gallery with windows on either side, several long glass shelves contain row above row of perfectly arranged goblets, compotes, lamp bases, and here and there a well-placed hen on a basket. The colors are dazzling: two yellow candlesticks next to two purple next to blue. The light shines through and the effect is real artistry.

This specialized collection is made up primarily of pieces from the Boston and Sandwich Company, which operated only between 1825 and 1888. An interesting model recreates the red-brick factory interior about 1850. In an area off the main room, one figure is seen mixing clay and water to make the pots in which the ingredients for glass will be mixed.

The glass is displayed chronologically, and there is a good representation of the lacy glass for which Sandwich is noted. There are also some elegant paperweights, cologne bottles, and lamp bases. I was taken with a few of the opalescent goblets and surprised to note that one had a blue tint while the overtone of the other was rather rosy.

In one room is a table that looks like a large display case for a kaleidoscope. In fact, it is a collection of broken pieces of Sandwich

glass, shards that were found when the factory site was excavated. These pieces came from less-than-perfect objects that were broken and discarded. Somehow that is a strangely stirring display.

This museum is probably not a place for children. A visit should take about an hour.

⌒∾ Briar Patch Characters ⌒∾

THORNTON W. BURGESS MUSEUM
4 Water Street, P.O. Box 972
Sandwich, Massachusetts 02563
Phone: 617-888-4668
Director: Nancy Titcomb
Hours: April until Christmas, weekdays 10:00–4:00, Sunday 1:00–4:00
Directions: This museum is across the street and a short walking
 distance from the Sandwich Glass Museum and Yesteryears Doll
 Museum.

Those who grew up with a love for the works of Thornton W. Burgess, the author of more than 170 books and 15,000 newspaper stories, might enjoy the visit here if just to soak up the atmosphere. Burgess created Reddy Fox, Jimmy Skunk, Johnny Chuck, Whitefoot the Woodmouse, and other talking critters as well as Mother West Wind and her Merry Little Breezes. Although he never lived in this house—it belonged to his aunt—he was born in Sandwich in 1874. (He died in 1965 at the age of ninety-one.)

The theme of this museum is nature conservation (the stuffed fox and skunk are a jarring note). It has the largest known collection of Burgess's writings as well as a number of original Harrison Cady illustrations. The gift shop occupies about as much space as the museum, if not more, but the site of the house is exquisite, on the shore of a small lake heavily populated with geese, ducks, and swans, and there is a sweet-scented herb garden beside it.

There is no charge (although donations are accepted), and a spin through the museum with a young Burgess fan should take about fifteen minutes. A bonus for the youngster is that Monday through Saturday at 1:30 p.m. there is "story time."

❧ Dolls ❧

YESTERYEARS DOLL MUSEUM
Main and River Streets
Sandwich, Massachusetts 02563
Phone: 617-888-1711
Director: Mary Justice
Hours: May through October, Monday through Saturday 10:00–5:00,
Sundays 1:00–5:00.
Directions: Once you are on Cape Cod, take Route 6A to Route 130
into Sandwich. You will see signs to Yesteryears, which is in the
center of town.

After I saw the collection at the Margaret Woodbury Strong Museum (see page 171) in Rochester, New York, I said there could never be another doll museum. It's true: this one doesn't compare in either quantity or excellence. But it does have a certain charm and certainly a different atmosphere. Housed on two floors of a building that was once a church, it represents the enthusiasm of a woman who began collecting while traveling with her husband, who was in the military. The variety is wide, from an odd collection of flat-faced Coronation dolls (maybe supposed to represent the crowning of Elizabeth) to strange shadow puppets from Java. The curatorial notes are sometimes insufficient and sometimes just right. A nice touch is that they are handwritten. I particularly liked a Charlie Chaplin doll and, when I went downstairs, was impressed by the collection of paper dolls and their clothes. Some of them are made with fragile tissue paper that has been folded and shaped with extraordinary care.

A half hour will take you through, and children who like dolls will enjoy the visit. There are no provisions for handicapped visitors.

❧ Iron ❧

SAUGUS IRON WORKS
244 Central Street
Saugus, Massachusetts 01906
Phone: 617-233-0050
Director: Jim C. Gott
Hours: April 1 through October 31, 9:00–5:00, November 1 through
March 31, 9:00–4:00

Directions: Saugus is just north of Boston. From Route 128 take exit
 31. The Saugus Iron Works are in the center of town, about
 five miles from the exit, along a well-marked route. Just follow
 the signs.

John Winthrop the Younger started the iron works on the banks of
the Saugus River in 1646, importing laborers from England and
Wales to work there. The laborers' jobs were filthy, dangerous, long,
hard, and noisy. They drank and brawled and didn't go to church
and, together with their womenfolk, were often fined for extravagant
dress. They could only have tormented the stalwart Puritans who
had settled in Saugus and lived sober, religious, and industrious lives.
 Saugus had the first successful iron works in North America. A
splendid job has been done to retrieve what could be found and to
reconstruct the compound—furnace, forge, waterwheels, and so on.
A small museum explains how iron was made and displays some of
the found objects.
 The exhibits are very nicely designed, showing the variety of
things that were, and still are, made from iron—from nails to the in-
ternal framework for the Statue of Liberty. Discovered during the ar-
chaeological dig were pieces of a waterwheel, and they are preserved
here. There is also a model of the working system, including a cut-
away of the blast furnace that enables even the least technologically
minded to visualize the iron-making process.
 One particularly evocative display shows a case full of the ob-
jects that were uncovered at the site during excavations, everything
from prehistoric Indian arrowheads to horseshoes, from pieces of old
pottery to modern trash.
 This museum can accommodate handicapped visitors. It is a
good place to bring children. A visit that includes a tour of the
grounds should take an hour or more.

ᑫᘩ Home of Basketball ᑫᘩ

BASKETBALL HALL OF FAME
1150 West Columbus Avenue
Springfield, Massachusetts 01103
Phone: 413-781-6500
Director: Joe O'Brien
Hours: Daily, 10:00–6:00
Directions: From I-91 take exit 7 (Broad Street). Follow signs.

The city of Springfield has done itself proud, for this city is determined to be known as the home of basketball. It all started back in 1891, when Dr. James Naismith invented the game for eighteen players, YMCA gym students mainly. There were thirteen rules, two peach baskets, and a soccer ball. When the ball got lodged in one of those baskets, there it stayed until a janitor brought the ten-foot ladder, retrieved it, and returned it to play.

You'll find pictures of the great players, the balls they dribbled, the uniforms they wore, the plaques to honor them. You can hear their voices reconstructing some of the great games they played; you can contemplate and dream about great moments of the sport.

There are memorabilia here to entrance a basketball fan and to start his or her head spinning with dreams of glory. When the new museum is completed, it will have the most up-to-date audiovisual, multimedia presentations of this sport. It will rival the National Baseball Hall of Fame (see page 137) in Cooperstown, New York, and will, no doubt, send multitudes of youths back to the garage door to shoot some more baskets.

Kids and grown-ups who like this sport will love it here and could spend a couple of hours seeing the whole thing. The new building will be accessible to the handicapped visitor.

ᐢᣮ Time of the Samurai ᐢᣮ

GEORGE WALTER VINCENT SMITH MUSEUM
On the Quadrangle
222 State Street
Springfield, Massachusetts 01103
Phone: 413-733-4214
Director: Richard Mühlberger
Hours: Tuesday through Sunday 12:00–5:00
Directions: From I-91 heading south, take exit 7 (Columbus
 Avenue/Springfield center). Stay left for State Street and turn
 left onto it. Continue to Dwight Street (the third light) and
 turn right. Follow the loop around to the left, back to State.
 Cross to Chestnut. The first right goes into the Quadrangle.
 From I-91 going north, take exit 4 (Broad Street) to Union
 Street (the second light) and turn right. At Maple Street (the
 second light) turn left. Cross State (the next light) onto
 Chestnut Street. Take the first right into the Quadrangle.

Small lions with glaring glass eyes and fearsome grins are tucked into every nook and cranny of a Shinto shrine. It took Genzo Komatsu fifteen years of carving and was completed, after he died, by his son, in the early years of the nineteenth century. Atop the shrine is a large and awesome dragon with bulging eyes and a crystal ball on its head. This creature may be the celestial dragon who guards the home of the gods. Rabbits, symbols of long life in the Japanese Shinto religion, leap and scramble along the base. Shinto means "The Way of the Gods" and is a religion that worships nature.

The portable Shinto shrine is in the arms and armor gallery of the George Walter Vincent Smith Museum, which has a fabulous collection of Japanese works, not just armor but also decorative arts. The rumor is that the collection rivals, even somewhat surpasses, what the Museum of Fine Arts in Boston has on display, but because the GWVS is so small and so underfunded, it hasn't been able to publish a full-fledged catalogue. In fact, the Shinto shrine should have more than the single crystal ball atop the dragon's head, but light-fingered visitors have caused the staff to put the other crystal in storage until enough money is collected to encapsulate the shrine.

Also exceptional here is a world-renowned collection of cloisonné with, for those of us who have always wondered, a good explanation by example of how that process of enameling metal is accomplished. You'll have to travel to California or Canada to find a larger assemblage of cloisonné.

My attention was drawn to a Japanese incense burner, a magnificent accomplishment of several artists. A female peacock is starting to climb a gnarled tree stump, atop which a proud male stands guard. Above his head is the metal urn. The entire piece is made with different kinds of bronze. Technically as well as artistically it is a masterful work.

Scholars, collectors, and others (including one Japanese consul) have been known to go through the GWVS exclaiming at the treasures here. To those interested in Oriental art and culture, it is a true find. There are fine collections of Oriental rugs, European and American paintings, and other works of art. The collections originated in the taste of two Victorians, George and Belle Smith, who acquired their treasures during extensive worldwide travels.

The amount of time to allocate to this museum depends a great deal on individual interest. The GWVS is on Springfield's Quadrangle, which is also home to three other museums—the Museum of Fine Arts, the Historical Museum, and the Science Museum. It is a

busy and lively scene, where a whole family could plan to take a picnic and spend the day.

ൟ Motorcycles ൟ

INDIAN MOTOCYCLE MUSEUM
33 Hendee Street
Springfield, Massachusetts 01139
Phone: 413-737-2624
Director: Charles Manthos
Hours: Monday through Sunday 10:00–5:00
Directions: From I-91 in Springfield take I-291 to the St. James
 Avenue exit. Go down the ramp and turn right onto Page
 Boulevard. Go about one quarter of a mile and turn right onto
 Hendee Street. Cross the railroad into an industrial parking lot.
 Follow signs to the museum.

The Indian Motocycle Company, established in 1901, was the very first American manufacturer of motorcycles. It was started by George Hendee, a "high wheel racer" who owned a bicycle company, and Oscar C. Hedstrom, also a racer and the inventor of the Indian. The company was in operation from 1901 to 1953; it succumbed, according to the curator and owner of the collection, Charles Manthos, to mismanagement.

Manthos believes the Indian was the finest motorcycle ever made—its motor had only five moving parts and it got seventy-five to a hundred miles per gallon. He is devoted to upholding the Indian's good name. His museum has one of the first Indians ever made. There is also a replica of the very first motorcycle anywhere, invented in Germany in 1885 by Gottlieb Daimler.

During World War II small collapsible Indians were designed to fold up and fit into a tube so that paratroopers could jump out of planes with them and have transportation when they landed. (It would be pretty nice to have one of those in the back of the station wagon.) Some postwar Indians had skis attached.

A lot of people have tried to talk, or buy, Manthos out of his collection. No way. Manthos is a believer: he loves his motorcycles and would rather buy more than sell what he has, even for a cool million dollars. He likes to look at them, he likes to sit on them, and he likes to show them off. He even has miniature motorcycles, what he believes to be the world's largest collection of toy motorcycles.

◀ "Kukailimoku"
 (Photo by Mark Sexton) Peabody Museum of Salem, Salem, Massachusetts

Keeping up with the times, he's launched an exhibit on women cyclists—a case of photos and articles about women who race.

This collection represents the devotion of one man, and the mystique here can touch even a confirmed four-wheeler. It takes an hour to look at everything, and children who like wheels will enjoy the visit. The museum is entirely accessible to handicapped visitors.

∽ Flintlocks, Muskets, Carbines . . . ∽

SPRINGFIELD ARMORY NATIONAL HISTORIC SITE
One Armory Square
Springfield, Massachusetts 01105
Phone: 413-734-6477
Superintendent: W. Douglas Lindsay, Jr.
Hours: Daily 8:30–4:30
Directions: From the Massachusetts Turnpike (I-90) take exit 6 to
 I-291. Coming from Albany on I-91, take I-291 eastbound and
 follow the signs to Boston.
 From I-291 take exit 3 to Armory Street and follow it to
 Federal Street. The museum entrance is on Federal Street, near
 its intersection with State Street. Drive through the grounds of
 Springfield Technical Community College to the Main Arsenal.

The Springfield Armory sits on a hill above the Connecticut River, on a site chosen by none other than General George Washington and his chief of artillery, Colonel Henry Knox. They liked it because it was centrally located, within easy reach of American troops, and, most important, safe from the British. They designated it an arsenal, a place to store weapons. That was in 1777, and during the next 190 years this warehouse for muskets became one of the world's most important armories, where military small arms were not only stored but also designed, developed, and manufactured.

In 1787 poor farmers from western Massachusetts, led by Daniel Shays, tried to steal the arms from this arsenal. They hoped to close, by force, state and county courts that were taking their land in settlement of their debts. Although the Shays rebellion failed, it did instill a fear of local vulnerability among wealthy landowners, which led to the adoption of the federal Constitution and support of a stronger central government for their own protection.

After World War II the main responsibilities of the Springfield Armory were the development and testing of new small arms. Dur-

ing the war in Vietnam the armory worked on machine guns for both ground and air use, grenade launchers, and associated equipment. In 1968 the Defense Department closed the research and development facility. The fifty-five-acre site eventually was largely turned over to education—it became home to Springfield Technical Community College. The National Park Service now runs the Main Arsenal building, where the weapons collection is housed.

This collection is reputedly the largest in the world, competing for the distinction with British holdings in the Tower of London. Springfield's collection was started in 1871 as a gun library for research on weapons designs. Designers could actually check out guns, as one would textbooks, to study and improve upon them.

Today the instructional function of these pieces is mostly to reveal the evolution of firearms. There are flintlocks, the guns the Pilgrims actually carried (rather than the blunderbusses they're pictured with in Thanksgiving lore), percussion lock muskets (as in *The Red Badge of Courage*), carbines, Winchesters, and swords from around the world. The fine detailing in the construction and ornamentation of these antique weapons is awe inspiring. There is a double-decker gun rack in which rows of rifle barrels look like organ pipes and were so memorialized by Henry Wadsworth Longfellow in his poem "The Arsenal at Springfield." There are also weapons of more recent wars—Gatling guns, recoilless rifles, anti-aircraft guns, and machine guns used by American, Russian, British, French, and German soldiers in both world wars.

Children may enjoy this museum. It really depends on whether or not they are interested in guns. The displays also describe methods of manufacture and the mechanics of construction so that visitors learn more than they guess they might. This museum is accessible to handicapped people. An hour to an hour and a half is a standard visit.

⚬⚬ Daniel Chester French ⚬⚬

CHESTERWOOD
Off Mohawk Lake Road, P.O. Box 248
Stockbridge, Massachusetts 01262
Phone: 413-298-3579
Director: Paul Ivory
Hours: May 1 through October 31, daily 10:00–5:00
Directions: Going west on the Massachusetts Turnpike take exit 2

and follow Route 102 five miles to Stockbridge. Going east on the New York Thruway, exit from Berkshire spur at exit marked Austerlitz/New Lebanon and follow Route 102 immediately. Signs in Stockbridge mark the route from the west end of Main Street. Take Route 102 west approximately two miles to Route 183. Turn left and travel for one mile to the Chesterwood sign on Mohawk Lake Road. Turn right and follow the signs for half a mile. Chesterwood is on the right side of the road.

It is not because this is the workplace of Daniel Chester French, one of America's greatest classical sculptors, that Chesterwood is here, for homes of the famous are not within the guidelines that define this book's territory. But this home and studio contain the largest collection of French's work and therefore, like the home of Augustus Saint-Gaudens (see page 25) in Cornish, New Hampshire, this estate is happily included. Happily, because the pleasure of a visit is greatly enhanced when the settings are as beautiful as these. Just as the Saint-Gaudens home had a fabulous view of the mountains, so does this Stockbridge mansion in the Berkshires. The gardens are lovely, too. But the ambience is quite different here.

French and Saint-Gaudens were contemporaries: French, born in 1850, was two years younger than Saint-Gaudens. French lived until 1931, twenty-four years longer than his friend. For a time French was part of the Cornish community but, according to Chesterwood director Paul Ivory, French found the company there a bit too "artsy." He summered instead in these mountains, which he and his privileged cohorts dubbed Newport in the Berkshires. In the dining room of his house is a Saint-Gaudens *Diana*. It was bought for French by his son-in-law and stands before a window that has a splendid view of the hills.

Daniel Chester French, during his long, full life, completed a great number of monumental statues. The most familiar is his seated *Lincoln,* which is in the Lincoln Memorial in the nation's capital. Another well-known statue is *The Minute Man* in Concord. He was only twenty-five years old when that work was unveiled, and it brought him instant fame and unending commissions. With more than eight hundred casts, models, and finished pieces here, this assemblage makes up the largest study-collection of any major American sculptor.

French's daughter, who lived in the house after her father died, maintained his studio as he left it, tools, supplies, and equipment in

place, as well as a multitude of plaster casts. It is stirring to consider that he worked here surrounded by his own masterpieces. The piece on which he was working when he died, a terribly beautiful and nubile Andromeda in white marble, is in the center of the room where he left it.

There are sculptures that have been seen, probably in passing, and only here will you recognize them as the work of Daniel Chester French: the *Alma Mater* at Columbia University, the Francis Parkman Memorial in Boston, and statues representing the continents at the United State Custom House in New York. How I would love to see in place what is only pictured here, *The Republic,* a colossal gilded figure that stood sixty-five feet above its pedestal, which was forty feet above the lagoon at the Columbian Exposition in Chicago in 1883.

As I explored Chesterwood (which is, by the way, administered by the National Trust for Historic Preservation), Saint-Gaudens National Historic Site was still fresh in my mind. I wondered if there wasn't at least an undercurrent of rivalry, if not an apparent one, between the two sculptors. I heard a guide say, "By the time he was forty-six years old, Daniel Chester French was number one in the country." Saint-Gaudens was still alive then. At both sites you find working copies of Leonard Volk's life mask of Lincoln. Saint-Gaudens often collaborated with the architectural firm of McKim, Meade and White and was a friend of the principals. French had a close working relationship and friendship with architect Henry Bacon, who, when given the commission for the Lincoln Memorial, saw that French became the sculptor. While they were having masked balls in Cornish, there were garden parties at Chesterwood, and you can watch a 1925 home movie of a French garden party in the gallery. It wasn't a bad life anyway, not bad at all.

Plan at least an hour for this outing, which is a treat for all ages. The staff makes every effort to help disabled visitors since some stairs and drives may be difficult for them to negotiate, but it is wise to call in advance. Brochures in braille are available.

ᕯᕲ Americana ᕯᕲ

NORMAN ROCKWELL MUSEUM
Old Corner House
Main Street
Stockbridge, Massachusetts 01262
Phone: 413-298-3822
Director: David H. Wood
Hours: All year 10:00–5:00. Closed Tuesdays, major holidays, and two
 weeks at the end of January. Visits are by guided tour unless
 there are too many people, in which case guides stationed in
 each room can answer questions.
Directions: Going west on the Massachusetts Turnpike take exit 2
 and follow Route 102 five miles to Stockbridge. Going east on
 the New York Thruway, exit from Berkshire spur at exit
 marked Austerlitz/New Lebanon and follow Route 102
 immediately. Museum is on routes 102 and 7.

The works of Norman Rockwell make Americans sentimental. The
scenes he painted and the emotions they call forth touch a quality of
national pride and conscience.

Norman Rockwell, who died in 1978, lived many years in
Stockbridge. During his lifetime he produced more than four thou-
sand works, including 321 covers for the *Saturday Evening Post*. A
complete collection of those covers is at the museum, which also
owns the largest collection of original Rockwell paintings, more
than four hundred. Every January the works are rotated, so a visit a
year could turn up something new. At least fifty paintings are on
view at any time. (Eventually the museum will be moved to larger
quarters.) I hadn't been to the Rockwell Museum for many years,
and going back to refresh my memory reminded me how powerful
an impression the original work makes, despite familiarity with re-
productions.

One painting that touches a great many visitors is *Outward
Bound*—an old sailor and a little boy in a sailor suit stand at the
ocean watching a ship in the distance. Rockwell, incidentally, never
titled his paintings. "Ask him when he did *Outward Bound* and he'd
say, 'Which one was that?' " said museum director David Wood,
who was a friend of Rockwell's.

Another work, less typical of Rockwell in subject matter if not
in execution, brings an entire, painful era of this country's recent

Dog Armor ▶
Higgins Armory Museum, Worcester, Massachusetts

past into sharp focus: a small black girl in a white dress, her hair tightly braided, carries notebooks, ruler, and pencils in one hand. The background is a concrete wall against which a bright red tomato has been thrown—the place where it smashed and fell is splattered bloody red. In front and in back of this small child, their heads above the edge of the canvas, are the four U.S. marshals who escorted her to class. Few if any other works of art bring the reality of school integration so vividly to our consciousness. The work is dated January 1964. Not so very long ago.

A recent acquisition of the museum shows another rather atypical work. *Aunt Ella Takes a Trip* was commissioned to illustrate a *Ladies Home Journal* short story, but Wood calls it "a painting first and an illustration second." It is, by virtue of its painterly merit, an excellent work that stands easily on its own.

Besides these uncharacteristic pieces and a series of portraits of American presidents—in which the artist's fondness for Lyndon Baines Johnson illuminates one canvas while his distaste for Richard Nixon shades another—there are all the wonderfully familiar works, full of humor and patriotism: in *Doctor and Doll* a little girl is holding her doll up to the doctor's stethoscope and he is accommodating; in *The Four Freedoms* Freedom of Speech brings to life the idea of a young man speaking out at a town meeting and Freedom from Want will always typify the idyllic American Thanksgiving dinner. And there is the main street of the town he loved so well, Stockbridge itself.

Plan forty-five minutes to an hour for the guided tour. Children should enjoy this museum; adults, especially those with memories of Rockwell as a contemporary, will love it.

ᑌᗩ Cardinal Spellman's Stamps ᑌᗩ

CARDINAL SPELLMAN PHILATELIC MUSEUM
235 Wellesley Street
Weston, Massachusetts 02193
Phone: 617-894-6735
Director: Russell W. Dillaway
Hours: Tuesday, Wednesday, and Thursday 10:00–4:00, Sunday
 2:00–5:00, or by appointment. Closed holidays.
Directions: The museum is on the campus of Regis College. Weston
 is west of Boston and just west of Route 128. From Route 30
 take the Wellesley Street exit. Follow signs to Regis College.

The eastern bluebird is the state bird of New York state and the rose is its flower. Both are vibrant and carefully articulated. The artistry in itself is extremely fine, but considering that these pictures are collages made of tiny fragments of postage stamps, it becomes a feat of ingenuity as well as creativity.

Joseph Jagolinzer pictured birds and flowers of all fifty states. He was so meticulous that even the black lines used for definition are cancellation marks from stamps. The Cardinal Spellman Philatelic Museum owns the entire, unique collection, in addition to the largest collection of worldwide stamps in this country. (The Smithsonian in Washington, D.C., has the largest collection of U.S. stamps since it is owned by the U.S. government.) "We have fifty-nine countries who send us each new issue as it is issued," said executive director Russell Dillaway.

Francis Cardinal Spellman was a devoted philatelist who believed that through collecting stamps people gained a greater understanding of their "world neighbors," as he put it. The stamps on display are chosen to illustrate certain themes. For instance, to commemorate an anniversary of the Marine Corps, various stamps that had some connection to the corps were exhibited. As a memorial to President Kennedy, Dillaway displayed an interesting series issued by the Kingdom of Yemen, which had reproduced pictures of JFK as a child, as a lieutenant on PT-109, out sailing with his wife, and as president. Several Nigerian stamps also honored the former president. Another exhibit was about Graf Zeppelin flights to South America, and another depicted U.S. national parks.

It becomes clear to a noncollector that one of the pleasures of collecting stamps, especially if you define a particular area of interest and pursue it avidly, is that you will learn a lot about whatever subject you've chosen for a theme. Also, from a design perspective, some stamps are certainly fine artistic representations.

Besides the gallery there is a U.S. Post Office here as part of the museum. The actual furnishings came from an old country-store post office in Harding, Massachusetts, which was closed down in 1972. It carries an unusual number of stamps and is able to cancel them with the museum's logo.

This is not a razzle-dazzle museum, and it probably loses a good portion of its lay audience—those who are not already collectors— because it is so understated. But there is potential here to learn. If you have a mind to delve into something brand new, or maybe if you pursued this hobby briefly as a child, the museum might inspire. It

would probably not be of any interest at all to children who are not collectors.

∽ Men of Steel ∽

HIGGINS ARMORY MUSEUM
100 Barber Avenue
Worcester, Massachusets 01606
Phone: 617-853-6015
Director: Warren M. Little
Hours: Tuesday through Friday 9:00–5:00, weekends and holidays
 12:00–5:00
Directions: Take exit 20 from I-290. Follow Burncoat Street north to
 Randolph Road (traffic light). Turn left onto Randolph Road
 and go half a mile to the Armory.

The building that houses this museum seems a cross between a high-tech metal design and an ornate, rococo fantasy. In fact, it is a bit of both. It was thought to be the first multistory all-steel-and-glass building in the United States, and it is attached to a manufacturing company that, until 1975, made pressed steel. John Woodman Higgins, one of this country's first industrial millionaires, was the founder; he was also the collector whose interest in metal led to this, the largest display of armor in the Western Hemisphere. More than seventy-five suits of armor are on display, and the number is matched by the variety. Apart from a snappy item now worn by a plaster dog (much needed, one might add, during those wild boar hunts of the Middle Ages), there are some of the most elaborately engraved and etched designs for coveralls imaginable. One Italian suit of armor, dating back to about 1590, is covered all over with tiny etchings of Medusa's head—she of the snake hair and eyes that turn men to stone. Some rare Greek and Roman helmets in the collection are being carefully treated and tended for something called bronze disease, so they are kept in humidity-controlled cases. The Roman gladiator's hat is a magnificent piece of haberdashery.

The design of the suit of armor itself depended a great deal on the use to which it was put. The armadillo and the turtle have their appropriate shells, and the gladiator, jouster, warrior, horse, and hound had theirs.

Although many of the suits and the weapons on display here (there is also a fine collection of swords) are works of art, it is the

craftsmanship that most interested the man who collected them, according to my guide, Alex Helfenbein. Higgins started his career as a blacksmith, Helfenbein told me, and thus he was drawn to these objects as works of metallurgy. He acquired most of them after World War II, buying up collections owned by aristocrats who'd fallen on hard times.

Alex Helfenbein is a student at Bradford College and a resident of Worcester who works at the museum during the summer. He first became interested in knights and armor and medieval times as a player of Dungeons and Dragons. His enthusiasm and interest in armor are contagious.

This museum is definitely an excursion for kids, who will find their imaginations taking directions different from those of adults. But all age groups should see something of interest here. Plan to spend at least an hour.

Yale University Collection of Musical Instruments ▶
New Haven, Connecticut

RHODE ISLAND &
CONNECTICUT

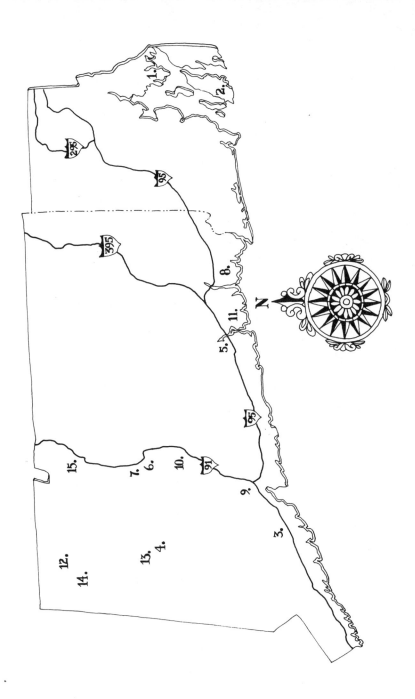

�governaᄋ Rhode Island ᄋᄂᄀᄉ

ᄋᄂᄀᄉ Connecticut ᄋᄂᄀᄉ

Ꮼ Anthropology at Brown Ꮼ

HAFFENREFFER MUSEUM OF ANTHROPOLOGY
Brown University
Tower Street
Mount Hope Grant
Bristol, Rhode Island 02809
Phone: 401-253-8388
Curator: Barbara A. Hail
Hours: June, July, and August, Tuesday through Sunday 1:00–5:00;
 March through May and September through December, Saturday
 and Sunday 1:00–5:00; closed January and February.
Directions: From Providence follow I-95 east to exit 2 (Route 136).
 Continue on 136 through Warren to Bristol. A mile beyond
 Veterans' Home, turn left at the museum sign on Tower Street.

It doesn't look promising. In fact, as you drive along a road that
seems to penetrate nothing but wilderness, it seems a highly unlikely
route to a museum. Don't be discouraged. The road will suddenly
open on a lovely site overlooking Mount Hope Bay. A tepee set up
in front of the building is also somewhat incongruous—but it's all
worthwhile, and it all has an underlying logic. Mount Hope Bay is
where the famous King Philip, a Wampanoag Indian chieftain who
terrorized the English, met his end in 1676. Now, that won't help
explain why the Haffenreffer has a splendid Plains Indian (as in Da-
kota) collection, but the following will.
 Rudolph F. Haffenreffer II lived on Mount Hope in Bristol on
the site of a Wampanoag Indian campground. The locale provoked
his interest in Indian artifacts, an interest beginning with the local
tribe and then expanding to include, on his trips west between 1917
and 1928, those of the Plains. When Haffenreffer died in 1954, he
left his treasured collection to Brown University.
 As I discovered and rediscovered during my museum trips,
many objects currently on view will be in storage in the future.
Great care must be taken that materials, whether feathers or fabric or
even metal, are not left too long in the light.
 Although the particular beaded clothing and painted skins I saw
in this collection may not be on display, others of similar quality will
replace them. Still, it's difficult to pass up a chance to mention a cer-
tain red bonnet with a star for decoration. According to the cata-
logue of this collection, entitled *Hau, Kola!* (which means "Hello,

Friend" in the Lakota dialect), the bonnet, made around 1890, "has been glorified by the painstaking [porcupine] quill embroidery skill of a loving Yankton mother." The five-pointed star was probably copied from the American flag.

Another extremely fine collection at the Haffenreffer is African. I was interested to find a wooden head, called an *atwonzen,* decorated with the same tiny, colorful beads that the Plains Indians used on their saddlebags and clothing. These are the glass Venetian beads that Europeans brought with them for trading purposes.

It certainly should be noted that the university has an important Arctic program and a unique collection of archaeological items from that area.

This is a relatively small museum and children should enjoy it. Reserve up to an hour for the visit.

⌘ Cup Defenders ⌘

HERRESHOFF MARINE MUSEUM
18 Burnside Street, P.O. Box 450
Bristol, Rhode Island 02809
Phone: 401-253-5000
Director: Halsey C. Herreshoff
Hours: May through October, Wednesday and Sunday 1:00–4:00
Directions: From Providence follow I-95 east to exit 2 (Route 136).
 Continue on 136 to Warren and there pick up Route 114. Turn
 onto Burnside Street from Route 114, south of the center of
 Bristol

Herreshoffs have been described as the Rolls Royces of the boating industry. But maybe Rolls Royces should be called the Herreshoffs among cars. I'm not sure that any Silver Shadow ever achieved the fame that the *Reliance* did in 1903 when she defended the America's Cup.

A photograph of the *Reliance,* blown up to about six feet wide by four feet high, is on the far wall of this museum. But as Louise Henry DeWolf says, the boat doesn't look all that big until you get up close to the picture and see the tiny black spots along the side— heads. The boat was 144 feet long and 199½ feet from water to rig top. And beautiful.

Miss DeWolf, now an octogenarian, is a granddaughter of John Brown Herreshoff, founder of the company and an extraordinary

man who, though he had become blind at the age of fourteen, designed and built models of the boats he invented. Family pictures along the walls add perspective to the exploits of this yachting clan. There is, for instance, a handsome young man on something like a water ski with a beautiful young woman poised on his shoulders. He is Sidney Herreshoff, who accompanied his father on the trial trip of their America's Cup winner. He said that she had such speed and momentum that upon returning they lowered the sail and shot the mooring across about half the width of Bristol Harbor. It sounds astonishing even to a landlubber. Sid Herreshoff died in 1977 at the age of ninety-one. His wife, Rebecca, who is nearly ninety, is a hostess at the museum along with Louise DeWolf.

Theirs is an eccentric museum, the collection jammed into one room about the size of a fire station, with little rhyme or reason. Never mind, it's the spirit of the venture that fascinates the idly curious, and undoubtedly it is like finding the source to ardent yachtsmen.

No, the *Reliance* isn't here, but memorabilia of the Herreshoff boat-manufacturing company are. It was during the early 1900s that the workforce was at its peak, feverishly building and launching yachts. By the outbreak of World War I the complex held twenty-one buildings.

The museum is currently disorganized. You must have an a priori interest in the subject before you bother to visit, but after that, heaven knows how long you'll want to spend.

∞ Tennis Museum, Anyone? ∞

INTERNATIONAL TENNIS HALL OF FAME
Newport Casino
. 194 Bellevue Avenue
Newport, Rhode Island 02840
Phone: 401-846-4567
Executive Director: Jane G. Brown
Hours: May through October 10:00–5:00, November through April
 11:00–4:00
Directions: Follow either Route 114 or Route 138 into Newport and
 continue, past Newport Harbor, to the intersection where you
 will begin to see signs for Newport Casino. You will turn left
 and continue up Memorial Boulevard to Bellevue Avenue.

The Newport Casino faces on a main street and doesn't give a clue to what is waiting when you walk through the doors. The building opens up and surrounds a green grass court, which was, when I stopped there, set up for croquet; no one was playing. One wing of the former casino is now a restaurant. Across the green and upstairs in the other wing, the tennis museum begins with a collection of trophies—a large crystal vase given to winners by *Family Circle* magazine, a gilded tennis racquet with gilded leaves and a bow that Martini & Rossi presented (John Newcomb won it in 1969, Arthur Ashe in 1975), and the Volvo Norseman helmet with horns that Jimmy Connors won (somehow that prize seemed entirely fitting).

Thereafter the museum goes on, and on, and on, and on. Not an aspect of this aristocratic sport is left uncovered. The history, the fashions, the racquets. The racquet with which Jimmy Connors won the U.S. Open in 1983 is here, a Wilson 2000, and the grip looks almost as if the end of it was chewed. Or did that happen when he threw it down? There is also a 1906-vintage wooden racquet that was used by William Clothier. It has a huge grip and looks like an extremely heavy instrument.

In an alcove in one room a collection of mannequins shows off tennis court fashions through the years, among them an outfit Billie Jean King once wore. Every kind of tennis racquet ever made and most of the racquets of famous players are on display. Some mysterious tennis art includes a couple of oil paintings by Harry V. Douglas. One surrealistic picture shows a racquet floating in a blue sky surrounded by—loaves of French bread. No amount of guessing answered why, but the clue is that the work is based on the mystery novel, *The Golden Legend* by Rene Magritte.

After the Newport Casino experience, tennis is raised from the plane of a good game to the level of devotional mystique. The casino, designed by debonair and notorious architect Stanford White about 1880, has some grass courts for the public to play on and, still in the old style, with wooden chairs under the awning and bleachers under the sun, a championship grass court where the Virgina Slims is played. It is the oldest Court Tennis court in the United States.

If you stopped to look at every label it would take you forever to get through this museum. If your interest is mild, give it about an hour. Children who have serious tennis futures may get inspired here. Others probably won't. No provisions for handicapped visitors.

The American
Turtle

ﾟ Collectors' Cars ﾟ

NEWPORT AUTOMOBILE MUSEUM
One Casino Terrace
At Bellevue Avenue
Newport, Rhode Island 02840
Phone: 401-846-6688
Director: Tom Occhiuzzo
Hours: Summer 10:00–7:00, winter 10:00–5:00
Directions: This museum is right around the corner from the
 Newport Casino. Take Route 114 or Route 138 into Newport
 and follow it, past Newport Harbor, to the intersection where
 you see the first sign for the casino. Turn left and continue up
 Memorial Boulevard to Bellevue Avenue. Turn right onto
 Bellevue. The auto museum is a left just past the casino.

Tom Occhiuzzo is a survivor. He believes he's found the answer to
staying open and solvent. He's selling the cars in his museum, like
Raymond Lowey's 1941 Lincoln valued at $75,000 and a 1923 Rolls
Royce Silver Ghost valued at $300,000. He was a car dealer before he
was a museum curator—now he's both.

Not every car here is for sale, though. In the permanent collec-
tion is the 1923 Rolls Silver Ghost that Woodrow Wilson received
as a present for his sixty-seventh birthday. Unhappily, he didn't enjoy
many rides in it before he died. A real knockout is the 1941 white
Alfa-Romeo six-cylinder 2500 roadster that Benito Mussolini gave
Adolf Hitler. Only two others of this model were built, one for
Mussolini's mistress and one for Mussolini himself. A nostalgic vi-
sion to those of a certain age is a great lump of a car, the 1939 Ford
Woody. The 1940 is the most collectible, but the '39 comes in right
after that. And talking about nostalgia, how about the 1904 shiny
red Maxwell of the kind Jack Benny and Rochester used to tool
around town in?

Even if you don't love antique and classic cars, you may enjoy
this place, and kids will not believe what their grandparents used for
cruising. It is accessible to wheelchairs. Half an hour, probably.

◀ "American Turtle"
 Connecticut River Foundation at Steamboat Dock, Essex, Connecticut

⊙ P. T. Barnum ⊙

BARNUM MUSEUM
820 Main Street
Bridgeport, Connecticut 06604
Phone: 203-576-7320
Curator: Robert L. Pelton
Hours: Tuesday through Saturday 12:00–5:00, mornings by
 appointment
Directions: From I-95 take exit 27. Follow Route 8 north to Main
 Street. The museum is at the corner of Main and Gilbert Streets.

So far there are several hundred pieces—figures, tents, railroad cars,
and circus wagons—on the third floor of the Barnum Museum. This
exhibit is a working model of a circus, a set-up that measures twenty
feet wide by sixty feet long and is based upon a circus that Robert
Brinley saw when he was nine years old in 1915. Young Brinley went
home and began to recreate the Greatest Show on Earth, which was
then being transported in a hundred railroad cars. Under the model
Big Top, which used up five bedsheets and took Brinley a year to sew
by hand, are five (yes, five) rings. As I write, Brinley is still working
on this circus; the week before I visited he delivered another 131 fig-
ures for it.

This museum was bequeathed to the city of Bridgeport by P. T.
Barnum before he died in 1891 but wasn't finished until later. At
first it was just a run-of-the-mill museum with the standard natural
history specimens. At one time it was taken over by the city and used
as an annex of city hall. Today it is increasingly devoted to the life of
P. T. Barnum and to Barnum's favorite protégé, Tom Thumb. Bar-
num discovered Tom Thumb when the midget was only five years
old. Tom Thumb worked for Barnum throughout his life. When
Tom married Lavinia, she joined him in his tours under Barnum's
sponsorship, and the museum has the carriages they traveled in as
well as the brass four-poster they slept in and the wood stoves they
cooked on. Even their wedding outfits are on display, on little plaster
models.

Almost the entire second floor of the museum is dedicated to
Tom and Lavinia Thumb, except for a mummy: "See a real
Mummy," the sign invites, and above the specimen that Mrs. Bar-
num bought after her husband died is this sign: "Stranger/ Pause as
you pass by/ as you are now so once was I." There is also the

scrawled challenge: "Look if you dare through the glass coffin top!" The 2500-year-old mummy has become a cult figure among Bridgeport's younger set, who are guaranteed to exclaim "Oh! Gross!" when they do take a peek. Fortunately, hanging on the wall is a ritual net to ward off evil spirits.

On the ground floor are circus wagons, posters, portraits of the Barnum family and their mansions. There is also a Jenny Lind corner—since Jenny Lind, known as the Swedish Nightingale, was another of Barnum's protégées. There is also a circus elephant—not the famous Jumbo, the largest elephant ever recorded and a member of the Big Top troupe—but a baby elephant who died and was preserved. Because of all the layers of paint that have been used to preserve him, people insist upon believing that he is plaster, but perhaps that's just as well.

When the Russian circus came to the United States in the late 1970s, the members made a pilgrimage to Bridgeport to see the Barnum collection. For circus lovers it's well worth a detour, and it's fun for everyone else, too. Give it an hour.

⨳ Clock Country ⨳

AMERICAN CLOCK AND WATCH MUSEUM
100 Maple Street
Bristol, Connecticut 06010
Director: Chris H. Bailey
Hours: April 1 through October 31, 11:00–5:00. Closed winters.
Directions: North of Waterbury and west of New Britain, stay on
 Route 72. Pick up Route 229 and stay on that to the end, where
 you will turn left onto Route 6. Follow 6 to Maple Street. Go
 left up the hill to the museum, on the left.

"Everyone talks about Eli Whitney making interchangeable parts. I don't know why they don't pay just as much attention to Eli Terry."

The guide at the American Clock and Watch Museum had a good point there. Terry, who was born in 1772 in East Windsor, Connecticut, pioneered in developing wooden mechanisms for clocks. Among the exhibits here is one that shows all of the working parts of a clock carved from wood. Wooden gears made the clocks less costly, but people then (as now) liked the prestige of owning expensive things. So manufacturers of clocks with wooden parts sometimes painted keyholes on the clock faces, despite the fact that

the clocks were run with weights and did not need keys. To keep them going, you opened a door and pulled the weights.

There are more than a thousand clocks and a thousand watches in this museum, which is in a house built in 1801. It is a very nicely mounted collection, meant to give visitors a good idea of the history of horology. The rooms are devoted to different eras, and it is interesting to note how closely the style of clock cases followed the furniture style of the times.

You will learn, from a map on one wall, the astonishing fact that in the mid-1800s there were 280 or so clockmakers in the Bristol area. Each was vying with the others to make clocks more cheaply and, as a result of what we might well call the clock wars, most of them went under.

A tour of this museum is accompanied by an understated ticking that ushers you from room to room, from a collection of early nineteenth-century clocks that were painted not only on their faces but also on the cases to make them look more expensive, through a room where turn-of-the-century clocks have their original prices next to them. I was intrigued by a brass figure of a philosopher who had an open book on his lap and a compass in his hand. He is part of an ornate timepiece that cost $32.50. Wisdom was relatively expensive in those days.

Elaborate oak cases of the 1920s and 1930s are accompanied by some examples of the heavy metal rollers that were used to press the designs into the wood. The first electric clocks, encased in wood, remind us that the first mass-produced clocks were designed to look custom-made. The degree to which all this is history was exemplified by a young boy who asked, "Are all your clocks run on batteries?"

Young children who tend to run around definitely should not be brought into this museum. A leisurely tour and the slide show could take upwards of an hour. There are no provisions for handicapped visitors.

⌘ Connecticut River ⌘

CONNECTICUT RIVER FOUNDATION AT STEAMBOAT
 DOCK
Main Street, P.O. Box 261
Essex, Connecticut 06426
Phone: 203-767-8269
Director: Brenda Milkofsky

Hours: April through December, Tuesday through Sunday 10:00–5:00
Directions: From I-95 or I-91, take Route 9 to exit 3 and follow signs
 to Essex and the historic waterfront. The museum is located at
 the foot of Main Street in Essex Village, right on the river.

On the first days of fall the water shimmers and sparkles behind the
white clapboard building and gulls take their stations atop the posts
of the pier. It is an idyllic scene, crisp and beautiful.

The second story of this building houses the museum's perma-
nent collection. Here are some evocative nautical paintings, includ-
ing the portrait of an important riverman, Captain Samuel L.
Spenser. There are shipbuilding tools and mementos from long-gone
riverboats, and there is even a model of David Bushnell's *American
Turtle,* the first submarine.

My favorite display was the model of the *City of Hartford*: it
looked like a particularly enjoyable steamboat on which to cruise the
Connecticut River. It had elegant chandeliers, rosewood furniture,
and twenty-five staterooms along the upper deck. A Victorian plea-
sure ship, it made its first trip on June 10, 1852. Perhaps the tiny fig-
ures standing on the model deck happily waving were meant to be
the passengers on its maiden voyage.

Alas, on March 29, 1876, it met with a terrible fate. It rammed
into the Middletown railroad bridge, lifted the whole structure up,
and carried it downstream. Photos show the ship's sinking shape
after the bizarre accident.

This is a pleasant, small museum that can be seen in half an
hour or less. Children will enjoy it. There are no special provisions
for handicapped visitors.

⟡ American Excess ⟡

HILL-STEAD MUSEUM
671 Farmington Avenue, Box 353
Farmington, Connecticut 06034
Phone: 203-677-9064
Director: Philip G. Wright
Hours: Wednesday through Sunday 2:00–5:00
Directions: From Hartford take I-84 west about eight miles to exit
 39. At the second traffic light turn left onto Route 10 heading
 south. At the first light turn left onto Mountain Road. The
 museum entrance is on the left, just after the intersection.

Stone gates and a long drive lead to this white clapboard house, which was described by Henry James in 1901: "A great new house on a hilltop that overlooked the most composed of communities; a house apparently conceived—and with great felicity—on the lines of a magnified Mount Vernon." Was James trying to say, in his marvelously understated and roundabout way, that Hill-Stead is derivative, lacking the genius of originality? Hill-Stead, a historic house, in some ways falls outside the general guidelines of this book, but it is included here because it provides a unique insight into a slice of the American character at the turn of the century. In addition, it is the only place where you will be able to see certain important works of art of that era. The story of the people who built Hill-Stead and lived there is what distinguishes this museum.

Alfred Pope made his fortune in the malleable iron business in Cleveland, Ohio. Like other upwardly mobile fathers at the turn of the century, he sent his only child, Theodate, to Miss Porter's School ("of course," as the guide will tell you) in Farmington. Theodate was very happy among the eastern upper crust and persuaded her parents to build a house in Farmington. Not only that, but as she was an aspiring student of architecture, she talked them into hiring *the* architect of the era, Stanford White, and she got him to let her help. The cost of building the house then was $95,000; the architect's fee was $50,000, which represented a discount of $25,000 in view of Theodate's contribution.

Theodate went on to become one of the first women licensed to practice architecture in the United States. Mom and Dad proceeded to stock their home with the very best that money could buy, acquiring objects from every era, country, and art the imagination could embrace. Pre-Columbian statues, contemporary bronzes, Brady photographs, a Hepplewhite bird cage (which had the Popes' own stuffed parrot inside), the finest porcelain, Chippendale furniture, a custom-designed Steinway, and an outstanding collection of Impressionist art, including three Monets (one bought the year after it was painted), a Degas pastel (for which Mr. Pope paid $900), a Manet, and a Cassatt.

Theodate did not marry until she was in her middle years and until after her father had died. She and her husband, John Wallace Biddle, had no children. When Theodate died in 1946, she left a fifty-page will with instructions on how the house and everything in it were to be maintained as a museum. All was to be kept just as it had been when the family lived there—nothing added to the Pope collection, and nothing ever lent out. Anyone who wants to see

Mystic Seaport Museum ▶
Mystic, Connecticut

Monet's lovely rosy sunset on Lake Geneva will simply have to see it here.

A tour of Hill-Stead is a filling experience. "I feel as though I've spent the afternoon gorging in a Viennese pastry shop," one over-stuffed tourist remarked. This museum is an amazing example of conspicuous consumption, almost more than an ordinary mortal can absorb—but not quite. It is not a place for young children. There are no provisions for the handicapped. The tour takes about an hour.

ᥩᥩ Buttons & Guns ᥩᥩ

CONNECTICUT STATE LIBRARY
RAYMOND E. BALDWIN MUSEUM OF CONNECTICUT
 HISTORY
231 Capitol Avenue
Hartford, Connecticut 06106
Phone: 203-566-3056
Director: David O. White
Hours: Monday through Friday 9:00–4:45, Saturday 9:00–1:00
Directions: From I-91 take the Capitol Area exit. Follow Elm Street
 to Trinity Street, turn left to Capitol Avenue. The museum is
 on Capitol between Trinity and Oak Streets.
 From I-84 take the High Street exit. Follow High to Trinity and
 continue as above.

A museum such as this is, by nature, eclectic—to the degree that the state's history is diverse and also to the extent that benefactors pro-vide gifts. Here is material related to the history of the state: portraits of all the governors, documents, clocks, guns, carriages, and the Sel-den automobile (for which the patent was challenged by Henry Ford).

The Colt Firearms Manufacturing Company is not only en-twined in Hartford's commercial history, it is also a bright landmark in this city of gilded domes (the state capitol's is particularly fine). The Colt building's dome is a periwinkle blue with gold stars. The Wadsworth Atheneum (see page 109) in Hartford owns Samuel Colt's personal collection, and the State Library museum has a his-toric collection of guns the Colt company produced. It was bought for the museum by J. P. Morgan.

Serial number 1 of the Colt revolver, the weapon he thought of when he was a sailor, is a gun with a dagger that looks a lot like an

ice pick. The guard on duty reminded me that in the early nineteenth century, when Colt's inventions were patented, sailors used to shoot from ship to ship and then jump aboard and fight. There is a small but handsome wooden gun, a working model carved in 1855 from Connecticut's Charter Oak. Bizarre door hinges from the Colt factory are cast from—guns, in particular, the third model Dragoon revolver. Presentation firearms, elaborately engraved and inlaid, are beautiful objects, to the extent that one can forget the purpose of guns and call them beautiful.

But the hidden treasure and a palliative to all these weapons I came upon by surprise: a case of buttons, from a collection of ninety thousand buttons that was given to the state of Connecticut.

A good place to take children. You should plan about half an hour here.

⨭ A Chest & a Camel ⨭

WADSWORTH ATHENEUM
600 Main Street
Hartford, Connecticut 06103
Phone: 203-247-9111 (information tape) or 203-278-2670 (main
 number)
Director: Tracy Atkinson
Hours: Tuesday through Sunday 11:00–5:00
Directions: From I-91 either the downtown exit (just beyond the exit
 to I-84 west if you are heading south) or exit 29A will take you
 to Prospect Street. The Atheneum is between Prospect and Main
 Streets, between Travelers Tower and City Hall. The back of the
 museum is on Prospect Street. There is metered parking on the
 streets and a parking lot in the vicinity.

The Wadsworth Atheneum, founded in 1842, boasts of being the oldest public art museum in America. It can also boast of a fine renovation which, in the 1980s, allows it to fill new galleries with paintings from its permanent collection, especially colonial American works and great nineteenth-century French and British art, and to devote special rooms to Frederick Church and Thomas Cole.

One of the Atheneum's two unique collections is Samuel Colt's personal collection of antique firearms. These weapons were in storage when I visited; if your particular interest lies there you ought to call before you go.

The museum is included here because of the Wallace Nutting collection—the largest and best-known collection of colonial American furniture. It includes more than a thousand examples of furniture, ironwork, kitchenware, and related domestic furnishings dating from 1630 to 1730, the so-called Pilgrim century. Nutting is known to a great many of us for his hand-tinted photographs—apple-orchard-in-pink-bloom; silver-birch-along-a-pleasant-lake sorts of things. He was a Congregational minister who, in 1905 at the age of forty-four, began his collection of early Americana. J. P. Morgan bought it from Nutting in 1925 and presented it to the museum.

One piece of particular interest is a so-called Hadley chest (Hadley, Massachusetts, having lent its name to the style, although this piece probably came from Hatfield, a town west of Hadley). The chest is a hefty, sturdy piece of furniture that opens on the top and has a drawer across the bottom. It has a peasant look about it: the tulip and leaf motif is stylized in a way reminiscent of Pennsylvania Dutch design. For contrast, there is a rare American colonial chest with bright and fanciful painting. A funny design on one drawer is a head in profile with a scroll emerging from the mouth. It brings to mind the cartoon that introduces the twentieth-century comedy team Monty Python's Flying Circus.

Another excellent collection is porcelain, an assemblage of pieces from major European manufacturers—the Atheneum owns the largest collection of Meissen figurines outside Europe—as well as some from the Orient. A magnificent piece to note is a Chinese camel of the T'ang dynasty (A.D. 618–906). It has a primitive glaze in which the color seems to be bleeding; but the strangest detail is a saddlebag that is the likeness of a gargoyle's head.

Another work is so humorous and outrageous that no one should miss it, even though it doesn't quite match the special-collection criterion we are aiming at. Still, take a look at a sculpture called *Sunbather,* by Duane Hanson. It's a polyester and fiberglass creation polychromed in oil. The sunbather is a very large woman who is being roasted on a beach chair. By her side, in her tote bag, are the remains of her picnic, including an opened box of Apple Jacks. As you stand and look at her, you can just about feel the burn she has on the top of her thighs—and you know she is going to hurt tomorrow.

The Atheneum can absorb an hour at least, and it will be a fine visit for children, who may not like everything but will surely find some memorable works here.

⁓ Figureheads and Scrimshaw ⁓

MYSTIC SEAPORT MUSEUM
Route 27
Mystic, Connecticut 06355
Phone: 203-572-0711
Director: J. Revell Carr
Hours: Summer 9:00–5:00, winter 9:00–4:00
Admission: Adults: $8.50 one day, $10.50 two days. Children: $4.25
 one day, $5.25 two days.
Directions: Mystic Seaport Museum, about ten miles east of New
 London in southeastern Connecticut, is located on Route 27,
 approximately one mile south of I-95, exit 90. There are signs.

The museum is a huge complex that includes historic ships, boats, buildings, how-it-was-done exhibits, a restored whaling ship that visitors can climb aboard and explore below deck, and a children's museum that depicts the lives of children who went to sea in the late nineteenth century. Representations of a bank, shipping office, grocery and hardware store, printer's shop, chapel, clock and nautical instrument shop, give visitors the impression of nineteenth-century maritime crafts and industries. Taking in the entire museum is a major commitment. For purposes of this book, however, there are two exhibits of particular interest.

Mystic has one of the country's most interesting collections of ship figureheads, one of which is a huge (perhaps four-feet-long) eagle's head. It hangs above your head, fierce and stunning, among the exhibits on the first floor of the Stillman building. But most of the figureheads are displayed in the Wendell building, where they are raked against the wall in a darkened room. These pieces vary in theme and size, from a large, kilted Scotsman to a gargantuan lady to a curious pair of dancing twin sisters with garlands in their hair.

Back in the Stillman building, where there are fine displays of leaded glass windows with ship motifs, models, and a great variety of facts and objects having to do with maritime life, there is also a nice exhibit of ships in bottles. Actually not the most elaborate or beautiful examples to be found, they are, however, explained. Now I know how the makers get those ships in there!

The other exceptional collection at Mystic is the scrimshaw on the second floor of the Stillman building—the only other I've seen to

equal it is at the Whaling Museum (see page 63) in New Bedford, Massachusetts. The special attractions in Mystic, which they call the "most significant pieces of American scrimshaw to be found anywhere," are from the ship *Susan,* which sailed out of Nantucket on whaling voyages between 1826 and 1853. During the late 1820s a sailor named Frederick Myrick engraved a series of whale teeth that are now called Susan's Teeth. These pieces are the earliest known scrimshaw and they are wonderful. One piece is mounted in a box with a mirror on its bottom so that you can see the engraving on the underside. The tooth has a silver cap on one end, and a chain. It may have been used for that all-important shipboard sip of grog. It is decorated with an eagle and a drawing of the *Susan* during one of her voyages to Japan.

This museum is a place for people of all ages. You may want to take a whole day or two to see this extensive operation in a leisurely way. Certain parts of it are entirely inaccessible to handicapped visitors, however, so it would be wise to call in advance if you have special needs.

ᝋ Hail Britannia ᝋ

YALE CENTER FOR BRITISH ART
1080 Chapel Street
Box 2120 Yale Station
New Haven, Connecticut 06520
Phone: 203-436-3909
Director: Duncan Robinson
Hours: Tuesday through Saturday 10:00–5:00, Sunday 2:00–5:00
Directions: From I-95 take exit 47 and follow the downtown
 connector to the end. You will merge with city traffic. Turn
 right at the first light onto York Street. Go two and a half
 blocks and, just past Crown Street, turn into the parking lot
 behind the museum.

If there is such a thing as an English sensibility, then you will be able to track it down here. This collection, the most extensive outside the British Isles, surveys the development of British art, life, and thought from the Elizabethan period onward. Special emphasis is on the era called the "golden age," the period between the birth of William Hogarth (1697) and the death of J. M. W. Turner (1851).

The challenge is to put your finger on that sensibility. Is it to be found in the definition, color, and lighting of the dense leaves in landscapes and pastoral scenes by John Crome and Francis Danby? A refined appreciation of nature, a touch of understated passion and drama, is expressed by these eighteenth- and early nineteenth-century artists.

All that understatement breaks loose in the sky studies of John Constable though. He did a series of rapid compositions between 1821 and 1822 in which the excitement brewing overhead is tangible. These studies were later incorporated on canvases that have come to be recognized as the greatest of landscapes.

There are seascapes by Turner: a rough and stormy sea with bold, impressionistic brush strokes (before the era of the Impressionists as we know them), and a placid harbor scene with a becalmed packet boat, the water so still that you feel your breath will ripple it.

A portrait of Miss Sarah Campbell by Sir Joshua Reynolds has a rough, tumultuous sky behind the lady, whose porcelain face could hardly be more composed. The sky is rivaled in depth and texture, though, by the folds of Miss Campbell's white satin dress. Frederick Lord Leighton's portrait of Mrs. James Guthrie, by contrast, is dark, liquid, and elegant.

The galleries housing these works are in the last building designed by American architect Louis Kahn before he died in 1974. The spaces are dramatic and admit natural light to illuminate the travertine marble, white oak, and undyed wool carpets. For Anglophiles, art lovers, and anyone who wants to see an excellent collection, it's right here.

It is definitely a museum in which children can be introduced to fine art. It is fully equipped to accommodate handicapped visitors. I would save an hour or two, at the very least, to enjoy this museum.

∽ Brontosaurus ∽

YALE PEABODY MUSEUM
170 Whitney Avenue
New Haven, Connecticut 06511
Phone: 203-436-0850
Director: Leo J. Hickey
Hours: Monday through Saturday 9:00–4:45, Sunday and holidays
 1:00–4:45

Directions: From I-91 take exit 3 onto Trumbull Street. Follow
Trumbull to Whitney Avenue and turn right on Whitney. The
museum is on the left, at the corner of Whitney and Sachem
Street.

The "thunder lizard," or brontosaurus, seen here in all its glory, has
to be a major drawing card to this museum, although the mural de-
picting the age of dinosaurs is pretty impressive, too. The painting is
heralded as the largest natural history mural anywhere, and anyone
steeped in dino lore will find it fascinating.

But standing next to the brontosaurus skeleton (which was, in-
cidentally, the first, and the most complete specimen of brontosaurus
ever to be mounted) is certainly an experience of prehistory. The ani-
mal was sixty-seven feet long and nearly sixteen feet high at the hips;
it weighed thirty-five tons. Scientists estimate that a thousand
pounds of food were needed to keep it fueled—every day.

On the whole this is a typical natural history museum, with a
few stuffed animals, dioramas, rocks, American Indian artifacts, and
an Egyptian exhibit complete with skeleton. Although not excep-
tional in any special collection, it is a nice museum to initiate young
children into the wonders of the world. On the Sunday when I vis-
ited, a number of families were making the tour. A visit can take up
to an hour; a twenty-minute movie is shown from time to time.
There are a ramp for the handicapped and an elevator.

↫ Musical Instruments ↬

YALE UNIVERSITY COLLECTION OF MUSICAL
 INSTRUMENTS
15 Hillhouse Avenue, P.O. Box 2117
New Haven, Connecticut 06520
Phone: 203-436-4935
Director: Richard Rephann
Hours: September through May, Tuesday, Wednesday, and Thursday
 1:00–4:00, Sunday 2:00–5:00; June and July, Tuesday,
 Wednesday, and Thursday only, 1:00–4:00
Directions: Take exit 3 on I-91 (Trumbull Street). Go left at the
 second set of lights onto Temple Street. Take the first right
 onto Grove Street. Take the first right again, onto Hillhouse
 Avenue.

◀ Yale University Collection of Musical Instruments
 New Haven, Connecticut

This is one of the most important instrument collections in the world; in this country it is unrivaled except by the Metropolitan Museum of Art. I'm sure that to musicians there are refinements that the layman won't ever notice, but to the layman, I can testify, these are some extraordinarily beautiful objects. A stringed instrument from nineteenth-century India is carved as a peacock embellished with feathers. A "Russian bassoon" was "neither Russian nor a bassoon . . . most are conically bored instruments pitched in C with six fingerholes, one thumbhole," and this one ends with the head of a snake. It isn't known whether this nineteenth-century Italian specimen was used to amuse spectators at a parade or to scare an enemy during battle. There is a crystal flute, and there is the most beautiful guitar to be found anywhere. Its surface is entirely covered with designs in ivory, tortoiseshell, and mother-of-pearl inlay. In one scene Orpheus is charming the wild beasts, in another Apollo and Pan are having a musical contest. This instrument was made in Germany in 1702 by Joachim Tielcke.

On the second floor of the museum are the keyboard instruments, also exquisitely decorated, with both marquetry and painting. How do they sound, one can't help but wonder. They are sweet and elegant of tone, I was told by a music student who was on curatorial duty. Although we are unable to touch them, there are, from time to time, lecture-concerts. It would be rewarding to catch one of those.

A child interested in music could appreciate this museum. It is not equipped for handicapped visitors. The amount of time to spend depends a great deal on the depth of interest. For the passing curious, half an hour will take you through.

⌘ Ham Headquarters ⌘

AMERICAN RADIO RELAY LEAGUE MUSEUM
225 Main Street
Newington, Connecticut 06111
Phone: 203-666-1541
Director: Laird Campbell
Hours: Weekdays 8:00–5:00
Directions: Take Route 175 into Newington town center and turn
 north (right) on Main Street, away from downtown. Numbers
 start in the 1000s. Continue for about one mile until you see a
 brick building on the left with a multitude of "ham" antennae
 around it.

Keep your eye on this museum. When the American Radio Relay League gets its act together and spreads its collection around, giving the items appropriate labels and digging some more of the material out of storage, this will be a terrific museum.

Right now it's the kind of place where hams go. The older ones sigh and say, "There's the thing I used when I was sixteen," while young hams say, "Imagine using one of those."

The cases are literally stuffed with tubes, tuners, transmitters, all the paraphernalia of an amateur radio operator. There is also a nifty trophy called the Elser Mathes Cup that hasn't been awarded yet, although it was made back in 1928. It has a couple of bizarre brass figures on it and will be awarded to the first ham who works Mars. Working another ham, or a country, really means contacting and communicating with other operators. It is illegal for hams to broadcast; they must communicate directly with someone else.

The museum doesn't yet have out any documentation of the fact that one of our astronauts got permission to take his ham radio with him in space, and while on his mission he worked lots of hams on earth. Nor has it put out material to demonstrate that during the 1983 crisis in Grenada, when American students were endangered on the island, the only communication with them was via ham radio.

The American Relay League is a nonprofit service organization to which amateur operators belong. As one official of the organization put it, "We are to hams as the National Riflemen's Association is to sportsmen." But the league's lobbying is rather wider since it is concerned with the preservation of frequencies worldwide. The headquarters is in Newington because the founder of the league, one Hiram Percy Maxim, lived in the area. The league has been in operation since 1914, and the hobby has a lively story to tell. At present the museum isn't telling it very well.

This museum probably is not yet for the general public.

ଚ୬ Art Colony ଚ୬

FLORENCE GRISWOLD MUSEUM
96 Lyme Street
Old Lyme, Connecticut 06371
Phone: 203-434-5542
Curator: Debra A. Fillos
Hours: Summer, Tuesday through Saturday 10:00–5:00, Sunday

1:00–5:00; winter, Wednesday through Friday 1:00–5:00, Sunday 1:00–5:00

Directions: Take I-95 to exit 70. If you are coming from the east, turn right at the exit; the museum is the second building on the left. If you are coming from the west, turn left at the exit, then right at the first light. Turn left at the next light. The museum is the second building on the left.

In the early part of the twentieth century, this house, which belonged to Florence Griswold, the daughter of the sea captain who built it for his bride in 1841, was a lively salon, a center where artists stopped to visit and to paint. There was a core of some thirty painters, many of whom were well-established landscape artists, including Childe Hassam, Willard Metcalf, and Henry Ward Ranger. They invited others, who considered themselves privileged to be asked, and Old Lyme became a major center of American Impressionism. It must also have been a lot of fun. There were picnics, parties, evening musicales; the artists played practical jokes and games and improvised theatricals, and, to be sure, they painted.

They also left their mark on the Griswold house, where many of them boarded, in a way that makes this museum unique: they painted the panels of the dark wooden doors throughout with lively and lovely pictures. A black and white cow, for instance, decorates a door in the parlor; landscapes and portraits embellish other doors. But the dining room is the pièce de résistance. This entire room is decorated with painted panels, including one long scene over the fireplace in which caricatures of artists are the theme of a hunt scene.

In addition to the painted woodwork, the Griswold has a fine collection of art. Particularly well represented are about 110 of the artists who enlivened the spirit of Old Lyme.

Plan to spend about an hour. I don't think it's advisable to bring young children. There are no special provisions for handicapped visitors.

◦◦ Nutty ◦◦

NUT MUSEUM
303 Ferry Road
Old Lyme, Connecticut 06371
Phone: 203-434-7636
Director: Elizabeth Tashjian

Hours: May to October 31, Wednesday, Saturday, and Sunday
 2:00–5:00. Otherwise by appointment.
Directions: Take exit 70 from I-95. If you are coming from the west,
 turn right off the ramp onto Route 156. From the east, turn left
 onto Hall's Road, pass the shopping center, and then turn left at
 the light (Route 156). In a quarter-mile, about fifty feet before
 the flashing light, make a right turn onto Ferry Road. The
 museum is the second building on the right. A metal sculpture
 of a squirrel holding a sign marks the museum entrance.

Elizabeth Tashjian vowed to put nuts on the map and to give nuts a
good name. Well, she has done the former: there isn't anyone in Old
Lyme who doesn't know where her museum is to be found. The mu-
seum is also on some roadmaps and is in the state of Connecticut's
own guidebook. As to whether she has changed allusions to the nut,
that's another matter.

Tashjian refutes accepted theories of evolution when she pro-
claims that man descended, not from the ape, but from the nut. She
has written a nut anthem, and she has a series of sheet aluminum
sculptures hither and yon on her grounds and in her house. The
sculptures represent such things as the world's largest nutcracker,
which hangs from a tree, and a tongue—for tasting nuts—beneath
another tree.

Two rooms in her house, a Gothic Victorian with an ever-so-
slight eeriness about it, are devoted to an odd array of her paintings
and to raw, brassily colored, and offbeat sculptures, some of which
are sexually suggestive and all of which are nut-related—nut carv-
ings, nut jewelry, and nut toys. But, truly, the most interesting thing
about the museum is the owner-curator herself, who is voluble about
nuts, about all her television appearances, about all the newspaper
articles written about her. She lifts her voice in a loud falsetto and
even sings about nuts. She is eccentric, and when she covers her face
with an almond mask she has made of foam rubber, she even looks
like a nut.

This museum calls for a brief visit. There are no special provi-
sions for the handicapped. I don't know what to say about taking
children. It could be unsettling to sensitive youngsters or it could be
amusing.

ᨆ Painted Chairs ᨆ

HITCHCOCK MUSEUM
Riverton, Connecticut 06065
Phone: 203-379-1003
Director: Ellen Glennon
Hours: June through October, Wednesday through Saturday
 11:00–4:00, Sunday 1:00–4:00; April and May, Saturday only,
 11:00–4:00
Directions: Riverton is northwest of Hartford. On Connecticut Route
 8 north of Winsted look for Route 20 to Riverton. Follow signs
 to the museum.

Anyone who knows American antique furniture knows the name Hitchcock. While Eli Whitney was making interchangeable rifle parts and Eli Terry was making interchangeable clock mechanisms, Lambert Hitchcock set his mind to mass producing furniture. He built his factory here in 1818 and made chair parts and chairs that sold for anywhere from 45¢ to $1.75. Ten years later his factory employed more than a hundred people and was producing fifteen thousand chairs each year.

Although these Hitchcock chairs were mass produced, don't think for a moment that they were plain old chairs. On the contrary, they were very fancy indeed. They were elaborately hand decorated, and Hitchcock pioneered in the process of stenciling. As many as five stencils were used to embellish the backs of some of these wooden chairs.

The building that houses this museum is an old church that Hitchcock had built and was married in. The best way to start a tour is by going up to the second floor and watching a movie that provides a history of chair making in this small town, which was once called Hitchcockville. You will hear that when a chair was finished in the factory, it was dropped down from the second story to a waiting wagon and, if it survived the drop, it was ready to be signed and warranteed as a genuine Hitchcock.

Sadly, the manufacturer fell on hard times and died penniless in 1852. But a hundred years later a man by the name of John Tarrant Kenney came upon the abandoned factory and restored it to making Hitchcock chairs, which it still does. He opened the museum in 1972.

After I watched the movie, my appreciation of the furniture on

Elizabeth Tasjian ▶
Nut Museum, Old Lyme, Connecticut

display downstairs was greatly enhanced. Many chairs were ornamented in the Hitchcock fashion, and all of the chairs, benches, rocking chairs, and other pieces we were instructively labeled. I was particularly taken by two lovely arrowback Windsor chairs (1824–30), which look pretty uncomfortable—unless you like to sit on the edge of the seat—but which are elegantly shaped and prettily decorated with stylized leaves and a red design that may be a strawberry, or a flower, or just an abstract shape.

Children under the age of twelve must be with an adult. The tour plus the fifteen-minute film will take almost an hour. There are no provisions for handicapped visitors.

⨯ Locked Up ⨯

LOCK MUSEUM OF AMERICA
130 Main Street (Route 6), P.O. Box 104
Terryville, Connecticut 06786
Curator: Thomas F. Hennessy
Phone: 203-589-6359
Hours: May through October 1:30–5:00; other times by appointment
Directions: Terryville is west of Bristol. From Connecticut Route 8
 take Route 6 east into Terryville. The museum is on Route 6,
 next to the town library. Or from Route 84 take Route 229 to
 the end, then pick up Route 6 and travel west into Terryville.

Yes, there really is a lock museum, and you have to see it to realize just how long and various the history of locks really is. Consider, for example, a four-thousand-year-old Egyptian pin tumble lock. It's right here. Also here is a dog-collar lock of much more recent vintage but much less clear-cut need (you could still steal the dog but you had to take the collar?).

Terryville was for many years the home of the Eagle Lock Company. The factory was across the street from the museum, a site now occupied by a shopping mall. Two women arrived to oversee the museum for the afternoon when I visited, and they said that a large group of senior citizens volunteers time to keep the museum open. One of the women had a special interest in the collection—her father used to work at the Eagle company.

The museum's grand opening took place in 1972; it moved into a new building in 1980, and today the collection is installed on two floors. There are tumble locks old and new, fancy and plain. There

are padlocks and there are mail locks: the Andrus U.S. mail lock was invented by Burton Andrus, former superintendent of the U.S. Mail Service Department in Washington, D.C., and former Eagle employee. This lock is in the center of a brass eagle: the keyhole is a shield on the bird's chest. The eagle must have had double symbolism in this instance.

There are old colonial locks on display and there are some pretty serious looking safe locks. There is even a lock sculpture—a gigantic wooden padlock that was fashioned by an art student and donated to the museum.

In one of the upstairs rooms is evidence of how fancy locks can become. Some in the series of door knobs and escutcheons are elaborately ornamented. One knob is a brass lion's head; another beautiful object, from the Russel & Erwin Manufacturing Company, is a nineteenth-century brass enameled in royal blue. In the Yale room are several locks with built-in alarms. The alarms are brass bells.

Young children won't be interested in this museum. Adults who are should plan to spend half an hour or so browsing. There are no provisions for handicapped visitors.

∿ Lamplight ∿

KEROSENE LAMP MUSEUM
100 Old Waterbury Turnpike (Route 263)
Winchester Center, Connecticut 06094
Phone: 203-379-2612
Curators: George L. and Ruth R. Sherwood
Hours: Daily 9:30–4:00
Directions: From Connecticut Route 8 exit at Winsted (north of Torrington), and pick up Route 263, which will wind you around but take you to Winchester Center. You can't miss the museum, which is on the green, in the center of Winchester Center.

Winchester Center is a small community in a picturebook New England setting. The museum, which has been open for three years now, is right on the town green in a building that was previously a post office, before that a general store, and before that a mill.

Ruth Sherwood was a teacher and her husband, George, was an engineer. When they bought their house thirty or so years ago, it included some kerosene lamps, very handy for not-infrequent instances

when the electricity went out. Those old lamps sparked their interest, and before they knew it they were collectors. Now retired, they have their collection, which is up to five hundred pieces, in the former post office next door to their home.

You walk in to find lamps hanging from the ceiling, attached to the walls, covering every surface on which they can be set and filling every space that can be filled—and then some. It looks a little like Fibber McGee's closet. George Sherwood is happy to describe the particulars of each of his lamps and to demonstrate how some of the more unusual ones are operated.

There are lamps that innkeepers used with burners that would keep the light on long enough for a patron to get to bed, but not long enough to read in bed. The Sherwoods have a couple of so-called angle lamps in which the burners are on sides and angled so that the oil wouldn't spill if the lamps were used in railway coaches, for example. And they have a very nice old whale oil lamp that was made in 1834, but they don't know much about it yet. They do plan to try and track down its history.

This hobby has led the Sherwoods into research. When you visit the museum, you may pick up an article that Robert Sherwood wrote; it tells how the oil-refining process led to the use of kerosene lamps. The period covered by their collection is, according to this article, from 1856, when the kerosene lamp first came into use, until 1880, when Edison produced the incandescent lamp. Although the jumble of lamps has a charm of its own, the museum owners are hoping to set up one of the upstairs rooms to look like a Victorian parlor, with lamps in appropriate places.

Rambunctious children could do a lot of damage here, so it's probably best to exclude them from this museum. It is also not accessible to handicapped visitors. A tour conducted by George Sherwood could take up to an hour.

ᑯᓀ Aircraft Everywhere ᑯᓀ

NEW ENGLAND AIR MUSEUM
Bradley International Airport
Windsor Locks, Connecticut 06096
Phone: 203-623-3305
Curator: Phillip C. O'Keefe
Hours: Daily 10:00–6:00

Directions: Windsor Locks is north of Hartford. From I-91 take exit
40 for Bradley Field and follow it toward the airport. You will
see signs directing you to the museum.

In 1979 a tornado ripped through New England and in its path of
devastation scattered antique planes at Bradley Airport like dry au-
tumn leaves. Since then the aircraft and the museum have been ren-
ovated. In 1980 a new building housing the collection was opened. It
is one of the nation's four major museums of aviation history. The
only other in the Northeast is the National Air and Space Museum
(see page 244) in Washington, D.C.

The approach to the Windsor Locks museum building is
strange. You seem to be driving across a vast wasteland; you find
yourself parallel to a runway and probably witness to the takeoff of
one of the airport's commercial flights. When you finally arrive at
the museum building, a hangarlike space, you'll find it chock full of
aircraft. As you enter, you see a Bleriot XI monoplane from 1909 sus-
pended from your head, with fabric wings and wheels that look as if
they were borrowed from someone's tricycle. Yet this plane and be-
hind it the 1929 Heath Parasol (designed as a "safe, economical, reli-
able aircraft") have an elegance of design and workmanship that
their wooden propellers seem to embody.

There is also an extremely well-mounted exhibit on the life of
helicopter-developer Igor Sikorsky, traced from his youth in Russia
to his pioneering work in developing the first practical helicopter to
enter mass production.

When we consider the airplanes we board to travel across conti-
nents today, this collection serves to remind us how recent the devel-
opment of the aircraft industry really is, and how linked to warfare.
There are World War II bombers; there is the F-100A Super Sabre,
developed in 1954 as the world's first production supersonic fighter
and used by the U.S. Air Force. There is a huge F-105, camouflaged
for jungle warfare and nicknamed "Thud," which became legendary
because of the number of times it completed missions and returned
to base although severely damaged. One startling relic is an enor-
mous passenger module that looks like a bus but is the cabin of a
Goodyear blimp, vintage 1942.

Altogether you'll find forty to fifty airplanes inside and more
outdoors, where aircraft and parts of planes are kept for repair. Some
kids love this stuff. It looks pretty accessible to handicapped visitors.
Give it about an hour.

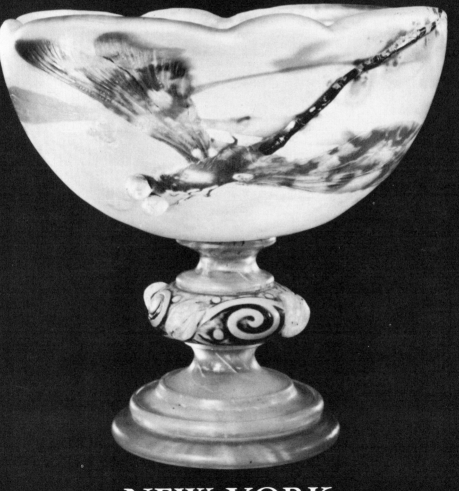

NEW YORK

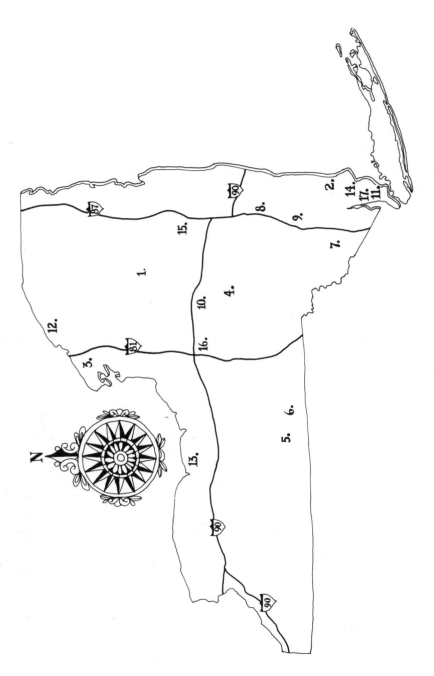

Numbers on map refer to towns numbered on opposite page.

ᘒ New York ᘒ

⮞ The Adirondacks ⮞

ADIRONDACK MUSEUM
Route 30
Blue Mountain Lake, New York 12812
Phone: 518-352-7311 or -7312
Director: Craig Gilborn
Hours: June 15 through October 15, 10:00–6:00
Directions: Blue Mountain Lake is south of Lake Placid and a couple
 of hours north of Albany. From the New York State Thruway
 (I-87) take the Warrensburg exit and Route 28 north. At
 Indian Lake pick up Route 30 north, which will take you right
 into Blue Mountain Lake. The museum is along the highway.
 From I-90 in Utica take the exit for Route 12 north. Follow 12
 to Route 28, which goes northwest in the Adirondack Park to
 Blue Mountain Lake.

It is simply impossible to exaggerate the merits of this museum.
 The site it occupies is beautiful, on a mountaintop with a view
of a lovely island-studded lake. The number and variety of exhibits
are exceptional, difficult to imagine, and impossible to describe with
any semblance of doing them justice. Let a few abstractions begin to
hint at the scope: there are twenty buildings on the western slope of
the Blue Mountain in a thirty-acre area in the middle of the largest
park in the United States. The museum is devoted to telling the his-
tory of the region, which it does with style and imagination. For ex-
ample, one small building is devoted to photographs, which are not
framed and hung on the walls, but rather displayed on a moving belt
that makes an elliptical turn around the room. Seats are provided so
that you sit down for the amount of time it takes you to watch
prints of 160 old photographs parade before you. There are mountain
views, deer, a picture of a dentist working on a patient in the corner
of his parlor while another patient awaits her turn nearby, pictures of
the hotels and camps, of the people who lived, worked, and vaca-
tioned in the Adirondacks during its heyday from the late nineteenth
century to the 1930s.
 Another exhibit shows rustic furniture—which doesn't mean a
rough pine table and chair. Ernest Stowe, for instance, used white
birch veneer and small birch branches as if he were inventing a
woodsman's version of marquetry. Mining and smelting iron were
Adirondack industries, and a very interesting exhibition demon-

strates, through dioramas, models, diagrams, and forged objects, the whole process. Logging, milling lumber, and harvesting ice are explored, and the Adirondack guideboat is especially featured. Paintings by great artists, including Thomas Cole and Arthur Tait, are in the collection. There are horse-drawn vehicles of every kind, from hearses to log carriers, buckboards to sleighs. Even harness making is carefully illustrated—a full-size model of a harnessed horse is next to a bank of buttons and lights. Press any one of eleven harness or eleven bridle buttons and the part of the harness or bridle named will light up on the model.

The richest families in America vacationed in the Adirondacks. They often headed north in their own private railroad cars. One of these furnished Pullman cars is on display, and what a strange sensation it is to walk through the wood-paneled, lavishly decorated car, what a sense of envy of an era and of a way of life that was never possible for most of us. There is also the very carriage that sped Theodore Roosevelt down the mountain to the railroad station on the night he learned that President McKinley had died and that he, Roosevelt, was the next president.

This really is a successful, exciting museum. A typical visit is three and a half hours long. It is a wonderful place to take children. It is accessible to handicapped visitors.

༺ Harlem, Borden, & Tilly Foster ༻

SOUTHEAST MUSEUM
Main Street
Brewster, New York 10509
Phone: 914-279-7500
Administrator: Robin Imhof
Hours: Tuesday and Wednesday 12:00–4:00, Saturday and Sunday
 2:00–4:00, or by appointment
Directions: From I-84 take the Brewster exit and follow the signs into
 town. The museum is on Main Street, on the lower level of the
 Old Town Hall.

There are a few very special items and a few very special people determined to put this museum on the map. The village of Brewster is in the township of Southeast, and four permanent exhibits highlight the area's history. Unless you are a circus enthusiast, a rock collector with special interests, a railroad buff with a particular passion for the Harlem Line, or someone who has, for some reason, a burning desire

to see the desk Gail Borden used, you probably won't travel across the country to visit this museum. But . . .

During the nineteenth century this area was winter quarters for some of the early, pre–Barnum and Bailey circuses. A lot of townsfolk worked as trainers, clowns, cooks, and even performers. All traces of the circus were gone until someone found a carved wooden piece, painted with gold, that looks exactly like part of a howdah, a carrier seat that used to sit on an elephant's back. The museum also has a carved eagle's head that is from the back of a calliope-wagon driver's seat. Both items are rare finds, and both date back to the 1870s. According to Pat Barber, one of the museum's guiding lights, the staff is researching the provenance of these pieces and is hoping to have them mounted so that they will not deteriorate any more.

Although Gail Borden was not originally from Brewster, he found the town a good place to establish his condensed-milk company. In addition to his desk, the Borden corner has old milk bottles and a charming toy Borden Milk wagon. Incidental information reveals that Borden also invented dehydrated foods, although his dried meat was not at all successful.

The distinction of the mineral collection is that all the specimens were found at a single site, the Tilly Foster iron mine. That assemblage represents more minerals from a single site than one should ever expect to find. As for the Harlem Line, the museum has old photographs of wrecks and stations and a coal tipple and a switch tower, and old timetables. The staff refuses to part with these items, which some railroad organizations have tried to talk them out of.

Finally, as a sort of embarrassing aside, the museum has a collection entirely inappropriate to its historic mission but quite attractive to a knickknack lover—a collection of about three hundred ceramic salt and pepper shakers disguised as children and animals and all sorts of funny things. Staff members haven't found a rationale for keeping the collection right there, but I hope they will.

It takes half an hour or so for browsing. I doubt that small children should be brought along.

∿ Wooden Boats ∿

SHIPYARD MUSEUM
750 Mary Street
Clayton, New York 13624
Phone: 315-686-4104

Director: F. I. Collins Jr.

Hours: May 14 to June 17, Thursday through Monday 10:00–4:00.
June 18 to September 9, daily 10:00–5:00. September 10 to
October 14, Thursday through Monday 10:00–4:00.

Directions: Clayton is a town in the Thousand Islands area of the
Saint Lawrence River. From I-81 take 47 north or exit 50 south
onto Route 12 into Clayton. At the stop light in the center of
town go straight ahead if northbound. If southbound, turn right
onto James Street. Go two blocks to Mary Street and turn left
to the museum.

Gold Cup powerboat racing on the Saint Lawrence Seaway must
have been tremendously exciting. In 1904 George Boldt raced a
39½-foot-long boat that had a cigar-shaped hull (the shape lessened
the drag as she cut the water). She was an absolutely beautiful, sleek
boat. He named her *P.D.Q.* because he meant for her to travel Pretty
Damn Quick, and she did. Boldt is the man who started building a
castle for his wife in Alexandria Bay. His wife died while it was
under construction and he abandoned the project, which is now an
eerie tourist attraction.

Another racer, a 1938 craft called *Miss Canada,* looks like a
spaceship. Rarely do you see wood polished to such a finish. She won
the President Cup in 1939, setting a record at 119 miles per hour.
Later, with a different engine, she hit 140 mph.

This is a museum with a mission—conservation of antique
wooden boats. The staff also does restoration work, puts on educa-
tional programs, gives boat rides in an antique craft, and sponsors an
antique boat show.

Besides racing boats there are half-hull models and an interest-
ing tribute to Homer Dodge, a man known as the dean of white-
water canoeing. The museum has documented his adventures and
has pictures of his last trip, at the age of ninety-one. Dodge died in
1983 at ninety-six.

Allow forty-five minutes to go through the museum. Parts of it
may interest children. Handicapped visitors can be accommodated.

ᴓᴔ Farm Life ᴓᴔ

FARMERS' MUSEUM
New York State Historical Association
Lake Road
Cooperstown, New York 13326
Phone: 607-547-2533
Director: Daniel R. Porter
Hours: April, November, and December, Tuesday through Sunday
 10:00–4:00. May through October, daily 9:00–6:00. Closed
 January through March, except to school groups by
 appointment.
Directions: Cooperstown is in central New York state, seventy miles
 west of Albany, thirty miles south of the New York State
 Thruway. From the west, use exit 30 at Herkimer and take
 Route 28 south to Cooperstown. From the east, use exit 29 at
 Canajoharie and take Route 5S to Fort Plain, then Route 80 to
 Cooperstown. Combined admission for Cooperstown's three
 museums is $9 per adult, $3 per child. Combination tickets for
 two museums range from $6.25 to $6.75 for adults and are $2.25
 for children. Single admittance is under $5 for any of the
 museums. If you enter Cooperstown from the west on Route 80
 you will see this museum on the right. If your approach is from
 the east, look for Route 80 west out of town: the museum will
 be on your left.

In one of the exhibits at the Farmers' Museum is a stump puller—a
machine with a chain and wheel that, using a pulley principle,
wrenched tree stumps out of the ground. In fact, there is a stump
right next to that machine to dramatize the principle. There were no
bulldozers and backhoes in the pre-industrial days of this exhibit, and
no chain saws or pickup trucks. What the settlers had to do to make
the forest into farmland is vividly illustrated here. Tools are paired
with graphic demonstrations, often by means of old lithographs
blown up to life size, of what they did and how they worked.

 From an educational point of view this museum, administered
by the New York State Historical Society, is incomparable. The
main exhibit hall was once a dairy barn. Besides displaying the tools
used to tame the land and the struggle to establish modern agricul-
ture, the museum has, upstairs in the loft, a woodworking, spinning,
and weaving area where people are actually working at the crafts. We

◀ Great Moments Room
 National Baseball Hall of Fame, Cooperstown, New York

even surprised a barn cat fast asleep in some handsome woolen yard goods. Other buildings on the grounds—a church, tavern, country store, offices, and schoolhouse—show the activity of a small New York village during the nineteenth century.

The collection of farming implements is, however, what singles out this museum from the point of view of specialized collections. These objects range from butter churns and molds to one of Cyrus McCormick's grain reapers, from a dog-powered treadmill to a grain cradle, wagons, axes, scythes, planes, pitchforks, harrows, and apple peelers.

A couple of hours here, which children will find interesting too, will pass quickly. There are provisions for handicapped visitors.

ᙟᓅ Folk Art ᙟᓅ

FENIMORE HOUSE
New York State Historical Association
Lake Road
Cooperstown, New York 13326
Phone: 607-547-2455
Director: Daniel R. Porter
Hours: May through October, daily 9:00–6:00. November and
 December, Tuesday through Sunday 10:00–4:00. January
 through April, closed except to school groups by appointment.
Directions: Fenimore House is across the street from the Farmers'
 Museum. If you enter Cooperstown from the west on Route 80,
 you will see this museum on the left. If your approach is from
 the east, look for Route 80 west out of town: the museum will
 be on your right.

This museum has one of the country's finest collections of folk art, second only, it is believed, to the Abby Rockefeller collection in Williamsburg, Virginia. Paradoxically, a layman's eye is usually pretty sophisticated before folk art begins to have an appeal. Many people find the odd proportions and stiff demeanor of folk paintings uncomfortably stilted. But once you develop the taste for these primitive, idiosyncratic works by artists who usually did not have formal training, this museum is definitely inspiring.

Two works that I found entirely irresistible were paintings on the museum's second floor, large canvases, each of which had a young girl in a red dress. One is called *Walking the Puppy,* the other is

Picking Flowers. The girls are both stiff, oddly proportioned, and awkward. They are set against different backgrounds—one the woods, the other a white house by a pond—but they have the same flowers and tree nearby, and even the same yellow bird in the branches. The puppy in one is replaced by a striped cat in the other. As peculiar, flat, and humorous as these portraits are, they are also wonderfully attractive. Both are attributed to an artist named Samuel Miller and are thought to have been painted around 1845. In those days, remember, the traveling artist painted the family portraits for which today we usually go to photographers.

Besides paintings there are sculptures, often originally carved as store signs and advertisements. There are weather vanes, decoys, and domestic items like a fabulous quilt with a star of Bethlehem in the center in meticulous stitching and made up of bright reds, blues, yellows, golds, and greens. There are also Eunice Griswold Holcombe Pinney memorial paintings in which the family is portrayed mourning the departed at the site of the tombstone, women weeping into their handkerchiefs, men holding their brows.

Besides the folk art collection (which, incidentally, has contemporary artists represented), there are memorabilia of the family of James Fenimore Cooper, to whom this house belonged and after whom the town was named. There are also changing exhibits and a slide presentation.

Save an hour and bring children who won't be inclined to run around. There are provisions to accommodate the handicapped.

๛ Ballgame ๛

NATIONAL BASEBALL HALL OF FAME AND MUSEUM
Route 28, P.O. Box 590
Cooperstown, New York 13326
Phone: 607-547-9988
Director: Howard C. Talbot, Jr.
Hours: May 1 through October 31, 9:00–9:00. November 1 through
 April 30, 9:00–5:00.
Directions: The museum is on the main street that runs through the
 center of town. Look for signs.

In a way, it's incongruous. Here you are in a great hall with marble columns and polished terrazzo floors, and along the sides of the room are alcoves with embossed bronze plaques. All of the plaques,

and those on the great pillars in the center of the hall, are in honor of a hero, like Harold Henry "Pee Wee" Reese. You might expect royalty or maybe Louis Pasteur here in such decor. But Pee Wee Reese?

This is an exciting, lively museum. I have no interest in the game (un-American as it may seem, I have never sat through a whole one live), but in this museum the art of exhibiting reaches its peak. If I had no a priori interest in baseball, I am fascinated ex post facto. Why?

The hall of fame itself sets an elevated tone. Beyond that, you have four floors (counting the lower, basement level) of displays: the uniforms of today's twenty-six major league teams, memorabilia and photographs of Casey Stengel's career, displays on the evolution of equipment, and videotapes of the important games that have happened since cameras could record them.

I had already seen the Babe Ruth museum (see page 223) in Baltimore before I arrived in Cooperstown, so I had discovered that the Babe, who was born in Maryland, didn't play for the Orioles. Here, looking at a display devoted to the Boston Red Sox, I saw a photo of a proud Ed Barrow in morning coat and derby hat and learned that in 1918 he was the coach who decided that ace pitcher Babe Ruth had star potential. In the same case was a tribute to Harry Hooper, the spectacular outfielder whose bat, a Louisville Slugger, and heavy maroon sweater were here for all to see.

I looked at all the baseball uniforms, beginning with those that were made of wool and had long sleeves, and I looked at baseball cards, which first showed up in tobacco packets around 1877, and I ended up believing in baseball. Judging by the crowds, I think a lot of people discovered this sport before I did.

You could spend a couple of hours here. Children seem tremendously enthusiastic. The museum accommodates handicapped visitors.

⌘ Glass Universe ⌘

CORNING GLASS CENTER
Centerway
Corning, New York 14831
Phone: 607-974-8271
Director: John D. Fox, Jr.
Hours: Daily 9:00–5:00

Directions: Corning is in the Finger Lakes region of the state. Take
the Southern Tier Expressway (New York Route 17) into the
center of Corning, where signs direct you across the bridge to
the Glass Center.

There are two museums in the city of Corning, but when residents
talk about "*the* museum," there is no question which one they are
referring to.

The Corning museum is to glass as the Metropolitan Museum
of Art is to paintings, or as the Smithsonian is to all collections. It is
the beginning and the end; it has everything glass that can be imag-
ined. It is vast and varied and excessive, an entity impossible to de-
scribe other than to say, with no pretense at sophistication, that this
museum is unparalleled.

Still, dazzling as it is, some important particulars should be re-
corded. You can learn everything about glass here: the history, the
manufacturing processes past and present, and the ways glass has
been used, from ancient vessels and beads to contemporary telescopes
and heat shields for spacecraft. A tour permits visitors to watch fine
Steuben crystal being crafted. Not only is every possible angle on
glass explored, using almost every method devised by museum de-
signers, but the whole thing is exciting, from walking into the vesti-
bule and confronting your reflection in a gallery of glass art to
discovering that you can (bargain hunter alert!) buy Corning prod-
ucts, often at some great savings.

Here are just a few things that caught my attention. A piece of
ancient glass is secured in a plastic container with the bottom left
open so that you can run your fingers over the sandy, pitted base of it
and know that you are touching something that is many centuries
old. A large Venetian basket from the late seventeenth century,
about three feet wide, is made of minute beads that have been woven
into colorful leaves, flowers, fruits, and a lad and maiden. An outra-
geous table has heavy, turned legs that should be made of oak but are
glass instead; sitting on the marble table top is a fanciful glass boat
with cherubs riding in it. Candlesticks of yellow uranium glass have
a Geiger counter in the case reading out their radioactivity. A Benja-
min Franklin glass Armonica, made in 1761, is played in concert by
pressing fingers against the glass bells lined up along a metal shaft.
Press a button and hear an excerpt from Mozart's Adagio in C Major
played on that instrument. A glass chess set pits Jews against Catho-
lics. An artist named Edwin Eisch created a series of glass heads of a
man named Littleton, who appears as a poet, a gentleman, and a

spirit (as a spirit he has an indentation in his skull where the brain was, and a landscape is painted onto his head).

The only exhibit that left me with unanswered curiosity was one that promised "Future Display, Magic Glass Show," but it was all closed up. I couldn't figure out whether the future didn't exist or the magic wasn't working. Never mind. Even without that, the Corning museum is one of the premier museums in the world. Children may become satiated sooner than adults, but there is enough to interest everyone. There is almost too much to absorb in a single day. The time you spend there can range from one hour to several. It is accessible to handicapped visitors.

༒ The Old West ༒

ROCKWELL MUSEUM
Cedar Street at Denison Parkway
Corning, New York 14830
Phone: 607-937-5386
Director: Michael W. Duty
Hours: September through June, Monday through Saturday 9:00–5:00, Sunday 12:00–5:00. July and August, Monday through Friday 9:00–7:00, Saturday 9:00–5:00, Sunday 12:00–5:00.
Directions: Follow Route 17 (Denison Parkway) to the center of Corning. Turn right on Cedar Street. The parking lot is opposite the museum.

The excitement, the solitude, the honor and humor, the majesty, mystique, and meanness of the American West—on the third floor of a handsome brick building in downtown Corning, New York, all this comes alive. How did a collection of western art and artifacts make its way east? Robert Rockwell spent his childhood days on a cattle ranch in western Colorado and his adult years in Corning, New York. He decided to start collecting western art in 1960, and the first painting he bought, signed Frederic Remington, was a fake. Undeterred, but more careful, he continued his pursuit and in 1982 was able to install his collection in the restored old Corning City Hall. The Rockwell collection is the most extensive collection of western art this side of the Mississippi.

Among the drawings, watercolors, paintings, and bronzes are some gigantic canvases that stop you in your tracks. The *Great Buffalo Hunt,* painted in 1947 by William R. Leigh, 10½ feet wide by

6½ feet high, is one of the largest, but its knockout effect has more to do with the subject than with the size. A herd of buffalo is stampeding. The one in the foreground whose head seems to be bursting out of the picture is under the arrow of an Indian on horseback. Everything is in raging motion, and a strange, luminous orange is used to light the charging buffalo's head, making it seem as though the earth below his hooves is on fire. By way of contrast, another of Leigh's works, *Master of His Domain* (circa 1920), portrays an Indian sitting perfectly still and deep in thought at the edge of a cliff.

Works of the most famous western artists, Remington and Charles Russell, and romantic landscapes by Albert Bierstadt are in the collection. There are wonderful bronzes, including the famous Remington castings in which the horses are bucking furiously and the cowboys are holding on for dear life.

The buffalo hunt was a popular theme for many artists. Along one wall, however, the hunt is executed in an unusual oil painting using only black and white. Even more of a surprise is the signature of the artist: Norman Rockwell.

On the floor below the western works is an exceptional collection of Steuben glass manufactured under Frederick Carder's direction between 1903 and 1933. The colors and forms provide a glimpse of the decorative-art styles of those years. Also in the museum is a collection of antique toys.

Children and adults will find much to absorb their interest here. Save at least an hour for a thoughtful, enlightening visit.

↻ Soaring ↻

NATIONAL SOARING MUSEUM
Harris Hill, RD 3
Elmira, New York 14903
Phone: 607-734-3128
Director: Shirley Sliwa
Hours: Daily 10:00–5:00
Directions: Harris Hill is outside Elmira, just a little southeast of
 Corning. From New York Route 17 take exit 51 and follow
 signs for Harris Hill Park and the museum.

Climb into the cockpit of a canary yellow Schweizer with a black racing stripe along the side, straddle the stick, and read the instru-

ment panel: the oxygen level, the air speed, and the terrestrial mag-
netism on the variometer. The sides of the glider are snugly close.
Take a deep breath, and climb back out.

Even if you have no inclination actually to go gliding (the
Schweizer is well grounded and wingless inside the building), you
may still find this museum devoted to motorless flight interesting.
You may well hear planes with gliders in tow taking off at regular
intervals outside. Harris Hill is not just the site of a museum, it is
also headquarters of a soaring field from which sailplane rides take
visitors braver than I traveling on air currents high above New
York's Chemung Valley.

The building that houses the museum was designed by one of
the country's foremost architects, Eliot Noyes, and the exhibits are
well designed and laid out. Two beautiful wooden sailplanes hang
from the ceiling. One of them, the *Minimoma,* has wings that resem-
ble those of a gull, and their span is 55.9 feet.

There are drawings and paintings—an oil called *Pink Dawn at
8,000 Feet* by Eric Sloane was donated to the museum—and a variety
of displays describe the history of soaring. To illustrate how, during
the early 1930s, sailplanes were sent aloft by a "bungee launch" (the
principle is that of a giant slingshot), a small diorama shows two
lines attached to a glider: four people are pulling on one side, while
one is down and three are still pulling on the other. A glimmer of
humor is a nice touch, even when the subject is lofty.

In one part of the exhibit is a chunky old GM truck with a
winch on its bed. The truck, which first appeared on Harris Hill in
1937 to take part in a soaring contest, was designed by E. Paul du
Pont, and you will note a sign on the winch that reads "Danger,
Keep Hands Away from Guillotine." If the hook failed to release the
tow line, the guillotine would serve to chop it.

The science, the history, the romance, the exhilaration, the art,
the future, the rewards, and the awards of soaring are all here.
Among the awards, the one I liked best was a bronze trophy that was
a pilot's head with wings for ears—even Hermes didn't have such
large wings on his helmet. It is called "Winged America," and the
lettering on it reads "America Gave Wings to the World." Which
makes anyone just stop and think.

The museum is attractive to people of all ages and should take
about half an hour of browsing. Besides the pleasures of soaring, or
just plain looking over the edge of Harris Hill, there is also a large
park for picnicking.

∾ Trotters ∾

HALL OF FAME OF THE TROTTER
240 Main Street
Goshen, New York 10924
Phone: 914-294-6330
Director: Philip A. Pines
Hours: Monday through Saturday 10:00–5:00, Sunday and holidays
 12:00–5:00
Directions: From I-84 take the Maybrook exit. Follow Route 208
 through the village of Maybrook, go over a bridge, look for the
 caution light, and turn right to continue on the road for about
 three miles. Go through the tiny hamlet called Campbell Hall,
 and turn right onto Route 207, which, in about five miles, will
 take you into Goshen. The museum is right in town, on the
 left-hand side of the street.

Lesson One: Trotters are diagonally gaited. Their right front and left
rear legs will move in the same direction at the same time. (Pacers
are not diagonally gaited.)
 Lesson Two: Trotters pull a peculiar contraption called a sulky
in which the driver, dressed in colors much like a jockey, rides. The
sport is called harness racing.
 Lesson Three: Harness racing is an American sport.

 Now you're on your own. This is one of the best specialty muse-
ums you'll find. Besides the history of the horse, back to its five-toed
prehistoric ancestors, there are homages to more recent relatives.
First is the Great Granddaddy of Them All, a horse named Messen-
ger, who was foaled in 1790 and was buried with military honors
when he died. In 1849 the Granddaddy of Them All, a horse named
Hambletonian, was foaled. He was never a race horse but he spent
twenty-four years at stud and sired about 90 percent of the pacers and
trotters on the tracks today.
 The building that houses the hall of fame was once a stable, and
the horse stalls have been made into galleries. Behind this building is
the historic race track where trotters were first raced in 1838. Exhib-
its trace the development of the sport, the development of the sulky,
and an extraordinary collection of statuettes of people important to
harness racing in characteristic racing or business or casual clothing.

No women seem to be present, at least not as drivers, but nothing else is missing.

In fact, people who are fond of Currier and Ives may know that Currier and Ives were fond of trotters. The museum has a large collection of their prints and original oil paintings.

My favorite object is not well documented but surely piques my curiosity. It is a track scene carved out of wood with the title "Under the Wire." One of the drivers in the lead has fallen out of the sulky, which has lost a wheel. Three drivers coming along the stretch are pulling ahead and watching one another. It's a loaded moment. Apart from the educated guess that the era is about 1920 and the knowledge that the carving was found in an antique store in Maine, nothing is known about it.

Adults who are really interested in this sport could spend a couple of hours here. Children will also find a lot of interesting things, especially if they love horses, and children don't. Most, but not all, of the museum is pretty easy to get around.

ᓚ Fire Brigade ᓚ

AMERICAN MUSEUM OF FIRE FIGHTING
Harry Howard Avenue
Hudson, New York 12534
Phone: 518-828-7695 (phone is in the Firemen's Home office)
Hours: April through October, Tuesday through Sunday, 9:00–4:30,
 closed Monday
Directions: From the New York State Thruway (I-90) take exit 21 at
 Catskill and follow Route 9 west. Follow signs to the Rip Van
 Winkle Bridge, which you'll cross, and then signs into Hudson.
 On the east side of the river, take either Route 9 or the Taconic
 State Parkway and Routes 82 and 83 into Hudson. In Hudson
 follow signs to the Firemen's Home on Harry Howard Avenue.

This museum qualifies as one of the biggest and best surprises. It was really not a top-priority museum on my list, but I was never so glad I went out of my way as I was when I discovered this treasure house. The spirit here is right up front. In fact, the minute you walk in the door you encounter the statue of a fire chief. This fellow, dressed in a blue coat with red lining, high rubber boots, and a wide-brimmed fireman's hat with a huge gold shield, is calling through his trumpet,

which he is holding in one hand, while signaling with his other arm. Clearly he's directing his men. This "priceless hand carved wooden statue" (circa 1850) is, in the opinion of experts and according to the curatorial note, "undoubtedly the finest carved wooden figure of a fireman in the country." It stood in front of a firemen's association on Coney Island before it was lovingly restored, and it "fairly exudes the spirit of volunteer fire fighting."

In fact, the whole museum exudes that spirit, as does a wall plaque that reads "Our Duty is Our Delight." Just consider one of the engraved certificates, issued sometime between 1827 and 1861. It states that William B. Dunley was appointed "One of the Firemen of the City of New York." It is in a frame ornamented with fire hydrants that have curling hoses winding out of them.

An extraordinary silver-plated parade carriage wagon that dates back to 1870 has wheels about six feet in diameter and is topped by a statue of a fireman holding a baby. There are many representations of firemen either holding babies that they have rescued or carrying fainted maidens down ladders outside burning buildings.

The amazing collection of fire-fighting equipment ranges from hand-pulled to horse-pulled to mechanical wagons, from the ornate and elaborately decorated (with scenes like one of Pocahontas rescuing John Smith) to my very favorite, a bucket machine used in Brooklyn in 1840. It was hand pulled and carried forty buckets, all of which are set along its sides. "It was a racer," the label reads, "and shows marks of many upsets and collisions."

There is even a leaded, stained glass window, "believed to be Tiffany glass," with an old fire engine in the center, surrounded by flowers on a mauve glass background. There are liquid-filled glass balls, beautiful things that are, it turns out, fire extinguishers. There is an 1850 vintage weather vane with a fire wagon racing full speed ahead. There are firemen's hats of every style and beyond number; there are medals, uniforms, and the trumpets that were used to call orders, sometimes to start or settle brawls, and, with one end held closed, to hold a good measure of brew in the tavern after the fire was out.

There are objects of fascination and of history in this museum. It is a good place to take children, and you can expect friendly greetings from the elderly residents of the home that is right next to the museum. Give it an hour or so.

༝ FDR ༝

FRANKLIN D. ROOSEVELT LIBRARY AND MUSEUM
Albany Post Road
Hyde Park, New York 12538
Phone: 914-229-8114
Director: William R. Emerson. Curator: Marguerite B. Hubbard
Hours: Every day 9:00–5:00 except Thanksgiving, Christmas, New
 Year's Day
Directions: The museum is off Route 9 (the old Albany Post Road).
 Route 9 can be reached from I-84 east or west, or I-87 or Route
 44 north and south.

In a display is a wicker two-seater pony saddle, and in a photograph
above is a picture of little Franklin on it riding a donkey, with his
dog, Budgy, sitting next to him. It was the custom in those days for
little boys to wear their hair long, and his was first cut in 1886, when
he was five years old. A lock of his long, curly golden hair is in a
small box on a satin pad. A camera that he was given at the age of
fourteen is on a tripod, and his photo album is opened to images of
Strasbourg Cathedral in France. In 1905 he and his new wife,
Eleanor, sailed on the liner *Oceanic* for a three-month grand tour of
Europe. While they were in London the management of the Brown
Hotel insisted on confusing him with President Theodore Roosevelt
and assigned the couple a large, expensive suite. Franklin took a pic-
ture of it. He also took a picture of Eleanor in a gondola. Someone
else took a picture of Franklin changing a flat tire on a road some-
where along the Stelvio pass between Italy and Switzerland.
 What is the fascination of examining these relics of a great
man's past? They do provide a historic context, they allow us to
imagine the privileged life of a young Roosevelt, and they lead us to-
ward the adult years when he began to take shape as a person of con-
sequence. "Friends and associates regarded him as a pleasant, likeable
young man though some thought of him as a lightweight and, be-
hind his back, called him 'Feather Duster.' " That curatorial note is
an interesting introduction to the years when the man who would
later win four terms as president began his political career.
 Certainly the objects and memorabilia of his years as president
recreate the era. There is a Peter Arno cartoon done for the *New
Yorker* magazine that never was published. It shows the outgoing
president, a sullen-looking Herbert Hoover, riding in an open car

next to a widely beaming Franklin Roosevelt. After the attempt to assassinate Roosevelt in February 1933, the editors decided it would be in poor taste to run the drawing. There is, under a Plexiglas bubble, the president's old battered wide-brim hat—his "lucky hat." There are memorabilia of the Scottie, Fala, and the original copy of the speech in which FDR said that Fala hated war. There's also a copy of the famous inaugural address of 1933 in which he pronounced that the only thing we have to fear is fear itself. Two of his desks are on display. One is in the study of the library that he designed and planned but did not live to use after his presidency. The other is the desk from the White House just as he left it when he died. It is a wonderful jumble of small Democratic donkeys, Republican elephants, a ceramic Fala, and other bric-a-brac, or "toys" as he called them. There are also photographs of his four boys in their World War II service uniforms.

The FDR museum was opened to the public in June 1941. On May 3, 1972, an important addition—a wing containing a gallery devoted to Eleanor Roosevelt's life and career—was opened. Again, the clothing and objects used by an important person gain importance themselves—her christening outfit, a school desk and materials, her wedding veil, and, since she sewed and knitted, some of the tools she used and some of the things she made. The important work that she accomplished in the world is shown in, for example, a display emphasizing her United Nations role. But one picture here captures the significance of her life as nothing else does: after she died, cartoonist Bill Mauldin drew a scene with the billowy clouds of heaven and wide-eyed angels peeking over them, looking with anticipation in a certain direction as one angel exclaims, "It's Her."

The grounds here are beautiful and open to the public. At the time of my visit the house was still under repair after being greatly damaged by fire. It's a good museum for children, and you might want to spend several hours here. It is accessible to handicapped visitors.

ᦿ Firearms ᦿ

REMINGTON FIREARMS MUSEUM
Catherine Street off Route 5S
Ilion, New York 13357
Phone: 315-894-9961

◀ Hall of Fame of the Trotter
 Goshen, New York

Hours: Monday through Friday 9:00–4:30, May through October

Directions: Ilion is in the heart of New York's Mohawk Valley, just south of the New York State Thruway (I-90). Take exit 30 to Route 5s, which will take you into the center of town, where you will find the Remington Arms factory and the museum, which is in a new, red-brick building.

The Annie Oakley I admired sang with a gusty Midwestern twang that you can't get a man with a gun, and that anything he could do, she could do better. She was my kind of cowgirl. In this museum I found out that she used a Remington 22, and I saw one just like hers here.

I also saw how gun barrels are made and a full display of the historic and contemporary firearms manufactured by Remington, but nothing impressed me quite as much as seeing the kind of gun Annie used. More serious shooters than I am will probably like to see the first bolt-action gun the company produced in 1876, the world's first commercially produced high-powered pump-action repeater, all kinds of fancy presentation models, the classic 1873 Creedmore rifle, and the revolvers and pistols, including the 1865 double derringer, that, the company brags, kept many a notorious gambler "honest." Personally, I was interested in the Remington typewriter on display, like the one Mark Twain used.

This is a pretty small and particularly specialized museum. You can see it all in about fifteen minutes. It isn't for small children. There are provisions for handicapped visitors.

ᕦ Crafts ᕤ

AMERICAN CRAFT MUSEUM
40 West Fifty-third Street
New York, New York 10019
Director: Paul J. Smith
Phone: 212-956-3535
Hours: Tuesday 10:00–8:00 (admission free after 6:00), Wednesday through Sunday 10:00–5:00, closed Mondays and major holidays

The American Craft Council's museum will probably have an exhibition unlike any you have ever seen. Consider a silver and gold wristwatch of which the 1⅝-inch diameter dial is a circular conference table. Look closely and you see that men and women seated around the circumference have their papers in front of them and seem to be in animated conversation. This amusing piece, titled "It's Conference Time," is called a timeless watch. Another strange piece, called "Third World Civilian Ring," is made to fit on three fingers and holds a rocket being launched. A necklace that at first glance looks almost like a conventional silver and gold mesh piece is, in fact, made from safety pins and cotton thread. It is beautiful. Whimsical, strange, incomparably avant-garde, these pieces are part of a jewelry exhibit put on by the American Craft Council.

The watch, ring, and neckpiece were part of a jewelry show during my visit. Although the exhibit may be different when you visit, whatever it is will constitute something new and exciting in the most current craft design. Early in 1984, for example, a show entitled "The Robot Exhibit" traced the history of automation over three thousand years, putting R2D2 as well as space instruments like the Mars Lander and Viking III (of 1976) into perspective. "Art to Wear" presented clothing of colors, textures, and designs that challenge the imagination.

These are exciting things to see. There is no question that invention and creativity, as well as a devilish good humor, are still alive and well. Anyone who thinks of crafts as limited to candle making and needlepoint is in for a revelation. It won't take an hour to go through, and children may well find the themes less startling than adults do.

∽ Coins ∽

AMERICAN NUMISMATIC SOCIETY
Audubon Terrace
Broadway at 155th Street
New York, New York 10032
Phone: 212-234-3130
Director: Leslie A. Elam
Hours: Tuesday through Saturday 9:00–4:30, Sunday 1:00–4:00
Directions: The museum is in the Bronx, at 155th Street and
 Broadway.

Of the three collections on display at Audubon Terrace (see Hispanic Society of America, page 156, and the Museum of the American Indian, page 161), this is the most understated, but it is fascinating nevertheless. If, like me, you've never thought much about the money you carry around, you can discover a great deal. In fact, the money in my pocketbook has come to seem rather like a history lesson.

Although the U.S. Mint in Philadelphia and the Treasury Department Museum in Washington, D.C., provide information about manufacturing money, this museum collects coins of all eras and all countries and uses them to tell stories about the life and times in which they were used. For instance, the first coins used in China between 1000 and 500 B.C. were cast in molds in the shapes of the knives and spades that had previously been used as money.

An exhibit called "The World of Coins" divides the history of coinage into three main phases: ancient, medieval, and modern. The exhibit is enlivened by a computer terminal that allows visitors to follow up their interest in particular objects by tapping into the society's data bank.

It is possible that just seeing some of the beautifully crafted coins in the exhibit will make you want to become either a collector or a student of numismatics. If so, this museum is the place where enthusiasts can gather information and get their questions answered.

The amount of time you spend here depends entirely on the depth of your interest. The greatest part of the collection is not on display but can be seen by prior appointment. This museum is not likely to interest children. There are no special provisions for handicapped visitors. Save half an hour for the visit.

෴ True Love ෴

DOG MUSEUM OF AMERICA
51 Madison Avenue
New York, New York 10010
Phone: 212-696-8350
Director: William Secord
Hours: Tuesday through Saturday, 10:00–5:00, Wednesday until 7:00
Directions: The site of the museum is the thirty-story-high New York Life Insurance Company building at Madison and 26th Street. The building is a square block and you can enter it from all four sides. The two galleries of the museum are both just off the lobby, behind the information desk.

"Few museums are devoted to simple ideas that live forever, like love and devotion. Here, then, best of friends, is that museum."

For anyone who doesn't have a dog for a friend, the rest of us can only feel compassion. And, maybe suggest a visit to this museum. The quotation above comes from the inaugural show, called "Best of Friends, The Dog and Art," which launched the museum on its devoted way. Other exhibits have included "Pampered Pets," which displayed objects such as jewel-studded collars and ornate dog beds, and "Presidential Pets" in which you can be sure Roosevelt's Fala and Nixon's Checkers were represented, as well as Lyndon Johnson's Him and Her. No small part of the disfavor into which L.B.J. fell had to do with his lifting those poor beagles by their ears. W.C. Fields wisecracked to the effect that a man who hates children and dogs can't be all bad. What the rest of us know is that you can judge a person's character by the way he treats his pet.

The American Kennel Club Foundation formed in 1982 after the death of Geraldine Rockefeller Dodge and the auctioning off of her important collection of memorabilia and art related to dogs. It oversees the collection, preservation, and exhibition of works of art and literature relating to the dog. As the collections and programs expand, more and more of the exhibits—such as "The Era of the Pet: Four Centuries of People and their Dogs"—will travel around the country.

I can't think of a more wonderful focus for a museum. I can't wait until their resources and collections grow enough so that they will have a building of their own as big as, say, the Baseball Hall of Fame in Cooperstown, New York, or the Hall of Fame of the Trotter, in Goshen, New York, at the very least.

Call to find out about the currently scheduled exhibit. And, if you want to see it, any children you're in the mood to take probably will enjoy it, too. The galleries are quite spacious (about 2,000 square feet), but the time you'll spend will be determined by the particular exhibit that is on view.

໑ Record Breaking ໑

GUINNESS WORLD RECORDS EXHIBIT HALL
Empire State Building
Fifth Avenue and Thirty-fourth Street
New York, New York 10118
Phone: 212-947-2335
Hours: Daily 9:30–5:30

Should this exhibit hall be included here? Most of the objects on display are replicas rather than the real things, but would you really want to see the world's longest fingernails? Or the longest hair, or beard? The tallest man who ever lived, after all, died in 1940 at the age of twenty-two, after having grown to 8 feet 11 inches. Here he is, though, recreated in a pin-stripe suit, blue and yellow rep tie, and glasses. We can stand next to him and experience the relativity of human height—my head reached as far as his jacket pocket.

Here is the straitjacket worn by Mario Manzini when he hung upside down above the Snake River Canyon, and over there is a tribute to the most dedicated dentist: 2,000,744 teeth. Most of them look a lot like pebbles. But who's counting, anyway?

There seems to be an awful lot of hype if not hokum in this exhibit hall. It's down below the ground level of what was once the tallest building in the world, and the place is as dark as a movie theater. Only the displays are lighted, and the constant buzz of videotapes documents record-breaking events: thousands of dominoes go down one by one, Joe Louis knocks out ten opponents in a row, Babe Ruth and Lou Gehrig hit homers.

"We want to be sure people know the difference between us and Ripley's 'Believe It or Not,'" said managing director Marvin L. Reiter, whose office is behind a door a few steps away from the tallest man. "With Ripley's you can believe it—or not. But everything here is true." Reiter runs this exhibit as a franchise from Guinness, a corporation based in London, England, that makes beer. The company began publishing the now-familiar *Guinness Book of World Records* after hearing people arguing over such firsts, mosts, and onlys in the pubs to which they delivered their suds. "The beauty of world records," said Reiter, "is that they have a wide spectrum of appeal."

That is probably very true. The morning I was there, two

The Jewish Museum ▶
(Photo by Graydon Wood) New York, New York

groups of schoolchildren were lined up waiting to go in. Give it half an hour to an hour.

⚜ Spanish Treasures ⚜

HISPANIC SOCIETY OF AMERICA
Audubon Terrace
Broadway and 155th Street
New York, New York 10032
Phone: 212-926-2234
Director: Theodore Beardsley
Hours: Tuesday through Saturday 10:00–4:30, Sunday 1:00–4:00
Directions: The museum is in the Bronx, at 155th Street and
 Broadway.

I stumbled into this museum, and it was as close to uncovering hidden treasures as I have come. It is one of the three museums at Audubon Terrace, and I discovered it as I made my way from the American Indian museum (see page 161) to the numismatic museum (see page 151).

The Audubon Terrace at Broadway and 155th Street is a treasure trove that is all but neglected. It is in the northern end of the city, at the edge of the Bronx, where the streets have been abandoned by the upper and middle classes. But here is where Archer Milton Huntington, son of the railroad baron, had visions of grandeur.

Huntington was a well-educated student of Spanish culture who amassed a huge library as well as works of Hispanic art. As he saw Manhattan moving north around the turn of the century, he bought this property, which had belonged to the estate of John James Audubon, and in 1908 he constructed the first of the buildings to house his collection and the Hispanic Society, which was and still is devoted to the study of the people of the Iberian Peninsula.

Other societies—the American Numismatic Society, the Geographic, and the American Academy for Arts and Letters—followed. In 1916, at Huntington's behest, the George Gustav Heye collection of American Indian arts and artifacts moved in. Huntington's dream of an uptown cultural oasis must have seemed to be coming true.

The Great Depression and demographics changed the surroundings, but the collections are still here and one can only hope that these museums will once again find a way to draw the visitors they deserve.

The doors of the Hispanic Society are guarded by limestone lions, which protect the secret of this place as stoutly as they do its treasures.

You enter the museum and find yourself in a main court with a terra-cotta floor. The walls are paneled with carved wood, and arches and columns have elaborate designs; the style is Spanish Renaissance. And the paintings—there are works by Goya, El Greco, and Velázquez, the greatest among Spanish artists.

In another of the large rooms the walls are covered with a series of brightly colored paintings of Joaquin Sorolla y Bastida. These paintings show the costumes and fiestas of regional Spain. They are full of life and are bound to charm you.

Among the antique furniture is a chest with veneer inlaid with intricate patterns and tiny ivory diamonds in a Moorish design. A desk with its top opened has small drawers with surfaces all gilded and carved. There are ancient objects, a Roman glass from the first century A.D., illuminated manuscripts, religious statues. A gallery on the second floor is lined with paintings. Without any doubt the atmosphere of Spain and Portugal infuses this excellent museum.

Children are not likely to enjoy this collection. It is not, unfortunately, accessible to handicapped visitors. Adults who are interested and able to get around might reserve half an hour or more for the visit.

∾ Jewish History ∾

JEWISH MUSEUM
1109 Fifth Avenue
New York, New York 10128
Phone: 212-860-1889
Director: Joan Rosenbaum
Hours: Monday, Wednesday, Thursday 12:00–5:00; Tuesday
 12:00–8:00; Friday 11:00–3:00; Sunday 11:00–6:00
Directions: On Fifth Avenue at Ninety-second Street.

This museum, operated under the auspices of the Jewish Theological Seminary of America, is housed in a beautiful mansion that was built in 1907 by Frieda and Felix Warburg, a socially prominent and philanthropical couple. The purpose of the museum is to underscore the continuity of Jewish life through the ages, and it is the main repository in this country for art and artifacts representing that culture. It

is also the largest museum devoted to changing exhibits on Jewish culture.

An exhibit called "The Precious Legacy" was mounted when I was there. It showed a great variety of domestic and religious objects from the State Jewish Museum of Prague, Czechoslovakia. This assemblage of treasures as various as embroidered Torah curtains, Hebrew prayer books, silver basins, and brass keys were things the Nazis had confiscated and planned to use in a "museum to an extinct race." The collection, assembled by the Smithsonian Institution Traveling Exhibition Service, was to move from here to San Diego, New Orleans, Detroit, and Hartford.

Although the emphasis in this museum is on changing exhibitions, a permanent installation called "Israel in Antiquity" spans the millennium from the reign of King David to the Roman destruction of the Second Temple. The museum is also building its archive of broadcasting, which includes programs as diverse as a conversation with humorist Sam Levenson, Adolf Eichmann's testimony during his trial, and Edward R. Murrow's interview of David Ben-Gurion on *See It Now* in 1956.

The permanent exhibits are not for very young children. It would be wise to check the exhibition schedule before deciding whether to take them. The amount of time spent here will greatly depend upon your particular interest and the current exhibit.

∾ Folk Art ∾

MUSEUM OF AMERICAN FOLK ART
125 West Fifty-fifth Street
New York, New York 10019
Phone: 212-581-2474
Director: Robert Bishop
Hours: Tuesday 10:30–8:00, Wednesday through Sunday 10:30–5:30
Directions: In midtown Manhattan.

The museum had newly moved to this location on Fifty-fifth Street when I visited, and the show then was devoted to the works of Grandma Moses. It always lifts the spirits to see her straightforward, down-home images in the bright colors that are, as often as not, embellished with silver or gold sprinkles.

My appreciation of folk art has grown in proportion to the number of museums I've visited that have collections of everything

from ship figureheads to carousel horses. This museum changes its exhibits every few months, so it is worthwhile to check the schedule to see what is coming up.

There are two floors and it is not an enormous place. Forty-five minutes will probably take you through most exhibits. There were no special provisions for handicapped visitors. Whether or not to take children will depend upon what the show is.

⚬ Radio & TV ⚬

MUSEUM OF BROADCASTING
1 East Fifty-third Street
New York, New York 10022
Phone: 212-752-7684 (recording) or 212-752-4690 (offices)
President: Robert M. Batscha
Hours: Tuesday 12:00–8:00, Wednesday through Saturday 12:00–5:00

Once upon a time, many, many years ago, before it mattered at all what a radio comedian looked like as long as he made you laugh, there were some of the funniest radio programs you can imagine: Bob and Ray, Henry Morgan, Jean Shepard, Jack Benny, Bob Hope. Some translated to television OK, too. But if you would just love to listen to them as they were then, well, it's possible.

It's also possible to watch *See It Now,* a televised news program presented by one of this country's boldest and best newsmen, Edward R. Murrow. Murrow had conversations with Chou En-lai, Chiang Kai-shek, President Tito, and Prime Minister Nehru. He presented programs about Winston Churchill and the Brooklyn Dodgers, Carl Sandburg and the atomic scientists.

Consider Rod Serling's *Twilight Zone,* where strange is written in giant, vaporous letters, or Sid Caesar's programs, which some call high comedy and others consider bottom-drawer bad taste.

The collection of the Museum of Broadcasting includes ten thousand radio and ten thousand television programs spanning more than sixty years of broadcasting history. It is the only such collection available to the public and can be used through a variety of membership plans or a one-time admission fee. A library reference room has programs listed and cross-referenced in twenty-five ways by title, subject, date, network, etcetera. Consoles to hear and watch the programs are available on a first-come, first-served basis; thus it's wise to arrive early.

Besides giving visitors an hour at a time at the console with the programs of their choice, the museum runs special programs in its theater. These programs change regularly. When I visited, a Lucille Ball special called "Christmas in July with Lucy" was being run. There were also screenings that examined the early years of network broadcasting.

Young children might have a hard time fitting into the routine of this museum. There is an elevator.

∞ Three-Dimensional Images ∞

MUSEUM OF HOLOGRAPHY
11 Mercer Street
New York, New York 10013
Phone: 212-925-0526 (information) or 212-925-0581 (administration)
Director: David H. Katzive
Hours: Tuesday through Sunday 12:00–6:00
Directions: Mercer Street is at the lower, southern end of Manhattan.
 You can reach it by going down Broadway to Canal Street.
 Mercer is between Canal and Grand Streets.

You don't have to understand holography to enjoy this museum, but if you want to understand just how these images are made, you have every opportunity to do so here. A film describes the process in great detail, and there are also written descriptions, but most of all there are the holograms.

A real white candle is set on a piece of wood about two inches thick. It is not lighted, but if you stand about three feet in front of it, you see a flame burning. If you move slightly, the flame flickers a bit; if you move too much, the flame disappears.

Whatever the scientists say about holograms, I think they should be called ghost pictures. They have that quality of mystery and the ability to disappear before your eyes, just as supernatural spirits do.

There is a great deal of experimentation, both technical and artistic, in these works of holography. My favorite is a metal sculpture of a lion whose paws are actually stuffed gloves and whose head is a hologram of a man who seems to have a paper mane. When you move around the front of this creature, the man's mouth opens in a roar.

Holograms on display here are placed at the national average eye

level. Little people—who love this place—need something to stand on. Tall people will have to shrink or bend. There aren't currently provisions for people in wheelchairs. Plan to spend an hour or so.

⌒ Native Americans ⌒

MUSEUM OF THE AMERICAN INDIAN
Audubon Terrace
Broadway at 155th Street
New York, New York 10032
Phone: 212-283-2420
Director: Roland W. Force
Hours: Tuesday through Saturday 10:00–5:00, Sunday 1:00–5:00
Directions: The museum is in the Bronx, at 155th Street and
 Broadway.

Kachina dance masks from the American Southwest are painted in black with turquoise, yellow, and orange and are decorated with feathers. But when it comes to feathers, there is a feather necklace of tropical greens. A hide jacket embroidered with white flowers and pink deer is elegant. The Algonquins are represented with exquisite embroidery. A diorama shows the potlach ceremony of the Northwest Coast in which the host is surrounded by an ostentatious display of his wealth. He will give it all away—the carved masks, the carved statue, and a strange, huge, carved wooden crab.

This is the largest, finest, and most comprehensive collection of native American artifacts, books, and photographs in the world. The range is from prehistoric to contemporary, and the mandate of the museum, which was founded in 1916, is "to collect, preserve, study and exhibit all things connected with the aboriginal peoples of North, Central and South America."

Children will find this a fascinating place. You could easily spend a couple of hours wandering among the three floors. Unfortunately, the building is not easily accessible, although there is an elevator once you are inside.

Plan to spend some time at the other two museums at Audubon Terrace: the American Numismatic Society (see page 151) and the Hispanic Society (see page 156).

✌ Big Apple ✌

MUSEUM OF THE CITY OF NEW YORK
Fifth Avenue at 103rd Street
New York, New York 10029
Phone: 212-534-1672
Director: Joseph Veach Noble
Hours: Tuesday through Saturday 10:00–5:00, Sunday and holidays
 1:00–5:00
Directions: This museum, like the Jewish Museum (see page 157), is
 among the ten cultural institutions in an association called
 Museum Mile, which extends from the Metropolitan Museum of
 Art at 82nd Street to El Museo del Barrio at 104th Street.

New York City, when it was New Amsterdam in the seventeenth
century, was a charming little town. A large room is devoted to that
era, with exhibits showing the Dutch settlers' way of life through
models, small dioramas, tools, and even lovely antique Delft tiles.
But the most complete sense of place is created by an unusual means.
In the center of the room is a raised platform meant to represent a
fort. When you stand at the sides of this fort and look at the paint-
ing that progresses 360 degrees around the upper part of the walls,
you follow the landscape of the city in the 1640s. A key to identify
landmarks is drawn out along the side of the fort nearest the part of
the city you are seeing. It looks so peaceful, although it wasn't alto-
gether. There is the area where Hendrick van Dyke had a peach or-
chard, and in 1655 "hot tempered Hendrick" shot and killed an
Indian squaw who had taken a peach to eat. This event started one of
the longest and bloodiest Indian wars in New Amsterdam.
 Collections here all deal with the life and times of the city.
There are changing exhibits of such things as photographs, furni-
ture, silver, costumes, prints, and paintings. The museum was
founded in 1923 and first located in Gracie Mansion, which is now
the mayor's official residence. The museum is now housed in a Geor-
gian mansion that was opened to the public in 1932.
 There are paintings and prints and photographs, decorative arts
from jewels to compotes, costumes that reveal the extravagance of
fashions, and a theater collection that contributes to the Theatre Mu-
seum on Broadway (see page 166).
 When it comes to the audiovisual component, this institution
has invented a multimedia presentation that moves at a pace as fast

◀ Museum of the American Indian
New York, New York

as the city itself. It's called "The Big Apple" and takes a unique approach: a narrated presentation tells the city's story using slides of actual museum objects. At certain moments in the story, an actual object in the darkened auditorium, such as a ship figurehead or a box from the original Metropolitan Opera House, is illuminated.

It is difficult to leave this museum without a sense of awe about the city, which many of us forget was the first capital of the country. It's a wonderful museum for children as well as adults. Save an hour at least, and a couple of hours for a leisurely tour.

ᘓᘐ New York's Finest ᘓᘐ

POLICE MUSEUM
Police Academy
235 East Twentieth Street
New York, New York 10003
Phone: 212-477-9753
Director: Thomas Krant
Hours: Monday through Friday 8:00–3:00. Tours at 10:15 by
 appointment.
Directions: The museum is between Second and Third Avenues.

Ask him, "How are you?" and he usually answers, "I'm tall," except for when he says, "Still tall."

Detective Thomas Krant is that. He's also funny and New York. For fifteen years he was a policeman "on the street." He taught at the police academy for two years after that and he has only recently become curator of this museum. He's a history buff and seems to be in his element here. The collection has many intriguing objects, but most of them are without documentation. Give Detective Krant time and money, and my bet is he'll come up with solutions to some mysteries. For instance, there's a case with weapons that test the imagination: a wooden stick with a spiked lead ball attached to it by a chain, a belt with a concealed knife, a weapon that's something between a Turkish sword and a meat cleaver. These weapons were all confiscated by policemen and used as evidence during trials. They were stored for a time and then were about to be deep-sixed in the ocean when someone thought of giving them to the museum. By then their provenance was lost, so here they sit, conjuring up nameless crimes and criminals. It would be very interesting to

know how and when these extraordinary objects were actually used, and by whom.

Of course, not everything here is undocumented. In fact, you can take a good, hard look at a mean machine gun that belonged to Al Capone's gang and was used in the assassination of Frankie Yale. You can also admire, if it strikes your fancy, a Borchardt automatic, the forerunner of all other automatic guns. So far as anyone knows, it is the only one that has its case intact.

The whole collection here, which was started in 1920, is worth in excess of $200,000. Besides the weapons that were confiscated by the department, some guns were donated during amnesty periods. "People had them in a box somewhere and were afraid to get them out because they were illegal," Krant explained. During the amnesty they were able to get rid of them.

The history of the New York City Police Department comes alive in the old uniforms, newspaper clippings, posters, an elaborately carved nightstick, and a display case that shows the development of fingerprinting. But what would Thomas Krant save if the museum were about to burn down and he could carry off just one thing? At first he thought about the Teddy Roosevelt material—Roosevelt was once New York's police commissioner. But then he thought again and went to a case with some personal memorabilia donated by a man named Daniel Gibbons, whose father was appointed to the force in 1908. Gibbons was himself eighty years old when he came in, saying that he was afraid he was going to die and he didn't want to go without finding a place for his father's badge and pistol and the newspaper story telling how his father had died of a fractured skull while trying to stop a runaway horse. So there is something to the legend that those hard New York cops are soft at heart.

There's nothing slick about this museum, and let's hope there never will be. But there is a musty, tough pride that sets this place apart from and above most collections. Children will be interested, adults will be intrigued. Give it an hour or more if you manage to go on a tour of the place with Krant.

∽ Broadway ∽

THEATRE MUSEUM
1515 Broadway
Mail c/o Museum of the City of New York
Fifth Avenue at 103rd Street
New York, New York 10029
Curator: Mary C. Henderson
Phone: 212-944-7161
Hours: Wednesday through Saturday 12:00–8:00, Sunday 1:00–5:00
Directions: In the heart of the theater district this museum is in an
 arcade that runs parallel to Broadway and is between
 Forty-fourth and Forty-fifth Streets. On the west side of
 Broadway, turn into either of those side streets and you will see
 the entrance to the Theatre Museum a short way down the
 block.

The Museum of the City of New York owns the finest collection of
theatrical materials in the country. This satellite of that museum has
changing exhibits with a variety of themes. When I visited, the cur-
rent exhibit was called "Show Stoppers—Great Moments of the
American Musical." Costumes and music, especially the Ethel Mer-
man memorabilia, brought those moments alive. Miss Merman had
died while the exhibit was on, and it was kept beyond its allotted
time in honor of that great star.
 Anyone interested in the theater would find it worthwhile
checking for the schedule of this museum.

∽ Ukrainian Heritage ∽

UKRAINIAN MUSEUM
203 Second Avenue
New York, New York 10003
Phone: 212-228-0110
Director: Maria Shust
Hours: Wednesday through Sunday 1:00–5:00
Directions: The museum is on Second Avenue between Twelfth and
 Thirteenth Streets.

An undertone of both sadness and pride surfaces frequently as you
tour this museum. The Ukraine, you learn quickly, is an independent

country that was captured by the Soviet Union. Because of its annexation by the Soviets, it is often overlooked, although with fifty million people it is the sixth most populous nation on the European continent.

The location is a strange one for a museum—it seems more like an apartment building—but there are elevators to the floors with changing exhibits and to the fifth floor, where the permanent display of festive costumes can be seen. This colorful clothing is wonderfully embroidered. A wedding dress from the early part of the century has a red skirt with metallic threads woven through, a black vest with Persian lamb edging, and leather trim that is punctured with grommets and stitched with tiny pom-poms of many colors. But it is the headpiece, a sort of tiara, that expresses the delight of this outfit. It is built up of bands of metal with tiny, colorful sequins and beads dangling in row after row.

The changing exhibits are likely to reflect the story of immigration to the United States as well as art works by Ukrainians. These exhibits are sure to touch anyone whose ancestry includes people from the Ukraine. It is not a museum for children, however, nor is it accessible to the handicapped. If your interest is piqued, you may want to spend an hour here.

∾ Western Lore ∾

REMINGTON ART MUSEUM
303 Washington Street
Ogdensburg, New York 13669
Phone: 315-393-2425
Hours: May through October, Monday through Saturday 10:00–5:00, Sunday 1:00–5:00. November through April, Tuesday through Saturday 1:00–5:00.
Directions: Ogdensburg is on the Saint Lawrence Seaway, above Clayton but below Massena. From the east take Route 68, from the south Routes 12 and 37. Signs will direct you to the museum, which is at the corner of Washington and State Streets, and a block away from the water.

In 1984 the Museum of Fine Arts in Boston organized a major and very exciting show entitled "A New World: Masterpieces of American Painting." The poster for the exhibition was Frederic Remington's painting of two men and a dog in a canoe on glassy-still violet water. The work, dated 1905 and entitled *Evening on a Canadian*

Lake, captures a moment in time and place perfectly. That scene reads like a short story: the men have stopped paddling and are listening, the dog is listening, and you need only let your imagination wander a moment before you too have heard the sound and identified its source. I thought of that painting as I toured the Ogdensburg museum, which owns two very different canoeing scenes by Remington: *Howl of the Weather* and *Hauling in the Gill Net.* In these works the water is rougher, and all of the arrested motion that the first painting holds in reserve is brought into full play in these two. But mostly I thought of that always-painful irony—how the artist who was not taken quite seriously enough by his contemporaries would have been gratified to know that his work was a symbol and announcement for a collection of American masterpieces.

I love Frederic Remington's works—his bronzes of bucking horses and cowboys holding on tight, of Indians and cavalrymen, and especially his evocative paintings. Probably the most haunting of these is *The Last March,* painted in eerie shades of green: a saddled horse that has lost its rider is making its way across a snowy plain; it is surrounded by three wolves.

The Frederic Remington Memorial Collection, as this museum is called, also has a replica of the studio in which the artist worked. After he died in 1909, at the height of his career, when he was only forty-eight, his wife moved back to Ogdensburg, where Remington had grown up. She kept intact the paintings, sketches, sculpture, and western American artifacts that adorned his workroom and turned all this over to the city. The workroom has a huge stone fireplace, above which is a moose head. There is Indian pottery on the mantel, a gun rack on the wall, Indian beaded weavings and baskets, and, in fact, the very artifacts you might have guessed would adorn this artist's studio.

Save at least an hour for this museum, and bring children. There is a special entrance for handicapped visitors.

⟳ World of Photography ⟳

INTERNATIONAL MUSEUM OF PHOTOGRAPHY
George Eastman House
900 East Avenue
Rochester, New York 14607
Phone: 716-271-3361
Director: Robert A. Mayer

Remington Art Museum ▶
Ogdensburg, New York

Hours: Tuesday through Sunday 10:00–4:30
Directions: Take exit 46 from the New York State Thruway to 490
 West; exit Culver Road. Look for signs marked "Museum
 Trail." The Eastman House is a mile and a half from the center
 of the city.

In the center of a great hall that has a splendid marble floor and an
exquisitely embellished doorway of elaborately filigreed wrought
iron, a wooden camera stands in solitary splendor. The only other
furnishing in the room, set discreetly against a wall, is a pipe organ,
but apart from that the large, wooden, wet-plate camera with its lens
encased in polished brass commands attention here.

George Eastman built this fifty-room Georgian yellow-brick
mansion in 1905 and lived here with his mother. He loved music and
used to hire organists to play for him in the morning and during
lunch. When his mother died, he lived by himself until he was sev-
enty-two years old and ill. He took his own life in 1932. Part of his
legacy was the Eastman Kodak Company, which he founded in 1880.

The galleries on the second floor of the museum arre devoted to
works of photographic art. The Eastman House has the largest col-
lection of nineteenth-century photography in the world. These ex-
hibits change over time, but an interesting collection is sure to be
mounted during any visit.

The first-floor galleries trace the history of photography through
the development of cameras, and in these displays is the material to
intrigue both young and old. In cases along the wall of the breeze-
way gallery is antique photographic jewelry: bracelets with photos in
their clasps, small onyx rings with photographic images, watches
with the camera's portrait burned into their golden covers. There are
photographs on buttons and in fantastic velvet albums; there are
early Kodak snapshots, and instant "Colorburst" pictures.

The darkened hall leads into the full light of a solarium, where
you pause before venturing into a marvelous gallery where the his-
toric development of the camera itself is traced. The gallery has a rep-
lica of an old traveling photographer's horse-drawn studio and just
about every variety of camera that can be imagined. An irresistible
novelty is the "Detective," a little metal camera with a viewfinder
half the size of a fingernail and a lens about as big as the pupil of an
eye. The film for this one comes in a box three-quarters of an inch
square. There's also a tiny pocket Instamatic in the shape of a ciga-
rette box, not to mention the "photo revolver de poche," a realistic-

looking revolver capable of making ten two-by-two-centimeter expo-
sures in a single load. Just warn any subjects that your intentions are
peaceful, the instruction manual advises.

There is a hands-on activity center for children, where they can
explore photography and satisfy their curiosity, and there are moving
picture cameras of the hand-cranked variety. A special treat is the
praxinoscope (1880, French), on which you press a button and a se-
ries of images drawn on glass slides, rotating mirrors, and light all
combine to present a live-action boy-holding-hoop-and-dog-jumping-
through show.

Rochester looks like a lovely city. The George Eastman house
sits on one of the most attractive city streets to be found anywhere,
and the museum itself is nothing less than a national treasure. Chil-
dren love it. Plan to spend at least an hour.

∾ Dolls & Dolls & More Dolls ∾

MARGARET WOODBURY STRONG MUSEUM
1 Manhattan Square
Rochester, New York 14607
Phone: 716-263-2700
Director: William T. Alderson
Hours: Tuesday through Saturday 10:00–5:00, Sunday 1:00–5:00
Directions: The museum is in downtown Rochester at the corner of
 Chestnut Street (Route 31) and Manhattan Square.
 From the New York State Thruway take exit 46 at I-390.
 From the south take I-390 north to I-590 north. Take exit 15 for
 downtown Rochester. From the north take I-590 to I-490 west
 (Rochester). Follow I-490 west to the Clinton Avenue
 (downtown) exit. Take the first right (Woodbury Boulevard)
 to the museum.

"When I was a little girl my mother bought a charming doll house
for me. It was by far my favorite toy and I spent many happy hours
playing with it. Doll collecting came along with the doll house."
That is how Margaret Woodbury Strong once explained her passion
for collecting. She didn't limit herself to dolls; she also accumulated
shells, buttons, marbles, door knobs, inkwells, paperweights, vases,
smoking pipes, shaving mugs, advertising cards, cut glass, toy banks,
figurines, toy sewing machines and stoves, other toys, kitchen uten-

sils, ivories, silver, ceramics, valentines, Victorian home crafts—not, as the museum's biographical brochure explains, "truckloads of trivia," but carefully chosen representations of popular taste.

Collecting and caring for her collection were her devotion and her vocation until she died in 1969. Having written in her will, "I believe my museum ... will offer a significant contribution to the cultural life of this area and will attract visitors from distant places," Margaret Strong left her possessions to posterity. The museum that holds the twenty thousand objects she cherished—a contemporary, three-story building constructed for that purpose—was opened to the public in 1982.

All that having been said, it is the dolls—unquestionably it is the dolls—that boggle the mind. No matter how well prepared you may be to see this vast collection, the sheer volume of ninety-two cases filled with dolls, thousands of dolls, is an astounding sight. If by chance you are a woman who grew up in an era that predated Barbi and Ken, watch out, because you will bump into your past quite unexpectedly as you turn a corner. It may be the timeless doll that cries "Mama," or maybe the Shirley Temple doll made in 1932, or the princesses, Elizabeth in her double-breasted blue coat and matching blue hat and sister Margaret, made in 1940, or perhaps President and Mrs. Eisenhower, whose likenesses were made in 1956.

The history of civilization could probably be represented through dolls. The skills of every era have been tested in their construction. Wood, wax (one of the ugliest dolls in the collection has a bright pink face made of wax), porcelain, plastic, and papier-mâché have served as materials. There are dolls with beautifully tinted faces who are dressed in the most elegant and elaborate fashions and others who wear no clothes whatsoever. There are dolls in the costumes of many nations and there are the Cabbage Patch dolls of 1913 to 1930, Rose O' Neill Kewpie dolls. And there is, if you can believe this, even a dead doll. Whatever you do, make sure to see doll number 86.1153, laid out in her glass casket surrounded by red, blue, and pink flowers. She wears a silver tiara and something that looks a lot like a halo around her head, and she is swathed from neck to toes in white lace and gold ribbon.

This is the largest doll collection, probably, in the entire world. It stands out among all kinds of collections.

You might consider spending a morning or an afternoon here, and certainly children will love it too. It is fully equipped for handicapped visitors.

⌘ Donald Duck to Doonesbury ⌘

MUSEUM OF CARTOON ART
Comly Avenue
Rye Brook, New York 10573
Phone: 914-939-0234
Director: Charles Green
Hours: Tuesday through Friday 10:00–4:00, Sunday 1:00–5:00
Directions: Rye Brook is north of New York City. Approaching from
 the west on the Hutchinson River Parkway, take the King
 Street, Port Chester/Route 102 exit (exit 30); turn right
 (south) on King Street (Route 102A). Approaching from the
 east on the Merritt Parkway (the Hutchinson River Parkway
 and the Merritt Parkway are the same highway; just the name
 changes to the east and west of Port Chester), take exit 27 and
 turn left onto King Street. Once on King Street go
 approximately one mile south to Comly Avenue. It will be on
 the left. Turn onto Comly and you will see the museum on the
 left. Look for the five-story concrete castle. For alternative
 directions, call the museum.

The Museum of Cartoon Art is in a reinforced concrete castle on the
top of a hill where it overlooks one of the best views around. But for
looking, you just can't beat what's inside this unusual building. Be-
fore you go in, though, remember to ask about the gigantic painting
in the middle of the parking lot. You'll find out it's the Yellow Kid,
an 1895 figure who is recognized as the first newspaper cartoon char-
acter.

There are graffiti in the bathrooms. A sign on the door says po-
litely, "The Graffiti in this Bathroom was Done By Professionals"
(someone penciled in, "Since when is graffiti a profession?"). The
note also asks people not to contribute their own ideas to the walls,
and the pencil pusher requests, "Get us a chalk board."

It's hard to tell you how much fun this museum is. As you
begin the tour, there is a notice that reads, "A cartoon is, simply
stated, a picture that tells a story or expresses an idea." But you look
down and see that a cartoon is also a rug, for you are standing on a
carpet with a design that includes Mandrake the Magician, Pete the
Tramp, and Henry. Every cartoon character you have ever loved is
here, perhaps on the walls in one of the artist's original strips, or

maybe in a giant papier-mâché statue—Dagwood Bumstead is scrubbing his back in an old four-footed bathtub. In another corner is a flaked-out Beetle Bailey.

The vast array of cartoon and comic book characters is matched by editorial cartoons (Paul Szep of the *Boston Globe,* for instance, is represented by a 1974 drawing of Lyndon Johnson committing harakari with a sword marked "Unity"). There is also the first of Norman Mingo's humorous illustrations with the one and only Alfred E. Neuman. It's the *Mad* magazine cover of 1956 that introduced the "What Me Worry?" character, and he's shown in a straitjacket—with his hands making a donkey sign above his head.

A television set has a constant supply of animated cartoons, movies are shown at regular intervals, and there are boards after boards of original drawings. The zany spirit of this art gets under your skin in short order.

Children should bring adults. Really, I can hardly think of anyone who wouldn't enjoy it, for there are cartoons for even the grouchiest and most cynical among us. Unfortunately there are no special provisions for wheelchairs or otherwise handicapped visitors. You can spend an hour here easily. You may want to stay for two.

ᘓᗗ Thoroughbred Racing ᘓᗗ

NATIONAL MUSEUM OF RACING
Saratoga Springs, New York 12866
Phone: 518-584-0400
Director: Elaine E. Mann
Hours: August racing season, every day 9:30–7:00. The rest of the
 year, weekdays 9:30–5:00. Saturday, May through December,
 12:00–5:00; Sunday, June 15 through September 15, 12:00–5:00
 January, February, March, April daily 10:00–4:00 (but subject to
 change).
Directions: Take the New York State Thruway to exit 24 at
 Albany-Northway (I-87). Take I-87 to exit 14 (Route 9P) into
 Saratoga. The museum is across from the track. From east to
 west, use Route 29 to Saratoga.

It was strange. In the morning I heard a news report that Swale's death had finally been traced to a heart lesion. In the afternoon, going through the National Museum of Racing, I stood in front of pictures of Swale taken two months earlier, as he came in first and

received his honors as the 110th winner of the Kentucky Derby. The room commemorated the last sixty Kentucky Derby races, and a photo of Swale's victory was hung above a huge silver trophy that had been won by Cavalcade in 1934. How fragile victory is, how sad that this splendid animal raced until his heart burst.

The dignity and beauty of these four-legged athletes set the tone of this collection. It is housed in a fine brick building across the street from the racetrack, which is the oldest thoroughbred track in the United States. The town itself is an absolute gem of Victorian buildings and it seems to be undergoing a renaissance. The museum was founded in 1950. The exhibits are along a circular path around a pretty courtyard with plants in cement urns and a birdbath. Floor-to-ceiling windows overlook the garden, and the ambience of the museum, furnished with elegant chairs and benches so that visitors may relax as they tour, is as pleasant as can be found anywhere.

One of the world's largest collections of equine art is hanging here. Two paintings particularly caught my attention: a wonderful huge oil called *Dead Heat,* painted to commemorate a race at Gravesend in 1894, and a large portrait of Man O' War. The latter is interesting because, although it is just his head and neck, and although most of the painting is pretty flat, a certain look in his eyes, a certain intelligence and dignity about this horse, is arresting.

The aristocracy of this sport is apparent in the room where portraits of people important to thoroughbred racing line the walls. No shortage of Du Ponts, Whitneys, and Vanderbilts. The racing silks—jackets and caps—of more than two hundred owners are displayed in a parade of brilliant colors. In a case of memorabilia are a pair of boots worn by Eddie Arcaro and three framed bookmarks, which are absolutely exquisite small weavings: two show race scenes and one depicts Dick Turpin's last ride on Black Bess. The bookmarks were woven in silk by Thomas Stevens in the nineteenth century and are unique works of art.

Plan to spend an hour here, and if you think children would like to visit, bring them along. But be aware that it is more discreet and subdued than, for comparison, the Hall of Fame of the Trotter (see page 144) in Goshen, New York.

ꙮ Erie Canal ꙮ

ERIE CANAL MUSEUM
Weighlock Building
318 Erie Boulevard East
Syracuse, New York 13202
Phone: 315-471-0593
Director: Vicki B. Ford
Hours: Tuesday through Sunday 10:00–5:00. Other times by
 appointment.
Directions: The museum is in downtown Syracuse between Water
 Street and Erie Boulevard East at Montgomery Street. If you are
 coming in on I-90, take exit 36 to I-81 into Syracuse.

The Erie Canal no longer wends through the city of Syracuse; the
waterway is now a paved highway and the red-brick building where
wide, blunt-nosed canal boats used to stop is landlocked. The two-
story Weighlock Building was on the verge of being torn down
when a group of canal enthusiasts organized to save it and recon-
struct it as a museum.

Building and traveling the Erie Canal were every bit as romantic
and exciting as laying the railroad and riding the rails in the early
days. On wall displays, fliers and newspaper accounts tell of the
grand celebration when the canal was completed in 1825. City Hall
was lighted with 1,542 candles, 454 lamps, 310 variegated lamps, and
a rooftop fireworks display that must have dazzled the entire Empire
State.

This museum reverberates with the enthusiasm of its creators.
There are models of the wooden boats that carried cargo and passen-
gers and were pulled by teams of horses that hoofed the towpaths.
The horses were allowed to travel at the breakneck speed of four
miles per hour. In one room, which has elaborate pressed tin walls
and ceiling, a plaster model of the weighmaster, specs on his nose,
sits at a real rolltop desk examining a real bill of lading dated May 5,
1847. A game of checkers is set up on top of a barrel, and the mood
of the place is really tangible. On the second floor, up a stairway that
tilts as if it were actually riding a wave, is a room for changing exhib-
its. When I visited, the museum was showing "The Draftsman As
Artist," a display of title pages, maps, and drawings from records of
building and repairing the New York state canals.

Of the several weighlocks along the Erie, this is the only one

◄ Goebel Collectors Club
Tarrytown, New York

left. The canal was diverted through the portico of the building; when boats floated into it, the water was drained and the boat weighed in order that a toll could be levied on the cargo. The portico is closed in now and is part of the exhibition area, but the original outside wall is intact. Among the displays along it is a description of canal life: "At night they heard the sounds of the canal and the city working around the clock. Sometimes they leaned here, rolling cigarettes, watching water rats and waiting for the next canal boat to come through. Once, J. Brinall, a clerk from the office upstairs, carved his name in the brick." If you look closely, you can see that he did it tight and neat, as if he had plenty of time to chisel the hard red surface.

Children should enjoy this museum. Give it about forty-five minutes.

∾ Happy Childhood ∾

GOEBEL COLLECTORS CLUB
105 White Plains Road
Tarrytown, New York 10591
Phone: 914-332-0300
Director: Joan N. Ostroff
Hours: Monday through Friday 10:00–4:30, Saturday 11:00–4:00
Directions: The museum is located in Tarrytown, just off exit 9 of
 the New York Thruway. It is close to the Tappan Zee Bridge,
 about thirty miles north of New York City.

Children with rosebud mouths and chubby cheeks playing musical instruments, feeding animals, skipping off to market or to school, pretending to be doctors, band leaders, waiters: these are M. I. Hummel creations. Their style is unforgettable; there is a sweetness about them, a sentimental wistfulness.

Sister Maria Innocentia was a Franciscan nun, born Berta Hummel in 1909. She studied art and lived in the convent of Siessen in West Germany. Franz Goebel, owner of a porcelain factory, saw the sketches of happy children she had drawn, mostly from memories of her own childhood, and in 1934 Goebel went to the convent and arranged to have Sister Innocentia's works of art translated into three-dimensional ceramic figures. He agreed to grant the artist and her convent artistic control over the reproductions and, in 1935, under their supervision, the first signed M. I. Hummel figurine, called

"Puppy Love," was produced. It is a small boy with a violin playing music to a little dog.

In 1946 Sister Hummel died of a respiratory illness at the age of just thirty-seven. But the Goebel manufacturing company continues as the sole manufacturer of her designs, which are, to this day, produced with the approval of the board of nuns. The sweet-faced children first gained popularity in the United States when American GIs returning from a tour of duty in Germany brought the M. I. Hummel figurines home with them.

The handsome brick Georgian-style building in Tarrytown, which the company bought in 1976 as a showcase for its works, has the largest collection of M. I. Hummel figurines in the United States, and one room in the building is devoted to antiques, rare figurines, and several of Sister Hummel's sketches in pastels and charcoal. But the M. I. Hummels are only part of what the company manufactures, and the interior of this building is a beautifully executed display area with showcases to exhibit the complete line. These objects include a wide array of happy children—besides those already mentioned. There is a brassy, carrot-top clan, for instance, that goes by the name of Charlot Byj Red Heads. These kids are occupied in a variety of endeavors: my favorite is sitting in her birthday suit reading a book in front of the washing machine. Others are more delicate but equally contemporary, toting cameras and wearing earphones. There are children with flowers in baskets, bouquets, and wheelbarrows.

Besides children, the Goebel collection includes ceramic animals and a variety of sculptural themes from dancers to fashion models. The museum is not a salesroom, so you cannot buy any of these objects; but you can inquire about retail outlets and you can also join the club. The club was formed to provide the information collectors are so interested in: dates when particular figurines were first made, for instance. Now, with a membership of nearly 200,000 in North America alone, members have meetings and take trips to visit the factory in Germany.

Part of the visit to this gallery can include a twenty-five-minute movie that is, in effect, a tour of the German factory. It is an education on the process of manufacturing fine porcelain. Save about an hour.

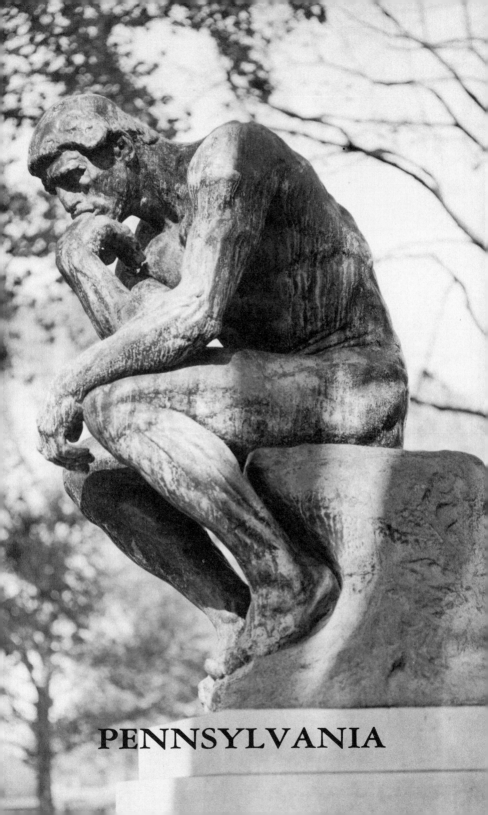

PENNSYLVANIA

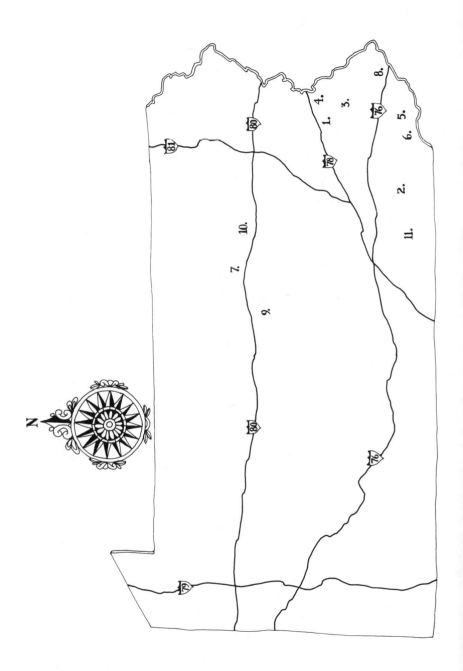

Numbers on map refer to towns numbered on opposite page.

ᴄᴡᴄ Pennsylvania ᴄᴡᴄ

⌘ Fire Brigade ⌘

LEHIGH VALLEY ANTIQUE FIRE MUSEUM
535 Main Street
Bethlehem, Pennsylvania 18018
Phone: 215-867-0330
President: Thomas E. Wainwright
Hours: Monday through Saturday 10:00–5:00, Thursday until 9:00,
 Sunday 12:00–4:00
Directions: From U.S. Route 22 take the exit at Route 378. Go south
 to the Bethlehem Center City exit.

If you've seen one fire-fighting museum, you have not, necessarily, seen them all. Although I was prepared to scoff at a lesser effort after my tour of the American Museum of Fire Fighting (see page 145) in Hudson, New York, this collection is estimable and merits attention.

In the first place, there is a fifty-five-foot-long gleaming red 1929 vintage American La France hook-and-ladder truck that is wonderful to contemplate. It has a seventy-five-foot extension ladder and weighs eleven tons. Bought by the city of Bethlehem, it was housed in the old Central Fire Station until 1958. It spent about thirteen years in an old barn, where it was used for target practice and left to the indignities of time, the elements, and neglect. Thomas Wainwright found it, bought it, towed it to a garage, and had it restored. That restoration meant lovingly repainting the details with twenty-two-karat gold as well as repairing, painting, and polishing.

This museum is made up of Wainwright's personal collection of more than thirty fire department vehicles of many eras. He describes it as "the culmination of a dream I had to display a bit of the colorful past of our courageous firemen and their equipment." Besides equipment there are, for instance, eight *Saturday Evening Post* covers, including one, for December 1950, in which the ladder of the truck parked outside the station is extended and is being used to get to the roof of the firehouse, where Santa and his reindeer are being set in place. There is a poster for *Gone with the Wind* that shows Atlanta in flames, and there are promotion stills from the 1974 Steve McQueen movie *The Towering Inferno*. There are games and cards and even glass trucks made to hold candy.

A super collection of hats includes a leather fire helmet from the

Revolutionary War. The museum has leather fire buckets that date from about 1700 to about 1890. Some of these buckets were elaborately decorated and, says a curatorial note, "every home had to have at least one [bucket]—either to supply the engine or to douse the fire." One kind of fire bucket had a different purpose, however. In 1799 Nathan Webb of Boston kept his fire bucket handy to put his personal belongings in should his residence catch on fire. The bucket is carefully painted with a picture of a house on fire—just in case he might forget what it was for.

This museum is a good place for children, and a tour should take about half an hour.

Ꮼ Clocks & Watches Ꮼ

NATIONAL ASSOCIATION OF WATCH AND CLOCK
 COLLECTORS MUSEUM
514 Poplar Street, Box 33
Columbia, Pennsylvania 17512
Phone: 717-684-8261
Director: Stacy B. C. Wood, Jr.
Hours: Monday through Friday 9:00–4:00, Saturday 9:00–5:00
Directions: Columbia is west of Philadelphia, twelve miles west of
 Lancaster. From Route 30, take the Route 441 exit, turn left,
 and follow 441 into Columbia to Poplar Street. Turn left onto
 Poplar and go two blocks to the museum.

On the front of the low, modern building that houses the National Association of Watch and Clock Collectors is a tile mosaic of a man checking his pocket watch against a sundial.

This museum is owned by the 32,700 members of the association, who have donated one of the most substantial horological collections in the country. There are fifteen hundred clocks and three thousand watches here, as well as a reconstruction of a turn-of-the-century jeweler's shop. The variety and beauty of the pieces will interest the general museum hopper because, as museum director Stacy Wood explained, "One thing we do here is try and show you what makes the clock tick." Many of the magnificently decorated clock faces have been removed to reveal the interior mechanism of the working clock. And everything is labeled.

There is an ancient clock from mainland China here, and one

from Japan. There is the heavy-duty machinery to operate a clock tower, and there are wall and shelf clocks and special items from the Terry family of Bristol, Connecticut (see American Clock and Watch Museum, page 103).

Lancaster County, where this museum is located, was the center for production of the tall case clock, also called the grandfather clock. Fanciers of antique clocks decorated with reverse painting will see fine samples of that style and even a display that shows how this art is executed. An "advertising clock" has three windows behind which the pictures and advertisements change regularly. One such clock was adapted by a father trying to marry off his seven daughters. In the space for ads he installed a series of pointed messages to suitors. One reads, "Let us then be up and doing with a heart for any fate, let's have done with endless wooing and propose or emigrate."

An interesting revelation is the extent to which American manufacturers at the turn of the century were preoccupied with besting the competition from European designers. Examples of elaborate carriage clocks that you would guess are French are, in fact, American made. One American clock with crystal pillars, for instance, has a porcelain dial delicately painted in the French Limoges style.

The word *clock* is derived from *clocca*, which is Latin for bells, and if you love the sound of clocks chiming, this museum is definitely the place to hear them. One clock plays "My Country 'Tis of Thee" in organ-grinder fashion; a German clock has eyes that move as the pendulum swings. There are more cuckoo clocks than you can imagine from Germany, France, and the Netherlands, and a white rabbit whose watch is not in his vest pocket but in place of his stomach.

Children under eight should be supervised by an adult. The museum is accessible to the handicapped. Plan on spending thirty to forty-five minutes.

↜ History Through Tools ↝

MERCER MUSEUM
Pine Street
Doylestown, Pennsylvania 18901
Phone: 215-345-0210
Director: Douglas C. Dolan
Hours: March to December, Monday through Saturday 10:00–5:00,
 Sunday 1:00–5:00

Directions: From U.S. Route 611 follow West State Street into town. Go south on Main to Ashland, which will take you to Pine and the museum. From U.S. Route 202 follow Main Street to Ashland and then Pine.

To call the Mercer Museum unusual is equivalent to saying that the Statue of Liberty is a large figure. The Mercer is outstanding, gigantic, and entirely incomparable. It is the accomplishment of one man determined to collect and exhibit what he called "the tools of the nation maker" in order to document the growth of America through its pre-Industrial Revolution handcrafts. But the objects he collected are only part of the intrigue—the place and the manner in which they are exhibited are equally fascinating.

Henry Chapman Mercer (1856–1930) was interested in history, archaeology, anthropology, and ceramics. He awed the people of Doylestown when, in 1910, he built a multivaulted home with turrets and balconies—entirely of concrete. That was the first of his concrete castles. The second was the Moravian tile works. Having seen, during his quests for hand tools, that the Pennsylvania-German pottery-making skills were disappearing, he revived them. The wonderful, colorful tiles with storytelling scenes were and are still produced in a concrete extravaganza called the Moravian Pottery and Tile Works.

From 1914 to 1916 work progressed on the reinforced concrete building that would house his collection of artifacts, which then numbered about thirty thousand objects. In the completed museum, galleries are sited around a central core. All the display rooms are enclosed by glass and all have printed guides to the objects within. Trade-specific exhibits are set up in individual rooms, smaller or larger depending upon the number and size of things on view. For instance, the kitchen implement display is in a large space since there is so much to see. Among kitchenware is everything from a clockjack (a mechanical device run by weights and gears that was used to turn long iron spits in front of the fire) to ladles, spatulas, pots, forks, cutlery, plates, and bowls. Right next to the kitchen is a small but intriguing room crowded with tools for working with tortoiseshell. Here are the drawknife, quarnet, grailles, mandril, and jigsaws used to carve shells, and the combs, watch cases, necklaces, and other stunning pieces that were made with these tools. There is even a huge, uncarved tortoise.

Around the central core, ascending higher and higher, the crafts are revealed: printing and fruit presses, candy-making pots and

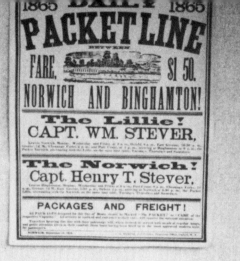

1865 DAILY 1865
PACKET LINE
BREWERY

FARE, $1 50.

NORWICH AND BINGHAMTON!

The Lillie!
CAPT. WM. STEVER,

The Norwich!
Capt. Henry T. Stever,

PACKAGES AND FREIGHT!

Beverage Distributor Boat

SPEC

Some types of car
boats. These vessels
often quite interes

ROCHESTER
ALBANY.
Red Bird Line of Packets.

Packet Boats 100 Feet Long
THE EMPIRE!
Capt. D. B. Brantly.
THE ROCHESTER
Capt. J. B. Warren.

275

molds, potters' wheels and pots, butter- and cheese-making needs, hatters' tools, cooperage materials. Tanning, wallpaper printing . . . In a room that demonstrates harvesting, along with the scythes, forks, and knives the farmers used, is a series of hollowed horns. These horns were worn around the belt as a pouch for the whetstone that was needed to sharpen the scythe blade. In a corner of one level is a country store as it would have been at mid-nineteenth century with shelves of textiles, sewing notions, tobacco, and a post office. Here and there are carved store figures; the cigar store Indian is just one of the sculpted figures meant to advertise wares inside. A beckoning, leering Punch is another.

As you climb, level by level, your attention is also drawn to the open central core, which is hung with all manner of large Americana: a Conestoga wagon, sleighs, whaleboats, apple grinders, corn shellers, a dugout canoe, and, reaching up from the ground floor many levels high, a strange device, a well sweep.

On and on. At level 7 I wrote in my notes, as I looked at a solar salt-melting device, a replica of an old schoolroom, and a coffin near a black hood to be placed over a man who was to be hanged, "Thank goodness it ends here." But around a corner I discovered something that left me breathless: vaulted ceilings and decorated columns paved with the beautiful Moravian tiles.

The Mercer Museum is a fabulous place. It is certainly a museum for children to see. People who have trouble with stairs may have a hard time, although there is an elevator. Both the tileworks and the home of Henry Mercer, called Fonthill, are also open to the public, although their schedules differ. One could spend an entire day or two exploring the Mercer world of Doylestown.

ᴄᴡ Watery Highways ᴄᴡ

CANAL MUSEUM
Hugh Moore Park
200 South Delaware Drive, P.O. Box 877
Easton, Pennsylvania 18044-0877
Phone: 215-250-6700
Director: J. Steven Humphrey
Hours: Monday through Saturday 10:00–4:00, Sunday 1:00–5:00
Directions: From U.S. Route 22 take the Fourth Street exit, Route
 611. The museum is less than one mile south of the exit.

◀ Canal Museum
 Easton, Pennsylvania

There once were five thousand miles of canal routes through twenty-two states in the United States. Canals were the country's first large-scale engineering projects and first interstate transportation system. Mules usually pulled canal barges along the Delaware and Lehigh—they were stronger, ate less, and were smarter than horses in that they knew when to quit. But horses, because they were faster, were used more often to tow packet boats. After 1860 the railroads started to take over and canals were abandoned.

Through a videotape and an interesting electrified map that lights up to display the development of the canal network, this museum looks at the national system of canals. In this it differs from similar museums that have a more local perspective. There's also a replica of the barge cabin, with bunk beds and tables that fold down from the walls, a nice patchwork quilt, and a cast-iron stove with the questionable talent of talking. A tape made to speak from within the stove describes the quarters.

A series of evocative photographs reveals the life of canal families; boat models and materials such as a headlamp and a mule harness make the past more tangible. Plan on forty-five minutes for a tour and bring children, by all means. They may get a kick out of the talking stove even if you don't. Also, there are hiking trails, picnic tables, and canal boat rides during the summer.

∾ Collectibles ∾

FRANKLIN MINT MUSEUM
U.S. Route 1
Franklin Center, Pennsylvania 19091
Phone: 215-459-6168
Director: Jack Braconnier
Hours: Tuesday through Saturday 9:30–4:30, Sunday 1:00–4:30
Directions: The museum is forty-five minutes south of Philadelphia in the Brandywine Valley just north of Delaware. It is on U.S. Route 1 four miles south of Media.

Just inside the door of the Franklin Mint Museum is an archway into a darkened room; the doorway is framed with tiny pinlights, which also surround all the shadow-boxed displays that are set into deep red flock. Harp music fills the air. The first item on display is a turning carousel with a tiger, lion, unicorn, and ostrich. The animals go up

and down as the carousel, no more than six inches high, turns. A full-size rose crafted of gold has pearls growing out of its leaves and a diamond- and emerald-studded center. There are Fabergé eggs, ornamented clocks, and other objects of porcelain and crystal. Visitors exclaim, "Ah! pretty" and "Talk about work!"

The intricacy and delicacy of some of the works on display at the Franklin Mint Museum are matched by the variety of things to be seen here. In another darkened room, lit by blue pinlights, is an exhibit of crystal. Here, in a "Great Leaders of the World" series, artists who work for this mint have etched cameos of Lincoln and Joan of Arc, which have been set in the finest lead crystal by Baccarat. There are a glistening crystal dolphin and a collection of Alice in Wonderland characters in glass.

In a display called "World of Miniatures," tiny silver coins are engraved with the heads of presidents and first ladies. A series of miniature etchings, also in silver, shows sailing ships through history, all no more than one inch by half an inch.

Flowers, birds, bells, heroes—in porcelain, in silver, in glass, in pewter, and on paper. There is not a medium that the artists of the mint haven't worked in.

Titles above some of the display cases are sometimes trite and sometimes telling: "It takes a child to make the whole world smile" is one example. A bridge walkway connects the circular white building that houses the museum with the mint itself, where the artisans are at work. A film describes the art of minting from conception to execution.

Children will find things to interest them. You might spend an hour or more.

↻ Mushroom Heaven ↻

PHILLIPS MUSHROOM PLACE
U.S. Route 1
Kennet Square, Pennsylvania 19348
Phone: 215-388-6082
Directors: The Phillips family
Hours: Daily 10:00–6:00
Directions: Kennet Square is in the historic Brandywine Valley just north of the Delaware border. Phillips is right on U.S. Route 1, southwest of Philadelphia and southeast of Lancaster.

Those who love mushrooms can't help but feel awe upon arriving at a place that calls itself the Mushroom Capital of the World. More mushrooms are grown within a ten-square-mile area around Kennet Square, they say, than anywhere else in the world. The mushroom museum is attached to a store that sells everything from fresh and pickled mushrooms to mushroom notepads, mushroom plates, and mushroom bread. Since the museum is small, it probably rates no more than a fifteen- or twenty-minute visit, and it wouldn't ordinarily be included in this book. But since it is also the only museum I'm aware of devoted entirely to *Agaricus bisporus* and since it is so interesting—here it is.

A three-foot-high plaster specimen stands near the entryway, where you will find out that there are thirty-eight thousand species of mushrooms. In the earliest recorded use of the mushroom, Egyptian hieroglyphics show it as a plant promoting immortality. From Egypt we progress to Kennet Square, where a miniaturized mushroom farm behind glass reveals the growing process, from composting the soil to harvesting the food. Since mushrooms grow in darkness, those who tend and pick them wear helmets with lights on top, like miners' hats. An old-fashioned helmet on display has a kerosene-fueled lamp.

Among the miscellaneous bits of information provided are some interesting tips that contradict old myths. For instance, the belief is widespread that mushrooms with "closed veils" (that is, with no gills showing) are best and freshest. The growers say that those with gills exposed are perfectly fine. A film is shown here, but it was out of order when I visited.

Whether or not a small child would be interested in this museum depends a lot upon the enthusiasm of the adult acting as chaperone. Whether or not an adult will be engaged depends, probably, on just how fond he or she is of mushrooms.

ᕗ Big Game Hunters ᕗ

FIN, FUR AND FEATHER WILDLIFE MUSEUM
Star Route, Box 59
Lock Haven, Pennsylvania 17745
Phone: 717-769-6620
Director: Paul Asper
Hours: April 15 to December 24, daily 9:00–5:00. December 26 to
April 14, Friday, Saturday, and Sunday 9:00–5:00.

Directions: This museum is actually in Haneyville, about eighteen
miles from Lock Haven, which you can reach via Route 220.
Follow Route 664 north out of Lock Haven, which will take
you over the mountains on a pleasant jaunt—pleasant in the
summer, at least. At the end of 664 you meet Route 44. Go
north on 44: the Trading Post and the museum will be two
hundred yards on your right.

Paul and Carole Asper, owners of this museum, are both big game
hunters and are responsible for bringing down most of the animals
in it. That is a major accomplishment. Here are more than two hun-
dred stuffed animals. The range of the Aspers' exploits is shown on a
map of the world with pins in it—from New Zealand to northern
Alaska.

Both Aspers have been hunting since they were small children,
but he pursues the sport more avidly than she. "One year he hunted
about eight months out of the year," said Carole Asper as she
ushered me into this amazing collection. I looked at what she de-
scribed as perhaps their most treasured trophy, a Marco Polo sheep
that her husband shot in Afghanistan in 1978. It was a beautiful, tan,
sweet-faced animal with elegantly coiled horns. An utterly gargan-
tuan animal is the two-ton stuffed walrus, not to mention the ele-
phants and the rhino.

A local artist has painted the backdrops to many of the exhibits,
using Paul Asper's photographs for detail. In display cases in front of
the stuffed animals are photographs taken on various safaris, some-
times showing the bagging of the very animal that is standing, re-
constituted, before you.

Short of the zoo, this museum may be the only place where
most of us will have an opportunity to contemplate some of these
rare and beautiful creatures. Asper says that his "goal is to try to col-
lect all of the major big game animals of the world." He's now about
halfway there, which may be what provoked someone leaving the
museum to remark, "When he dies and goes to heaven or hell, that
man is going to have a lot of animals waiting for him."

One large room is devoted to the skills of taxidermy, for this
place is also the National Taxidermist Association Hall of Fame.

Children can be brought here. The museum is easy to negotiate.
A visit will take about thirty to forty-five minutes.

ᕦᕤ Immigrants ᕦᕤ

BALCH INSTITUTE FOR ETHNIC STUDIES
18 South Seventh Street
Philadelphia, Pennsylvania 19106
President: M. Mark Stolarik
Phone: 215-925-8090
Hours: Monday through Saturday 10:00–4:00 (Library 9:00–5:00)
Directions: In center city Philadelphia.

In 1956, when she was ten years old, Marika Valeria Holecz Krause fled her native Hungary to escape the revolution. In her schoolbag she carried her dearest possessions: her parents' passports, a family photograph, religious pictures, and a fever thermometer. But it is her brown leather shoes—plain, stern, old-fashioned laced shoes creased by wear but no doubt always kept polished—that speak so powerfully of what it must have been like for a young girl, a refugee, to arrive in a strange country. Those shoes somehow embody the anguish and the hope of an immigrant.

The Balch Institute's collection is made up of many and varied objects that tell the story of ethnicity and immigration. Photographs, documents, letters, steamer trunks, ship manifests, clothing, posters, tablecloths, family albums. Hardly an American in this nation will be untouched by some part of the exhibits in this museum, for we are, spectacularly, a multiethnic community of immigrants.

The Balches, a prominent Philadelphia family, left their fortune for a library to be founded in their name. In 1957 trustees of their estate asked the Orphans' Court of Philadelphia (which oversees the execution of wills) for guidance. With a stroke of brilliance the court recommended a library devoted to the history of immigration and the significance of ethnicity in American society. Settlers are still arriving, and the recent immigrants from Puerto Rico, from Asia, and from India are also acknowledged here.

Philadelphia was a major port of entry during the past century, and "Destination Philadelphia" is a permanent exhibition. Not long ago, when a local television station showed the museum in the course of a program, a man watching at home was startled to see a photograph of himself and his family when they arrived in this country—in 1910.

Among the museum's changing exhibits was one called "Ethnic

Mummers Museum ▶
Philaldelphia, Pennsylvania

Images in Advertising," and it reveals both humorously and painfully how stereotypes have been used to hawk products: Chinese laundrymen with pigtails sell soap, a black porter carries suitcases and says, "Yes, suh—Everybody's on the go again," Scotsmen wear tartans, the Irish have red hair, Jews have crooked noses. Then, progress toward today: an American Indian is pictured with the copy "You don't have to be Jewish to love Levy's real Jewish Rye," and an advertisement from the J. Walter Thompson Company archives shows a black Santa taking a picture with a Kodak Instamatic. If you have a chance to see this wonderful show, you won't regret going out of your way to take it in.

Children should be taken to this museum. *Everyone* should visit, and since it is all on one floor, it is easy to get around. Depending on what the changing exhibits are, the visit may taken an hour or so. Also, on the second floor is a marvelous library where there are no fewer than a thousand ethnic newspapers, all published in the United States.

༚ Benny, Baby ༚

BENJAMIN FRANKLIN MUSEUM
Independence Historical National Park
Franklin Court
Philadelphia, Pennsylvania 19106
Phone: 215-597-8974
Park Director: Hobbie Caywood
Hours: Daily 9:00–5:00
Directions: Independence Historical National Park is in the core of
 the historic downtown, which includes the Liberty Bell Pavilion,
 Independence Hall, and the Philadelphia Maritime Museum (see
 page 204). Be sure to stop at the Visitor Center, Third Street,
 between Chestnut and Walnut Streets, if you want maps and
 information. All the sites in the historical park are free and,
 besides the Franklin Museum, there are a working print shop
 and a post office, both of which have costumed interpreters and
 small displays.

Philadelphia is a wonderful city to walk around in, and the sense of history here is almost tangible. But, curiously, one of the most unusual and avant-garde museums, to honor Benjamin Franklin, is underground. It is beneath the site where Franklin's house once was.

Although the house is gone, archaeologists have excavated enough to reveal some of the foundations that used to support it.

To get into the museum you go down a long ramp, rather as if you were going to catch a subway, but suddenly you think you are about to enter something more like the Benjamin Franklin discotheque. Blue neon lights usher you into a semidark area full of telephones. Row upon row of telephones on stands! And on the wall is a list of everyone from Louis XIII and his ministers to La Rochefoucauld to Harry Truman. Since the only person on the roster I knew was Henry Steele Commager, I called him. The phone rang a couple of times, then someone answered and began to say, "Franklin was a child of the Age of Reason . . ." But it was a woman's voice speaking Commager's words. It certainly wasn't the Amherst College professor I'd once interviewed. I also dialed Harry Truman at 417-782-2286, but I think he must have been walking in the garden.

In the center of this room is a large model with figures, in costume, representing Franklin, first at the British House of Commons discussing political matters, and later at the court of Versailles. Music and spotlights add to the dramatization. There is also a theater where a film is shown.

This degree of audiovisual extravagance gives history a contemporary flavor. The museum was crowded with school groups while I was there. It is certainly accessible to handicapped people. I think you could spend about an hour there.

๛ John Wanamaker ๛

JOHN WANAMAKER MEMORIAL MUSEUM
John Wanamaker Department Store
Thirteenth and Market Streets, P.O. Box 7497
Philadelphia, Pennsylvania 19101
Phone: 215-422-2737
Director: Rita Eisenberg
Hours: Daily 12:00–3:00
Directions: The museum is on the eighth floor of the center city
 Philadelphia store, Chestnut Street side, and is accessible by
 public transportation.

Past the TVs and the video games, past a vacant area of this elegant department store, you come first to a large wooden chair that is held up with four lions and looks very much like a throne. Appropriately

enough, it stands outside the entrance to the area reserved for the carefully preserved office of the department store founder, John Wanamaker, and the museum that is dedicated to his memory. Appropriate because, it becomes clear as you peruse this place, JW was a (probably benevolent) ruler.

The office, which is behind glass, is just as he left it when he died in 1922. He had a fine view of Philadelphia, and in front of the window that overlooks the city is a silver cup, about two feet high, that was made from melted dimes and was presented to him by his faithful employees on the twenty-fifth anniversary of the opening of his "new kind of store." There is also a collection of ceramic cats, JW's favorite animal because, as he remarked, "they can't talk back."

A bust of JW, who lived from 1838 to 1922, reveals a handsome man with high cheekbones and a bow tie. It doesn't take long to get the gist of his personality, for he was never one to hold back an opinion. In fact, he was rather given to pontificating and published thousands of newspaper advertisements that were printed to look like editorials. From the selection here you may read this, published on June 8, 1922: "It is Sheer Waste of Time to Dress Yourself Up in borrowed garments to appear wiser and better than you will deserve. . . . Be content to light and carry the little candle that belongs rightly to yourself, and strive vigorously to connect up with electric wires of learning and experience."

"The Continental European strains of Mr. Wanamaker's heritage added to his tendency to thrift, the love of industry and to the instincts of cleanliness and color," one of the explanatory labels tells visitors. A framed copy of the *Press,* datelined Philadelphia, July 12, 1915, has a story headlined "John Wanamaker, with 61,262 votes, Wins Proud Title of Greatest Pennsylvanian." The subhead goes on: "Hall of Fame Contest Inaugurated by The Press closes with a ballot total 321,386."

For a slice of life, a slice of history, and a true sense of who JW was, and perhaps a lesson or two in morality-whether-you-like-it-or-not, this is a terrific little museum. Elevators make it accessible. As for children, well, you could consider it in the nature of medicine that's good for them (or not). Half an hour will set you right.

✺ Mummers ✺

MUMMERS MUSEUM
Two Street and Washington Avenue
Philadelphia, Pennsylvania 19147
Phone: 215-336-3050
Director: Norma Gwynn
Hours: Tuesday through Saturday 9:30–5:00, Sunday 12:00–5:00
Directions: The Mummers Museum is in South Philadelphia.

When it comes to razzle-dazzle, sequins, feathers, and glitter, satin, velvet, and gold lamé, there is absolutely nothing quite like the Mummers Museum. Even the outside of the building, which sits on a corner in South Philadelphia, is one of the most colorful you are ever likely to see—a geometric pattern of blue, orange, and green climbs the walls against a yellow background.

Who are the Mummers? They are the lavishly costumed marchers who parade up Broad Street in Philadelphia every New Year's Day. Their theme song is "Oh, Dem Golden Slippers," and they do an odd step called the strut (probably an adaptation of a nineteenth-century dance called the cakewalk) to the strumming of their string bands. They do it for fun, they do it for tradition, they do it with devotion that is beyond belief.

The parade is actually a competition among a number of clubs made up of people from all walks of life. Awards for first prize may be as high as eight thousand dollars, but considering the cost of the costumes, the effort has to be for fun rather than profit. In the Winners' Circle at the museum I saw a black velvet creation studded with rhinestones and gold lamé and framed with fans of ostrich feathers. With ostrich plumes at something like forty dollars a dozen, and a costume like this using maybe ten dozen plumes, a winner just might make back the money for one creation. But the mummers use the prize money to throw a party for themselves and friends anyway.

Question: What is 2.55 miles long, 69 feet wide, 12 feet high, and covered with feathers? Answer: The Philadelphia Mummers Parade. To the thousands who march in it, the parade is a powerful commitment, and it usually becomes a family affair. Palma Lucas, who showed me around the museum, has been making costumes for about fifteen years. Her father was a mummer, her husband has been marching in the parade since he was seven years old, and her own

children have joined the parade. The only age limitation is that a child must be old enough to walk.

Costumes are on display, and a wall with portholes at different heights lets you see, in a mirror, what you would look like in a mummer's costume. At the head of the stairs to the second floor of the museum is a large, illuminated time alert. The day I was there it announced that there were 245 days, 11 hours, and 20 minutes left until the next parade. A forty-minute film highlights ten of the prize-winning string bands.

This place will fascinate people of all ages. An hour will go by quickly, especially if you stay for the movie.

↬ Philadelphia Physicians ↫

MÜTTER MUSEUM
19 South Twenty-second Street
Philadelphia, Pennsylvania 19103
Phone: 215-561-6050 extension 41
Curator: Gretchen Worden
Hours: Tuesday through Friday 10:00–4:00
Directions: The Mütter Museum is on the western edge of center city
 Philadelphia, between Market and Chestnut Streets, both of
 which are major crosstown transitways.

If you happen to be museum hopping in Philadelphia, and if you happen to go from the Mummers Museum in South Philadelphia to the Mütter Museum on the other side of town—which isn't necessarily a logical progression but is nevertheless the order I took them in—you could experience culture shock. To swing from the lavish extravagance of the mummer costumes to bare, naked skeletons will do it.

Dr. Thomas Dent Mütter, a professor of surgery at Jefferson Medical College from 1841 to 1856, presented his collection of anatomical and pathological specimens and models to the College of Physicians of Philadelphia after he retired. The college is a private medical society organized to gather scientific and medical knowledge, and to this day it actively serves members through its library, lectures, and the museum.

The museum is in a handsome red-brick building, where it occupies two floors, one of which is a mezzanine. "We are the only

nineteenth-century medical museum that still looks the same as it did in the nineteenth century," said curator Gretchen Worden. In a case containing twenty or so skeletons, the frame of a giant, 7 feet 6 inches high, is not far from the bony frame of a dwarf, 3 feet 6 inches high. One creature, especially startling as seen from the mezzanine above, is a woman called the Soap Lady. She died in 1792 and her body was exhumed in 1874. Because she was very fat, the soft tissue of her body, acted upon by chemicals in the earth, was preserved as a sort of fatty wax. Her face, although the features are not easy to recognize, seems to wear an expression of terrible shock at the indignity of this exhumation.

In a case of 140 skulls, it is interesting to note how very different each one is from the others, even though they are all from members of the same racial group. In another case, a fascinating model of a head is accompanied by the newspaper story about the mysterious death of a young woman in 1981. The wax head shows how forensic sculpture could reconstruct the soft tissue surrounding the skull of this woman, whose body had been burned beyond any recognition. Through the reconstruction authorities were able to identify her, although her murderer has still not been found.

There are oddities here such as the medicine chest and walking stick of Benjamin Rush, one of the signers of the Declaration of Independence and a founder of the College of Physicians; a plaster cast of the bodies of the famous Siamese twins Chang and Eng; a tumor that was removed from President Grover Cleveland's jaw during an operation performed in secret in 1883.

This museum is intriguing both for its glimpse into the past of medicine and for the uniqueness of its atmosphere. Very young children would probably be frightened, but older children who are full of curiosity will be fascinated. A visit should take about an hour.

⌒ Antique Toys ⌒

PERELMAN ANTIQUE TOY MUSEUM
270 South Second Street
Philadelphia, Pennsylvania 19106
Phone: 215-922-1070
Director: Leon J. Perelman
Hours: Daily 9:30–5:00
Directions: The Perelman museum is in the area of Philadelphia

called Society Hill. It is in the southeast end of town, close to the Delaware River, on Second Street between Pine and Spruce Streets.

We distinguish ourselves from other animals by our sense of humor: nowhere is that clearer than on the third floor of the Perelman Antique Toy Museum, where you'll find what may be the most extensive collection of toy banks in the country—if not the world. Here you see just how marvelously inventive and how very silly people can be. Small banks have taken the shape of a masked bandit on a silver horse, dogs of almost every description, bears tall and short, and one that is clutching a pig. There are buffalo banks and rabbit banks and a great variety of elephant banks. There are animated banks—put a coin in the slot and an Indian may shoot a bear, a horse may buck a man, or a child holding a dog may slide down a hill on a sled. A Queen Victoria Jubilee bank (1887) will make the queen roll her eyes for you.

Banks are not all. There are all kinds of toys here. One metal invention called "Woman's Rights Advocate" is a clockwork-operated doll of a black woman, looking strident and crazed, on a podium. Its label may be awarded the understatement-of-the-century prize: "Radical and ethnic groups were often grossly characterized in dolls. . . . This toy shows what a long road the woman's movement had ahead of itself in 1893."

One of the most unusual items on the third floor is the midget upright piano. Attached to the keys and perched atop the piano are dolls that move up and down as the notes are played.

On the second floor is a room full of transportation toys—cars, horses, circus wagons. My favorite is a swan chariot called a squeak toy. It originally had a small bellows that squeaked when the swan flapped its wings. The swan sits in front of the carriage, and in a shell-like seat behind it sits a little toy girl in a green dress and a bonnet. One of the strangest transportation toys is dated 1930. It's an old-fashioned motorboat that looks like a powered gunboat, and it's pulling someone on something that looks rather like a sled.

Children can compare their toys with those of their parents and ancestors. Plan about an hour. There is an elevator.

◀ National Association of Watch and Clock Collectors
Columbia, Pennsylvania

∾ Philadelphia Maritime ∾

PHILADELPHIA MARITIME MUSEUM
321 Chestnut Street
Philadelphia, Pennsylvania 19106
Phone: 215-925-5439
President: Theodore T. Newbold
Hours: Monday through Saturday 10:00–5:00, Sunday 1:00–5:00
Directions: The museum is in the downtown historic area of
 Philadelphia, close by the Independence Historical National
 Park, the Liberty Bell, Franklin Court, and the Benjamin
 Franklin Museum. It is on Chestnut Street between Third and
 Fourth Streets.

At the top of the stairs to the second floor of this museum is a dramatic figure of a woman in a flowing white gown. A lamb stands behind her and she holds a dove to her breast. She is called "Peace," and she is the figurehead from a ship, but no one knows which ship. She is believed to be by William Rush, a highly regarded sculptor and Philadelphian who lived from 1756 to 1833. Not only was Rush considered the first American sculptor, but also, according to a biographical sketch in my encyclopedia, "so long as he lived, . . . [he] was the whole of American sculpture." Although he was noted, throughout his life, as the best American maker of ship figureheads, this statue is the only full-length figurehead of his that is known still to exist. It turned up on someone's front porch in Lancaster, Pennsylvania, and a Philadelphia woman bought it to decorate her garden. But the more she looked at it, the more it reminded her of a style of wood carving she had seen elsewhere. Authorities were called in and they agreed it looked like Rush's style. The woman gave the statue to the maritime museum. The only thing is, the figurehead should be set at an angle, as if she were raked against the bow of a ship—which may someday be approximated—but she is glorious all the same.
Each of the many, many maritime museums has its special flavor, and the particular intent of this one is to show the history and influence of the port of Philadelphia. There are models of the Swedish sailing ships that arrived in Philadelphia in 1638, early navigational instruments, shipbuilding tools, and marine art. William Penn chose this site on the Delaware River for his city in 1682, and since then it has been an active harbor.

This museum is small but it has just the right flavor, especially for those who love the sea. Children will enjoy it. Plan on spending about forty-five minutes.

∾ The Rodin Connection ∾

RODIN MUSEUM
Administered by the Philadelphia Museum of Art
Twenty-second Street and the Parkway
Philadelphia, Pennsylvania 19130
Phone: 215-763-8100
Director: Ann d'Harnoncourt
Hours: Tuesday through Sunday 10:00–5:00
Directions: The Rodin Museum is in the northwest corner of center
 city. You can come in via Pennsylvania Avenue, the East River
 Drive, or the Benjamin Franklin Parkway. There is metered
 parking along the streets.

This museum has the largest collection of Rodin sculptures and drawings outside of France, and you cannot but wonder how and why it happened to be assembled in Philadelphia. The answer is straightforward: A benefactor, Jules Mastbaum, who made a fortune in the motion picture industry and headed the Stanley Company of America, acquired the collection during the 1920s with the intention of building a museum for, as he put it, "the enjoyment of my fellow citizens." He died while the project was still under way, but his widow completed it and turned it over to the city.

The sculptor's most famous work, *The Thinker,* sits before the gateway reproducing the facade of the Chateau d'Issy, where it is a headstone for Rodin's tomb. Although this statue has come to define contemplation, it was, in fact, devised by the artist as the focal point for *The Gates of Hell,* the culminating achievement of his career. He worked on the *Gates,* a commission from the French Ministry of Fine Arts, from 1880 until he died in 1917. Rodin used Dante's *Inferno* for figurative inspiration, and the thinking figure was at first meant to be Dante contemplating his poetic creation. It later became the anonymous symbol both of the sculptor's work and of thought.

The Gates of Hell had not yet been cast in bronze when Mastbaum discovered the plaster in 1924. He had two castings made, one for the Musée Rodin in Paris and the other for this museum in Phila-

delphia. After you have passed through the wrought-iron gates that enclose the museum grounds, skirted the formal garden and pool, and climbed the steps to the building, you stand before the representation of hell. It is more than twenty feet high and nearly thirteen feet wide, and there are more than 180 writhing, grasping, straining, wracked figures moving in bronzed anguish on its surface.

Inside the museum, which is all contained on a single floor and quite accessible, are the passion and sensibility that make Rodin come alive as the most unfettered of artists. If you know Rodin's works, you will seek them out. And you will find your way here.

It is difficult to decide whether children would enjoy this museum—it really does depend upon the child. Time—that depends upon you. I'd hazard that you'll spend anywhere from half an hour to an hour and a half.

✸ United States Mint ✸

UNITED STATES MINT
Fifth and Arch Streets
Philadelphia, Pennsylvania 19106
Phone: 215-597-7350
Curator: Eleanor McKelvey
Hours: 9:00–4:30: January through March, Monday through Friday;
 April, Monday through Saturday; May through September, seven
 days a week. October through December, Monday through
 Saturday
Directions: The Mint is adjacent to Independence Historical National
 Park. See page 196.

Peter, the Mint eagle, wings spread wide, is now on the wall in the lobby of the U.S. Mint in Philadelphia. The legend is that early in the nineteenth century a young eagle adopted the Mint as its home and was befriended by employees there. His fame spread: admired and respected, he became known as the Mint bird. Peter had access to every vault and department at the Mint and was well fed with handouts at lunchtime. But one day the flywheel on which he was perched suddenly started. Peter's wing got caught and was broken as he tried to fly away. Despite all efforts to save him, Peter died a few days later. He was mounted and to this day oversees the comings and goings at Philadelphia's fourth U.S. Mint.

This facility was opened in September 1965. On display here is a

series of exceptionally beautiful mosaics that were brought from the
third Mint, which was completed in 1901. These glass mosaics were
created by Louis C. Tiffany, and the panels, with colors that are rich
and vibrant, illustrate the ancient Roman coinage processes of melt-
ing, granulating, annealing or drying, weighing, stamping, and fin-
ishing. The inspiration for this series was a wall painting unearthed
during the excavations of Pompeii in 1895. The ancient version used
cupids, which gave Tiffany the idea of using children as the workers
in his coinage murals. These wall panels are magnificent enough
here, but one can imagine their splendor in their original home,
where they were mounted on white marble walls.

On the second floor of the building is a brick from the very first
U.S. Mint, established by act of Congress on April 2, 1792, in Phila-
delphia, which was then the capital city. This brick is encased in Lu-
cite, which seems rather bizarre. Next to it is set a wrought-iron boot
scraper, which was once a convenience in an era of cobblestone
streets and muddy walks and alleys. Nearby stands a hunk of big
black machinery that was the first coining press.

The contemporary production of coins is explained in a series of
cases in the David Rittenhouse Room. On the third floor a self-
guided tour gives you a look at the actual work in progress here.
However, the tour is somewhat abbreviated now, since some parts of
the process, from weighing the metal to rolling it into sheets, are
being contracted out to private industry. But from blanking to bag-
ging, the coin making can still be watched.

Most children will probably enjoy this visit. The tour plus ex-
hibits may take about an hour.

↔ Earth & Mineral & Art ↔

EARTH AND MINERAL SCIENCES MUSEUM AND ART
 GALLERY
Steidle Building on Pollock Road
College of Earth and Mineral Sciences
Pennsylvania State University
University Park, Pennsylvania 16802
Phone: 814-865-6427
Curator: David E. Snell
Hours: Tuesday through Friday 9:00–5:00, Saturday and Sunday
 1:00–5:00
Directions: University Park is right in the center of Pennsylvania. If

you are coming from the north, take I-80 west to Milesburg. Go south on Route 26 and follow signs to the university. Route 26 intersects Route 322 (Atherton Street). Turn right into the university entrance on Pollock Road and stop at the information booth.

From the south, Route 22 becomes 322 at Lewistown. Stay on 322 to University Park. Then, continue as above.

"I guarantee you've never seen anything like it before" was the comment that sent me off to this museum. What I discovered here was a fabulous tribute to one man's ingenuity and devotion.

Sure, there are numerous mineral museums. The one thing this museum has that none other can boast of is a collection of paintings related to the mineral industries—a surprising number of works that show mining scenes, below and above ground, as well as foundries.

But the most wonderful thing here is the way the exhibits have been mounted. The halls are lined with displays in which the curator, David E. Snell, has designed and built devices that reveal the properties of some of the minerals. For instance, to see the insulating properties of mica you press a button, which shoots an electric charge that arcs over the mica. What better proof? Copper wired to a lamp shows itself, at the press of another button, to be a poor insulator. Five tourmaline crystals dangle at the ends of nylon threads. When their temperature is changed, they begin attracting one another, but you can't predict in advance which two will pull together. One might wager . . .

The exhibits really are fascinating: a piece of flexible sandstone; a quartz wedge that rotates to show a spectrum of colors; a quartz crystal containing a bubble that moves back and forth and that has been trapped inside that crystal for several million years; what "might be the best collection in the country" of "velvet malachite," a rock that looks like deep green velvet, which was acquired at the turn of the century from one of the world expositions. It came originally from Brisbee, Arizona. Inside a dark room is an irresistible display of fluorescent minerals.

This museum has the kind of exhibit that inspires kids to become scientists. It's a great visit for both children and adults. Plan an hour at least if you are really interested.

Little League Baseball International Museum ▶
Williamsport, Pennsylvania

ᘓ Little League ᘓ

LITTLE LEAGUE BASEBALL INTERNATIONAL MUSEUM
Route 15, P.O. Box 3485
Williamsport, Pennsylvania 17701
Director: Jim Campbell
Phone: 717-326-3607
Hours: Monday through Saturday, 10:00–8:00 Memorial Day through
Labor Day, 10:00–5:00 remainder of the year. Sunday 1:00–5:00.
Directions: The Little League complex is located on U.S. Route 15, a
main north-south highway, just eighteen miles north of I-80 in
north-central Pennsylvania.

While I was driving through the streets of Williamsport, I saw three
boys ambling along the sidewalk. I asked them how to find the mu-
seum and got explicit and accurate directions. Then, when I was
about to leave the museum, they arrived. "I would have given you a
ride," I said. "We didn't know we were coming then," one of them
answered, "but I haven't been here in a while."

This really is a fine museum. It would be nice if each of the two
and a half million kids who play on Little League teams could visit
it. When you walk into the lobby you get the impression that you
are in the stadium field behind the building—that is where the Little
League World Series is played. The illusion is created by a photo-
graph of bleachers taken during the 1982 series and blown up large
enough to wallpaper the hall.

Displays and films describe the history of the Little League.
Other displays show how equipment has evolved and why, and how
it is fabricated. A multiple-choice board has just the right touch. For
instance, question 11 is:

> I am permitted only six innings of pitching a week. I am
> a) a major league player
> b) a little league pitcher
> c) a water pitcher

No doubt the biggest attractions are the fenced-in pens where
kids get ninety seconds for pitching and batting. The balls are on ad-
justable tees, and a video camera records the action so the players can
critique their form later.

You won't have a hard time finding out which major league

players got their starts in the Little League, and you can follow the progress of the Little League from its beginnings.

The question here is whether or not to bring adults, and the answer is yes. The building is accessible to handicapped visitors. A tour will take about an hour.

ᐳᐸ Weightlifting ᐳᐸ

BOB HOFFMAN WEIGHTLIFTING HALL OF FAME
Box 1707
York, Pennsylvania 17405
Phone: 717-767-6481
Founder: Bob Hoffman
Hours: Monday through Saturday 10:00–4:00. Guided tours at 1:00.
Directions: York is south of Harrisburg and west of Philadelphia.
 From I-83 take exit 11 to the museum.

The Weightlifting Hall of Fame is in the corporate headquarters of the York Barbell Company, a manufacturing firm founded by Bob Hoffman, also known as the Father of Weightlifting. If anyone epitomizes the successful combination of brains and brawn, it has to be Bob Hoffman, who has expanded and diversified his company to the inclusion of a whole line of fitness equipment, from barbells and benches to clothes, magazines, vitamins, high-protein snacks, and suntan lotion.

In the large vestibule of the building is an enormous model of a gold medallion. Colorful pennants hang from the high ceiling and ripple in the air-conditioned breeze. An oil portrait on a far wall is Hoffman in a black and gold brocade dinner jacket with a medal on the lapel. Down a hallway toward the museum, life-size photographs of athletic champions like Julius Erving and Nancy Lopez usher you into the Hall of Fame.

Bob Hoffman's own story is about a man who started exercising vigorously and training with a set of cogwheels on a metal axle that he found in a junkyard when he was ten years old. He didn't only lift weights, he ran marathons and canoed. He founded the York Barbell Company in 1932 and added winners of the Mr. America and Mr. Universe titles to the staff. John Terpak, now York's general manager, collected eleven national titles and two world championships and has coached the U.S. Olympic team. Hoffman also started the York Barbell Club, which has brought home more than fifty na-

tional championships. York's equipment is used in Olympic competitions.

Documentation, trophies, and memorabilia of the Iron Game, as it is called, are on display. In one case is a wide and hefty engraved silver belt that is inset with photos as well as jewels. This trophy used to be awarded by the *New York Police Gazette,* and Hoffman was the last man to have won it. There are statues and busts and photos of some of the mighty men of the past. One sculpture is of John Grimek, who came to York to train for the 1936 Berlin Olympics, has won four gold medals, and is the only man to hold four Mr. America titles. He works here, too, as editor of one of York Barbell's magazines.

In a case that holds four bear statues is a note with the information that Hoffman collects replicas of bears. Many of these creatures are tokens of esteem inscribed to Papa Bear. When York sponsors team travel, the teams endeavor to bring a bear of some description home to Hoffman. Against one wall is a very muscular, full-size Bob Hoffman himself, in bronze, standing on a pedestal; behind him, looming even taller, is a carved bear.

Hoffman is now eighty-five years old but still comes to his glass-walled office every day. He enjoys talking with visitors. Arrangements can be made to watch a film on weightlifting, and if you have any interest in softball, the history of that game is told in another exhibit space, which has been named the official Hall of Fame by the Amateur Softball Association of Pennsylvania.

Athletic-minded children will enjoy a visit here. You can buy sustenance at the snack bar (Hoffman products), and you might spend anything from half an hour to a morning (especially if you are fortunate enough to run into Hoffman) exploring the world of muscle building.

U.S. Naval Academy Museum ▶
Annapolis, Maryland

NEW JERSEY,
DELAWARE, &
MARYLAND

Numbers on map refer to towns numbered on opposite page.

∾ New Jersey ∾

∾ Delaware ∾

∾ Maryland ∾

∞ Soup, Beautiful Soup ∞

CAMPBELL MUSEUM
Campbell Place
Camden, New Jersey 08101
Phone: 609-342-6440
President: Ralph Collier
Hours: Monday through Friday 9:00–4:30
Directions: Camden is just across the Benjamin Franklin Bridge (over
 the Delaware River) from Philadelphia. If you cross there, go
 straight ahead to Route 676. *Follow Campbell Place signs.
 Drive past a red-brick building marked Campbell Soup
 Company: the museum is directly ahead, with parking in front
 of it.
 If you cross via the Walt Whitman Bridge, take Route 676
 north to the Camden business district. Continue from * above.
 If you cross via the Tacony-Palmyra Bridge, proceed to
 Route 73 south to Route 130 south to Route 30 west. Keep to
 the extreme right on Route 30 west. Drive about one mile and
 look for the overpass marked Campbell Place with a little arrow.
 Take the next right, which is marked Exit. Continue from *
 above.
 From the New Jersey Turnpike take exit 4. Then take
 Route 73 north to the Cherry Hill exit (about a third of a
 mile). Take Route 38 west to Route 30 west. On Route 30 go
 about one mile and look for the overpass marked Campbell
 Place with a little arrow. Take the next right, which is marked
 Exit. Continue from * above.

I thought, as we approached, that I smelled the ancient, familiar
scent of tomato soup. But it was my imagination, I'm sure.
 This is no joke of a museum; it is a bona fide collection of soup
tureens. A few are humorous—the large green head of cabbage, for
instance, on which a leaf lifts off for the cover and the handle, or fin-
ial, is a small yellow and brown frog—but most are serious in design
and all are extremely fine pieces of dinner table service. In most ser-
vices the soup tureen is the largest single object and shows pattern
and design to their best advantage.
 Many of the tureens in this museum (which is wallpapered in a
deep, velvety red that adds to the sense of luxury) are from royal
houses. There are tureens and ladles from nearly two dozen European

nations and from China; there is porcelain, silver, tin-enameled earthenware, and lead-glazed earthenware. Some bear familiar marks such as Wedgwood, Delft, and Meissen; some are elaborate and rococo, while others are eloquently simple. Consider number 110: "Tureen with stand; tureen hard-paste porcelain; stand ormolu and leather; Germany, Prussia, Berlin, 1823/25." The stand is decorated in bas-relief with a repeating motif that looks like an angel petting a lioness. The tureen, supported on the backs of lions, is decorated with finely painted views of Berlin and bands of beautiful, brightly colored flowers. The finial resembles an eagle. This magnificent tureen was part of a large dinner service of more than 356 pieces made for the marriage of Prince Frederick of the Netherlands to Princess Louise of Prussia in 1825. Think of that the next time you open a can of soup.

This is not a collection that will interest children. It should take half an hour or so to see. Except for a few steps to the door, it is all on one floor.

ᘯ Fore! ᘯ

U.S. GOLF ASSOCIATION MUSEUM AND LIBRARY
Golf House
Route 512
Far Hills, New Jersey 07931
Phone: 201-234-2300
Librarian/Curator: Janet Seagle
Hours: Monday through Friday 9:00–5:00, Saturday and Sunday
 10:00–4:00
Directions: Far Hills is east of Newark. Golf House is on New Jersey
 Route 512, about two miles east of U.S. Route 202, near I-287.

Among New Jersey's rolling hills, in an elegant, 1919 home designed by John Russell Pope, is a top hat full of feathers. A Scottish high hat was used, until the mid-nineteenth century, to measure just how many feathers were needed to stuff a golf ball (the cover of the ball was leather in those days). The feathers were boiled and forced into a sheath. Then came gutta-percha stuffing and finally the rubber used today. Interestingly, you also see here how the shape of the golf club was redesigned to accommodate the material of the balls.

Displays at the golf museum trace the history of golfing. There is also a variety of art work associated with the sport, from appealing

Harry Rountree watercolor illustrations for the book *The Golf Courses of the British Isles* to an oil painting by President Dwight D. Eisenhower of the sixteenth hole of the Augusta National Golf Club, to wonderful caricature lithographs from *Vanity Fair*. Clubs of many presidents and some scorecards are on display. One surprise is that John F. Kennedy, although he was never known for this achievement, was probably the most accomplished golfer among all our presidents.

Famous golfers are represented by their clubs. Over the years it has become traditional for the winner of a USGA championship to give the association a club. The museum also has a club that astronaut Alan Shepard used to tee off on the moon, trick clubs, "fancy faces" with ivory inlaid in the wood club, and all manner of golf-related paraphernalia from trophies to ice cream molds.

This museum isn't for children. Forty-five minutes to an hour should take you through. Students of the sport will be interested in learning that the library is believed to contain the most extensive collection of golf-related books anywhere.

ᴄⱳ Seashells ᴄⱳ

DELAWARE MUSEUM OF NATURAL HISTORY
Route 52, Box 3937
Greenville, Delaware 19807
Phone: 302-658-9111
Director: Barbara N. Butler
Hours: Monday through Saturday 9:30–4:30, Sunday 12:00–5:00
Directions: The museum is located on Route 52 (the Kennett Pike)
 five miles northwest of Wilmington.

"We are not the largest," said my guide, Dr. Russell Jensen, as he ranked collections of shells in North America, citing "the Smithsonian, Philadelphia Academy of Natural Sciences, Harvard, Field Museum in Chicago, McGill University . . . and, (in sixth place) we're neck to neck with San Diego."

"Considering we've only been in existence for thirteen years," Dr. Jensen enthusiastically continued, "that's pretty impressive."

The Delaware museum is in Du Pont country, and John E. Du Pont, an amateur naturalist who specializes in birds and seashells, is the patron in charge. As a collector, Du Pont doesn't just like to buy

pretty seashells—he dives for them. He has even used submarines to dive in search of rare specimens.

This museum opened to the public in 1971 with a nucleus of 100,000 shells. By spring of 1983 the staff had catalogued 1,670,000. The backbone of the collection is on the second floor, in the business part of the building, and is stored in row after row of metal cabinets in the largest room in the world dedicated to the preservation and study of seashells. It's open to those who have reason to examine the collection and who write in advance for permission.

For the museum hopper, the shells in the display on the first floor are worth a stop. The exhibit is organized in an educational manner, beginning with a simple question—"What is a mollusk?"—and, of course, the answer. Some very startling information is also presented in a case that shows the proliferation of a certain kind of clam. The clam was brought to this country by Chinese laborers, perhaps those who helped to build the railroad. The shells dropped into streams were transported by birds to other streams and, the exhibit reveals, their multiplication has been so rapid that they have taken over and choked freshwater streams all over the Delaware Valley. It looks pretty worrisome.

The miscellaneous education here is a lot of fun—how the scallop shell became a sign that someone had participated in the Crusades, how purple came to be the royal color (people in a Mediterranean village destroyed almost all the mollusks that produced the violet dye). At one spot you walk over a re-creation under glass of the barrier reef. And in a case against a dark background is one of the most expensive shells in the world, although you might not even be impressed enough to pick it up if you happened upon it at the beach. But there is one shell here that I'd almost go all the way back to see again. It is a masterpiece of a cameo from Florence, Italy, that is carved on a large West Indian helmet shell.

Children will love this museum. It will take almost an hour for careful examination of the shells, and while you are there, the rest of the natural history collection is worth taking in.

⋙ Weapons ⋘

U.S. ARMY ORDNANCE MUSEUM
Aberdeen Proving Ground, Maryland 21005
Phone: 301-278-3602

ROBERT TYRE JONES, JR.

Curator: Daniel E. O'Brien

Hours: Tuesday through Friday 12:00–4:45, Saturday and Sunday
 10:00–4:45

Directions: From I-95 exit at the Aberdeen Interchange (exit 5), take
 Maryland Route 22 (the Aberdeen Throughway) to the base.
 Or, from U.S. Route 40 (Pulaski Highway), turn onto
 Maryland Route 22. Direction signs are posted at all U.S. Route
 40 turn-off points.

The sight of all those cannons and tanks lined up so carefully in rows
on the smooth-cut green grass was startling. One cannot but wonder
at the ingenuity with which man has invented weapons to destroy
himself. And this museum has the most complete collection of weap-
ons in the world.

As you drive into the base, you have to stop at the guardhouse
for a permit to continue. Take your car registration and identifica-
tion with you and you'll get a visitor's pass to put inside the wind-
shield. Then be prepared, because the outdoor exhibit alone stretches
over an enormous space.

In front of the museum building is an eerie sight—a huge bomb
much taller than the building, with its nose to the ground: the T-12
was designed in 1942 as part of the intercontinental bomber pro-
gram. It was meant to fly from the East Coast of the United States to
Europe, where its targets were German submarine pens, and after re-
leasing its payload it was to have returned. Because work was step-
ping up on nuclear weapons, this bomb program was halted. But the
T-12, weight 43,600 pounds, was certainly impressive.

Also quite surprising is the sight of a German railway cannon,
known to the GIs as Anzio Annie. It sits on a rail siding with its
huge gun pointing skyward. Across the road from Annie is an
American gun on a truck bed, the M-65 known as the atomic can-
non.

The museum directors like to point out that the overriding
value of the collection is its research value, for each object represents
an engineering effort to solve a design problem. Sometimes an old
design is revived, as with the Gatling gun, which was reincarnated as
the Vulcan and developed for use as an aircraft weapon in 1956.

The Ordnance Museum, which gets about 200,000 visitors a
year, will interest children and adults. You can spend well over an
hour there, perhaps even half a day if you are so inclined.

One thing is certain; this is the only way to see all these weap-
ons of war.

◄ U.S. Golf Association Museum
 Far Hills, New Jersey

✌ Sailors Brave & True ✌

U.S. NAVAL ACADEMY MUSEUM
U.S. Naval Academy
Annapolis, Maryland 21402
Phone: 301-267-2108 or 301-267-2109
Director: William W. Jeffries
Hours: Monday through Saturday 9:00–4:50, Sunday 11:00–5:00
Directions: From U.S. Route 50/301 exit at Roscoe C. Rowe
 Highway (Route 70) and follow that road to the state capitol.
 Turn left at the capitol to the first traffic light; turn right and
 take the next left to the main gate of the Naval Academy.

Well-trimmed shrubs, well-clipped grass, handsome buildings, glis-
tening water—on a sunny spring day it is hard to imagine a stroll
around any more beautiful complex than the grounds of the Naval
Academy. It seems so peaceful that even inside the museum you
must jog your mind to remember that warfare is the basis for a
strong navy. As the purpose of this collection puts it, *ex scientia tri-
dens* (from knowledge, sea power).

Models of ships on display here are magnificent. The rigging of
some is more intricate than and almost as delicate as a spider's web.
As I stood studying and marveling at one labeled "British Second
Rate, Ca. 1715," from another part of the room I heard a ship's clock
chime the hour with the tone of fine crystal.

Here are all things pertaining to the navy: globes terrestrial and
celestial, ship models, paintings, prints, flags, uniforms, weapons,
medals, sculpture, manuscripts, rare books, photographs, ships' in-
struments and gear, and much personal memorabilia. This place is
the country's premier maritime museum. Among the extraordinary
ship models are seventeen that were built for the use of the British
Admiralty. The 1715-vintage second rate that caught my attention
was one of those, and later, when I asked the curator about it, I was
told that its rigging is "questionable." My momentary dismay disap-
peared upon second thought: in the first place, it seemed impossible
for any human to get such complicated rigging correct; in the second
place, an error in rigging made a couple of hundred years ago is
hardly worth worrying about.

Oil paintings of the USS *Constitution* sent me to my reference
books when I returned home. Was the Thomas Birch rendering of
the *Constitution* and the *Guerrière* a chauvinistic interpretation by a

patriotic artist? Both ships are engulfed in smoke, but the American flags on the *Constitution* fly proudly, while the *Guerrière* is in terrible shape. Well, of course, the *Constitution* (now berthed in Boston Harbor) is also known as *Old Ironsides*, and the painting was of the famous engagement during the War of 1812, when the British, whose contempt for American naval prowess created the challenge, were given their comeuppance. "In less than thirty minutes from the time we got alongside of the enemy," reported Captain Isaac Hull, the American commander, "she was left without a spar standing." Another exuberant rendering of *Old Ironsides* presents her in a completely different light: *Celebration of Washington's Birthday at Malta on board U.S.S. Constitution, 1837* shows the colorfully flag-bedecked sailing ship looking more like a pleasure boat than a warship.

A case of class rings of the U.S. Naval Academy has the school rings dating back to 1869 set on dark blue velvet. And the uniforms for enlisted men of 1846 remind us that sailors once wore straw hats. The very fancy saddle given to Fleet Admiral William F. Halsey by the chamber of commerce of Reno, Nevada, is here, as are ship bells and commemorative coins and medals.

This is a spit-and-polish museum of the first order, so it is strangely jarring to see a stained, shabby yellow raft against one wall. But its story is entirely in keeping with naval heroism. This is the raft on which members of a scouting flight crew for the USS *Enterprise* drifted for thirty-four days after their plane crashed into the Pacific at 7:40 p.m. on January 16, 1942. There is a picture of the emaciated crew members when they were rescued, and another reassuring photograph of them later, fattened up and back in uniform. I now have a strong inclination to read Robert Oliver Trumbull's book about this adventure, *The Raft*.

This museum is for all ages. An hour or two will not be too long for one who starts reading labels and thinking about history.

↶ The Babe ↷

BABE RUTH BIRTHPLACE/MARYLAND BASEBALL HALL OF
 FAME
216 Emory Street
Baltimore, Maryland 21230
Phone: 301-727-1539
Director: Mike Gibbons

Hours: April through October 10:00–5:00. November through March
 10:00–4:00. Closed Christmas week, Thanksgiving weekend,
 Easter Sunday.
Directions: The museum is in downtown Baltimore, very close to the
 B & O Museum (see page 225). There are signs along Lombard
 and Pratt Streets. The museum is one block south of Pratt
 Street and one block west of Greene Street.

Under the floorboards of a house where Babe Ruth once lived some-
one found a psalm book with the inscription "George H. Ruth,
World's worse (*sic*) singer, world's best pitcher." With such finds a
curator can enliven a collection.

The exhibits are well done. Even though I had no idea who Earl
Weaver was, the videotape of his last game, narrated by Howard Co-
sell, had enough raw emotion to touch my cynical heart.

There are trophies like the Ned Hanlan Cup that the Orioles
won in 1944, film clips of the Orioles' World Series highlights, Babe
Ruth's jersey, the home-run ball hit by the home-run batter in 1914,
the Most Valuable Player award given to James Emory Foxx (who
was nicknamed Double X), the uniform worn by four-year-old Harry
Howe in 1895 when he was the team mascot (his son gave it to the
museum recently), a life-size bionic model of Babe that moves and,
we're told, sounds like the man who was called the Sultan of Swat.
The Sultan's traveling case (one he used after he retired) is on dis-
play, along with a family photo album and the radio from his New
York apartment, which is fixed up so that his voice comes through
the speaker.

This museum traces the history of the Orioles, skipping the ig-
nominious period during which they went to New York and became
the Yankees, but moving forward from 1954, when they returned to
Baltimore, and not for a moment neglecting their World Series vic-
tory in 1983.

It's enough to make you want to see a ball game, even though I
was more than halfway through the museum before I realized that
Babe Ruth didn't actually play for the Orioles. So what. He was born
here.

Kids will enjoy this place. There are films, videotapes, and all
kinds of audiovisual memorabilia. An hour is probably long enough
for a visit. There aren't provisions for handicapped visitors, however.

∽ Railroad Heaven ∽

B & O MUSEUM
Pratt and Poppleton Streets
Baltimore, Maryland 21223
Hours: Wednesday through Sunday 10:00–4:00. Closed Monday and
 Tuesday.
Phone: 301-237-2381 or 301-237-2387
Museum Manager: Marian E. Smith
Directions: In downtown Baltimore, if you approach from the west,
 you will travel east on Pratt Street. From the east, take Lombard
 Street to Poppleton Street; turn left down the side street to the
 museum. There are signs along the way.

Baltimore is to train fanciers as chicken bones are to my cat—simply
irresistible. Baltimore is the source, the place where, in 1828,
America's first railroad, the Baltimore & Ohio, was born. Should you
for one moment doubt the weight of that event, it will be reaffirmed
as you enter the museum and stand before the first stone laid for the
B & O. Like Napoleon, like Nelson, and like the first president of
the United States of America, that stone rests upon a pedestal. Some
people and some things are simply that important.

On the July day that stone was set, a young, redheaded Irish girl
who'd just recently settled in Baltimore watched the proceedings.
She wore a dress with a delicate leaf pattern and a ruffled neck. She
stored it away, probably as much in awe of the occasion as young
brides are when they save their wedding gowns in the attic. But
today that dress is in a case as part of the B & O memorabilia.

On the second floor of the museum is a large model landscape
reproducing the Potomac Valley near Paw Paw, West Virginia. The
main line HO model train follows the contour of the river; it is the
"Low Line." The "Magnolia Cut Off," or the high line, goes
through a series of tunnels and over bridges. It's fun to watch model
trains chug along.

Fancy polished brass and copper lanterns reflect the era when
trains were the ultimate in high-class transportation. A menu from
the Pullman dining car of the Royal Blue line, dated March 29, 1891,
provides a glimpse of the way it was: blue points on shell, terrapin
soup, and boiled rockfish are a few of the items. The menu also notes
that Hygeia Water is used on the table. On the champagne list G. H.
Mumm Extra Dry was available for four dollars a quart.

I became a trifle nostalgic when I saw a row of passenger coach seats. The first was an elaborately framed red velvet one dated 1872, but the last in line was dated 1955, and I could very well have sat on it. On the walls were station clocks, cases with toy trains, railroad passes, drawings, and prints. An ornate silver service with railroad engravings and figures on it—a knob on the lid of a pitcher, for example, was a railroad bell—was presented to a retiring chief engineer in 1859. A very interesting series of models shows the variety and tells of the engineering feats accomplished by railroad-bridge builders.

The museum is inside the Mount Clare Station, the very place where railroad service was started in this country, where Peter Cooper built and tested the first locomotive, "Tom Thumb," and raced it against a horse (the horse won because a fanbelt broke), and where Samuel Morse strung his first telegraph wires. The splendid roundhouse, the heart of the museum, has a 123-foot-high dome and twenty-three engines and cars, from the double-decker stagecoaches on iron wheels through the steam and diesel age, spanning a century of railroad history.

How long you spend here depends on how much you love railroads and railroad history, or maybe just on how the spirit of the museum strikes you. Children will enjoy themselves, and some short train excursions can be taken.

❧ Chesapeake Bay ❧

CHESAPEAKE BAY MARITIME MUSEUM
Navy Point, P.O. Box 636
Saint Michaels, Maryland 21663
Phone: 301-745-2916
Curator: Richard Dodds
Hours: Summer, daily 10:00–5:00. Spring and fall, daily 10:00–4:00.
 January, February, and March, weekends and holidays only.
Directions: The museum is on a peninsula in the harbor of Saint
 Michaels. Take Route 50 to the Easton bypass (Route 322) and
 take that road to Route 33 into Saint Michaels. You will see
 signs to the museum, but look for Mill Street, where you will
 turn right.

Early in my research I discovered that there are a great many maritime museums. Later I discovered that that is a serious understatement. Consider: there are twenty-two Chesapeake Bay maritime

Babe Ruth Birthplace/Maryland Baseball Hall of Fame ▶
Baltimore, Maryland

museums alone! No, I have not seen them all. But I am assured that this one is the largest such in the area this book covers from Maine to Washington, D.C. It is distinct from the Naval Academy's museum and that of the Naval War College, both of which have a different focus. This collection is entirely concerned only with the bay it overlooks.

Blue crabs, oysters, terrapins, rockfish, and waterfowl have long been harvested in the Chesapeake Bay, and the museum has good and sometimes startling examples of the boats, rigs, and weapons used in their pursuit. There is a working skipjack as well as the largest collection of Chesapeake Bay small craft assembled anywhere. One building has exhibits that trace the history of the bay, and another contains some surprising weapons: an eight-barreled gun, for instance, and another shotgun with a barrel that must be six feet long. Even during the worst days of the Depression market gunners could get five dollars for a pair of canvasbacks. Outlaw hunters used to take lights out onto the bay at night, blind their prey, and shoot.

There are five exhibit areas in the fifteen buildings that make up this museum. One building, a hundred-year-old "screwpile" lighthouse (so called because its legs screwed into the sand), is itself an exhibit. It was moved here from a site about forty miles south of Saint Michaels, where it had sat about half a mile offshore, and is one of the last screwpile residential lighthouses in existence. As you climb inside it, you see displays of the tools that the two men on round-the-clock duty used to keep the lens polished and the oil lamps burning, as well as the domestic items that served their daily lives.

Children will love the Chesapeake Bay Maritime Museum. It is quite easy to get around, although people with disabilities may have to pass up some areas—certainly the lighthouse is inaccessible. A couple of leisurely hours will pass pleasantly.

⌒ Wildfowl ⌒

WILDFOWL ART MUSEUM
Salisbury State College
655 South Salisbury Boulevard
Salisbury, Maryland 21801
Phone: 301-742-4988
Director: Kenneth Basile
Hours: Tuesday through Saturday 10:00–5:00, Sunday 1:00–5:00
Directions: The museum is in Holloway Hall on the campus of

Salisbury State College in Maryland. North/south U.S. Route 13 into
Salisbury intersects College Avenue. Turn west on College and
go until you intersect Camden Avenue, then go south on
Camden to the college campus and the museum.

U.S. Route 50, which runs east and west, also meets
Camden Avenue in the downtown area. Look for and follow
signs to the Wildfowl Art Museum.

Kenneth Basile oversees the largest and finest collection of American
decorative bird carvings made from 1860 to the present, and he is in
awe of them. Part of their appeal is trying to understand just what
the whittler's motivation is, for these carvings are neither decoys nor
sculptures, in the fine-arts sense. They derive from decoy carving, but
they endeavor to reproduce, feather for feather, the live bird. No In-
dian, market gunner, or ordinary hunter ever needed or wanted such
a facsimile. The carvers strive to realize a personal vision that seems
to have been inspired by the muse, yet the occupation grew out of a
utilitarian one. Decorative bird carving, Basile reminds us, is rooted
in hunting, not self-expression. The art form "blossomed from the
carving of the working decoy designed to 'catch a bird' to the decora-
tive carving designed to 'be a bird.' "

Lem Ward of Crisfield, Maryland, is the individual most respon-
sible for the transition from decoy carving to decorative bird carving,
and the collection at Salisbury State College is assembled in his
name. Ward taught and inspired many others, and as he carved he
often spoke poetry—his own.

What of the birds on display here? They are spectacular. This
effect is only in part because, feather for feather and beak for beak,
they may duplicate a live specimen. They are even more interesting
for the undefinable but irresistible spirit with which the artist-carver
has infused them. From black ducks, canvasbacks, and mallards to an
owl that has captured a mouse and a walnut loon emerging from a
walnut lake (it is impossible not to stroke it), these creations are
more like bird spirits than bird sculptures.

The museum also has a more down-to-earth side: a good collec-
tion of decoys that are interesting in their own right and a fascinat-
ing sink-box diorama—in case you ever wondered what it might be
like to sit in the water, surrounded by decoys and wildfowl.

Most certainly bring children here. It will be difficult for dis-
abled people to see the decoy collection on the second floor, but the
decorative birds on the ground floor are pretty accessible. Reserve
forty-five minutes to an hour.

WASHINGTON, D.C.,
& ALEXANDRIA,
VIRGINIA

Numbers on map refer to towns numbered on opposite page.

◌ Washington, D.C. ◌

◌ Virginia ◌

෴ Society of the Cincinnati ෴

ANDERSON HOUSE
Headquarters, Library, and Museum
Society of the Cincinnati
2118 Massachusetts Avenue NW
Washington, DC 20008
Phone: 202-785-2040 or 202-785-0540
Director: John D. Kilbourne
Hours: Tuesday through Saturday 1:00–4:00
Directions: On Massachusetts Avenue between Twenty-first and
 Twenty-second Streets.

This is one of the many grand mansions in Washington. Can one, finally, stop being overwhelmed by the magnificent buildings in this city? I doubt it. The Anderson House was completed in 1906 for an American diplomat, Larz Anderson, who served abroad as an ambassador. It has a circular drive, a pillared entryway, and a front door that opens onto a solemn yet colorful sight: a marble bust of George Washington flanked by brightly colored flags of the states. Anderson, upon his death in 1937, left his house and its contents to the Society of the Cincinnati.

Who belongs to this society and why? It is made up of the male descendants of the officers who served in the regular Continental Army or Navy during the American Revolution, from 1775 to 1783. The members of this extremely elite group number close to three thousand. George Washington was the first president general of the society, Alexander Hamilton was the second. A blue-and-white membership badge was designed by Major Pierre Charles L'Enfant (who later became city planner for Washington itself), the colors representing the alliance between France and America. The name of the group derives from parallels his colleagues saw between the life of George Washington and that of none other than the distinguished Roman Lucius Quinctius Cincinnatus, who was born sometime around 519 B.C. It is all deliciously rarefied.

As might be expected, the objects on exhibit in this splendid palace concern the American Revolution: portraits of the founding members of the society by great painters, including Gilbert Stuart, orderly books, personal letters, and manuscripts as well as medals, swords, glass, silver, and china. A collection of military miniatures

represents the supportive French as well as other regiments of the period in a hall with trompe l'oeil ceilings and marble floors.

Whether or not to bring a child depends a great deal on whether the adult can provide an interesting enough narration to capture the child's attention. The second floor, which is decorated much the way the Andersons left it, is extremely ornate but might make the building less accessible to people in wheelchairs.

⚭ Diseases, Doctors, Instruments ⚭

ARMED FORCES MEDICAL MUSEUM
Armed Forces Institute of Pathology
6825 Sixteenth Street NW
Washington, D.C. 20306-6000
Phone: 202-576-2418 (recording) or 202-576-2348 or 202-576-2341
Curator: Frank B. Johnson, MD
Hours: Weekdays 10:00–5:00, weekends and most holidays 12:00–5:00
Directions: This museum is on the grounds of Walter Reed Hospital,
 which is northwest of downtown Washington. From out of
 town, take the Capital Beltway (I-495) to exit 31 south
 (Georgia Avenue). Go south on Georgia about a mile and a
 half to the District of Columbia/Maryland line. Turn right onto
 Alaska Avenue (U.S. Route 29 south) and continue to
 Sixteenth Street. Go south on Sixteenth Street for half a block,
 then turn left at a gate to enter Walter Reed. Continue on Main
 Drive one-eighth mile to Memorial Circle; there take the road to
 the left (Fourteenth Street) to the next intersection. Turn right;
 the museum is on the left (Building 54).

"I can always tell when children have reached this part of the museum," said Ann Zibrat, an official at the medical museum, as we stood in front of a leg that had been swollen by elephantiasis and preserved in formaldehyde for the past twenty-seven years or so. I was well prepared because children I had met in Washington spoke of it with vivid recollection.

This collection was started in 1862 with instructions to medical officers treating war casualties to "diligently collect and forward to the Office of the Surgeon General all specimens of morbid anatomy, surgical or medical, which may be regarded as valuable; together with projectiles and foreign bodies removed."

One zealous contributor went beyond the call of duty: a Civil War general by the name of Daniel E. Sickles who lost a leg at the Battle of Gettysburg forwarded the limb and the twelve-pound cannon that did it in to the museum along with his compliments written out on his personal calling card. Thereafter the general paid regular visits to the museum, and to his leg in particular. Visitors can still see the general's leg bone and cannon ball and can admire a photograph of the good-natured donor.

A strong stomach is an asset in this museum, but if you've got that and a healthy curiosity, this place offers an extraordinary opportunity to examine the history of medicine. Also, the hall of pathology shows diseases and their development through media such as plaster, wax, and papier-mâché models and through actual organs preserved sometimes in plastic, sometimes in liquid. Many of the models are antique works of art. A skull that appeared to be covered with something like woven hair netting, blue and red, actually showed the network of veins and arteries of the head. A life-size sequence revealing the development of a pregnancy, from the first month through to delivery, is a unique papier-mâché creation that was made in 1890. There is a skeleton of a man who died of rheumatoid arthritis, his body locked in a seated position. Also nightmarish is a startling set of plaster heads from World War I, models of terrible head wounds before and after plastic surgery. Fascinating models show a hospital train from the Spanish-American War of 1898 and a hospital ship of 1862.

One of the most important collections of microscopes in the world is here at Walter Reed. It was started by John Shaw Billings, a volunteer in the Union Army. Today the museum contains over eight hundred light microscopes, and a display shows the development of the microscope from the earliest models to the contemporary electron microscope. There are also medical instruments of all sorts (including eighteenth-century amputation knives used in the Revolutionary War) and a collection of eyeglasses.

An hour is hardly long enough, and if the subject matter is of particular interest, half a day might pass very quickly here. The grounds of the compound are lovely if the weather is fine. Very small children probably won't be interested, but a ten-year-old I spoke with had found the museum interesting. It is all on one floor.

➷ Daughters of the Revolution ➷

DAR MUSEUM
1776 D Street NW
Washington, D.C. 20006
Phone: 202-879-3242
Director: Christine Minter-Dowd
Hours: Monday through Friday 9:00–4:00, Sunday 1:00–5:00
Directions: The DAR building is on D Street between Seventeenth
 and Eighteenth Streets NW, just across from the Ellipse and a
 couple of blocks from the White House.

This museum is a largely undiscovered and untapped resource that
many of us who consider the DAR someone else's club might over-
look. Don't pass it by.

For one thing, it is in a spectacularly beautiful building—al-
though in Washington you almost have to say *another* spectacularly
beautiful building. This one is a beaux arts extravaganza with an
especially interesting interior detail—the staircase has, to commemo-
rate the thirteen original states, thirteen glass pineapple finials. The
pineapple is a symbol of hospitality.

Since the Society of the Cincinnati (see page 234) left women
out, during the late nineteenth century, women of the Revolution
started their own club. The official title is the National Society of
Daughters of the American Revolution, and the first president gen-
eral was Caroline Scott Harrison (wife of President Benjamin Harri-
son), who held the office between 1890 and 1892. A display case
holds a mannequin wearing one of her gowns, a beautiful silk dam-
ask of robin's-egg blue with lace lapels and a beaded fringe around
the waist. Mrs. Harrison was accomplished at decorating china, and
several of the pieces she embellished with lovely floral patterns are
also here.

The museum has collected objects of the decorative arts in sil-
ver, glass, textiles, furniture, handcrafts, and needlework that predate
the Industrial Revolution. These items are displayed in changing ex-
hibitions.

The most exciting parts of the museum, seen on guided tours
led by docents, are the thirty-three period rooms designed and do-
nated by thirty-three states. Each room is very different from the
others. The Maryland room, which was installed in 1967, is decorated
with elegant furnishings and a wallpaper mural that is thought to

have been hand-painted around 1900. The scene is of a colorful battle, commemorating the French Revolution of 1830. By contrast, the Texas room mirrors the pioneer flavor of that state with its simple, undecorated furniture, a turned-down quilt on the bed, at the foot of which is a dome-top chest; there is a cradle, and an oil lamp and a Bible are on the table. The white-painted board walls have a simple, lovely stencil design. The New York state room, with an empire sofa and wallpaper inspired by Chinese design, is elegant, while Georgia chose to be represented by another earthy, simple interior, that of a tavern. This room was furnished by following an inventory of objects in the Peter Tondee Tavern, which operated in Savannah during the Revolution. New Hampshire, a state well known for its independent if not contrary ways, is represented by an attic—with a large collection of childhood games, toys, and dolls of the eighteenth and nineteenth centuries.

Anyone interested in interior design will want to spend a good deal of time here. Children may also enjoy seeing tangible evidence of the kinds of rooms their ancestors lived in. There are elevators.

∽ Byzantine & Pre-Columbian Art ∽

DUMBARTON OAKS
1703 Thirty-second Street NW
Washington, D.C. 20007
Phone: 202-338-8278
Director: Robert W. Thomson
Hours: Tuesday through Sunday 2:00–5:00
Directions: Dumbarton Oaks is in Georgetown, the northwest
 section of the District of Columbia. Wisconsin Avenue is the
 closest major highway into town. Stay on Wisconsin heading
 south; at S Street turn left, heading east until you come to
 Thirty-second Street. You will see Dumbarton Oaks Park and
 the museum.

Robert Bliss and Mildred Barnes were married in 1894 at the ages of eighteen and fourteen respectively. Each was independently wealthy and, after thirty-three years or so in the foreign service, they settled here. Soon afterward they gave the house, its gardens, and their collections of art and books to Harvard University, Bliss's alma mater. If the name of the place rings a bell, it may be because two international meetings held here were known as the Dumbarton Oaks Con-

◀ Caucasian Embroidery, 18th century
 Textile Museum, Washington, D.C.

ferences, and principles later incorporated in the United Nations Charter were developed here.

The house, another one of Washington's magnificent mansions, is also renowned for its landscape architecture—ten acres of formal gardens—and its extensive library of books, manuscripts, drawings, and prints concerning everything that has to do with gardens, from history to plant materials.

Dumbarton Oaks is famous for its Byzantine and pre-Columbian collections. The Byzantine works—metal, enamel, carved ivory, and illuminated manuscripts—are religious in theme, detailed, painstakingly executed. Christ, the Virgin Mary, and the saints are elaborately embossed on silver plates, on minute clasps, and in complex mosaics.

But it is the pre-Columbian wing that takes the breath away and shows the powerful influence of space and montage in viewing art. Bliss, who was eighty-six when he died in 1962, asked architect Philip Johnson to design the gallery that would hold the New World collection that he had begun to acquire in 1914. Johnson's scheme is a brilliant series of glass circles that open onto a fountain. Each circle is a room that contains objects from a certain pre-Columbian (that is, pre–Christopher Columbus) culture, and each work is individually displayed in a translucent case and on a Lucite stand designed by Johnson. There is a seated jadeite rabbit, made by an Aztec some time between 1327 and 1521. A warrior's head in a helmet that resembles an eagle is emerging from its stomach. The back of the figure has a belt carved with a skull-and-crossbones design. Tantalizing. In another room is a colorful mosaic mirror of turquoise, pyrite, and shell, from Peru. Dated 650–900 A.D., it is both naive and elaborate in design, and very beautiful.

The museum could easily absorb an hour or two, the grounds as many hours as you can spare. Children may well enjoy the experience, but it's hard to know.

ᐤᕱᕲ Shakespeare ᐤᕱᕲ

FOLGER SHAKESPEARE LIBRARY
201 East Capitol Street SE
Washington, D.C. 20003
Phone: 202-544-4600
Director: Werner Gundersheimer

Hours: Monday through Saturday 10:00–4:00. Open Sunday
10:00–4:00 from April 15 to Labor Day.

Directions: East Capitol Street starts on the east side of the Capitol
building, and runs between Constitution and Independence
Avenues.

This building houses the largest collection of Shakespeare materials
in the world, assembled by Henry Clay Folger and his wife, Emily,
mostly between 1889 and 1919, when Americans voyaged and pur-
chased works abroad with passion, as if to make us "heirs of eternity"
(*Love's Labour's Lost,* Act 1). Today the library is administered by the
trustees of Amherst College, Folger's alma mater.

Besides the vast collection of books is an exhibition gallery
modeled after the great hall of an Elizabethan manor. Heraldic ban-
ners and coats of arms—including Shakespeare's own family em-
blem—fly above cases filled with texts and walls with paintings.
There are, for instance, various representations of Shakespeare and of
his characters, such as Thomas Sully's 1835 painting of Portia and
Shylock, and Benjamin West's 1793 Lear and Cordelia.

In addition, a theater here is a replica of the typical theater of
Shakespeare's time. It is modeled after an inn yard, with balconies
and a canopy over the stage. The theater can be visited whenever it
isn't being used for rehearsals, for this museum is also the site of an
active theatrical program. The theater season runs from September
through June.

Their age and interest should dictate whether or not children
ought to visit. Half an hour or so will give the flavor, although you
might just find yourself looking into one of the Folger's musical or
theatrical productions.

∾ Abraham Lincoln ∾

FORD'S THEATRE
511 Tenth Street NW
Washington, D.C. 20004
Phone: 202-426-6924
Hours: Daily 9:00–5:00
Directions: The theater is a good walk from the White House area.
Go east on Pennsylvania Avenue from the president's house,
then south on Tenth Street.

The theater where President Abraham Lincoln was shot on the evening of April 14, 1865, as he watched a comedy entitled *Our American Cousins,* was opened to the public, restored to the way it looked on that historic evening, in 1968. It has also been reopened as a live theater, where plays are presented on a regular basis.

In the theater basement is a museum with memorabilia of Lincoln's life and his death. Some of the objects are not authentic but approximate—for instance, a plow and an ox yoke are like those he would have used when he was a boy. Others—a cradle and chair from his home in Springfield, Illinois, his law books, his shaving mug, pieces of the china service he used at the White House—are authentic. All of that is interesting enough, in its way, but benign in comparison with a few of the other objects on display.

In one case is the clothing Lincoln was wearing on the night he was assassinated, including white kid gloves and square-toed high boots. A display called "Conspirator's Exhibit" contains John Wilkes Booth's diary, pocket knife, and pocket compass, which has a beautiful dial on which the directional hand is set into the heart of an eagle. There is a tiny wooden whistle that he was supposed to use to alert his co-conspirators.

But somehow the most chilling object in the exhibit is the one resting on the front page of the *Philadelphia Inquirer* dated April 15, 1865, and headlined "Murder of President Lincoln." Sitting right there is the small, wooden-handled, elegantly engraved 44-caliber derringer pistol from which Booth fired the fatal shot.

Children old enough to have learned about President Lincoln will be interested in this small museum as well as the theater itself; both of them are open for tours. A visit will take about an hour.

⊶ Whistler's Works & Oriental Art ⊶

FREER GALLERY OF ART
National Mall at Jefferson Drive and Twelfth Street SW
Washington, D.C. 20560
Telephone: 202-357-2101
Director: Thomas Lawton
Hours: Daily 10:00–5:30
Directions: The Freer is on Jefferson Drive, two buildings west of the
 National Air and Space Museum.

The Peacock Room haunts me—painted that deep, nearly iridescent blue of peacock feathers, with gold articulation of the wood panels and gold peacocks painted onto the wall. I dream of returning to it and imagine the possibility of sitting there uninhibited by any other obligations or appointments. An oil painting hangs above the fireplace: *Rose and Silver: The Princess from the Land of Porcelain.* She wears an Oriental robe in a room that has an Oriental aura but is above all a self-contained world of still and sensual pleasure. It is the work of James McNeill Whistler (1834–1903), friend and adviser to Charles Lang Freer, who collected both Oriental art and the works of Whistler.

Freer started working in a cement factory at the age of fourteen but made his fortune, associated with the railroad, by the time he was forty-four. He retired then and began collecting works of art. He is respected as a refined connoisseur.

In 1888 Freer was introduced to and became friends with Whistler, who led him to an appreciation of Japanese art—paintings, screens, and pottery. In his will Freer, who died in 1919, bequeathed his collection to the Smithsonian Institution. He was the first American to leave his personal treasures to the nation. The building he commissioned to house the works is in the style of a Florentine Renaissance palace. The Peacock Room was moved here from Detroit.

The Freer Gallery of Art has one of the world's outstanding collections of Asian art and one of the two largest collections of Whistler's works in the world (the other is in Glasgow, Scotland).

Children who visit art museums should visit this one. I'm sure the Peacock Room will impress itself upon them. I would recommend an hour here, at least. Handicapped visitors may enter through the Independence Avenue door; on weekends and holidays, prior arrangements should be made, either with the guard on duty at the main door or by calling the telephone number listed above.

↬ Indians & Eskimos, Mines & Waterways ↫

MUSEUM OF THE U.S. DEPARTMENT OF THE INTERIOR
C Street between Eighteenth and Nineteenth Streets
Washington, D.C. 20240
Phone: 202-343-2743
Hours: Monday through Friday 8:00–4:00
Director: Anne Madden

Directions: The museum is south and west of the White House, about a five-minute walk.

I am grateful to the guard at the U.S. Department of the Treasury who told me to go over and look at the exhibit at the Interior Department. He said it was a really fine museum, and he was right.

The doorway is guarded by a large buffalo head, and the first part of the exhibit is devoted to American Indians (the Bureau of Indian Affairs comes under the aegis of the Interior Department). Two large and regal American bald eagles sit in a case, a birchbark canoe hangs from the ceiling. Several dioramas show Indian life and historic events, especially events in the native American's relationship to white people. For instance, one scene represents trading at Fort Union in 1835. There are fine examples of arts and crafts and a magnificent headdress of white feathers with brown tips and a beaded band.

An intriguing diorama to illustrate the responsibilities of another part of the department—the Bureau of Mines—shows Juneau, Alaska, as it looked when a gold mine and mill were in operation. Into the side of the mountain where the mine is dug, a small railroad car travels on tracks and emerges later to dump its contents into the mill. On the far left of the bay a ship is arriving, and you get a glimpse of happy passengers waving.

Also fascinating is a diorama of the Hoover Dam, because it includes a cutaway of the canyon wall to reveal the construction that is involved. An Eskimo exhibit contains some fancy fur boots with beaded tops and, most extraordinary, a jacket made, not of fur, but of feathers. There is certainly great variety in the objects on exhibit here, just as there is variety in the department's authority. One work of art, part of the U.S. Trust Territory display, is labeled "A Palawn story board": it is an intricate legend carved onto a huge slab of wood that is in the shape of a whale.

You can spend an hour or more here. Young children and adults will find objects to capture their attention.

ᘓ Flight ᘓ

NATIONAL AIR AND SPACE MUSEUM
Sixth Street and Independence Avenue SW
Washington, D.C. 20560
Phone: 202-357-2700

National Air and Space Museum ▶
Washington, D.C.

Director: Walter J. Boyne

Hours: Daily 10:00–5:30. Free tours at 10:15 and 1:00.

Directions: The museum is along Independence Avenue between Fourth and Seventh Streets. There is underground pay parking beneath the museum. Enter the garage on Seventh Street between Independence Avenue and Jefferson Drive SW.

This must be one of the most exciting museums in the world, and you don't even have to be interested in airplanes or space flight to think so.

I visited on a lovely sunny day in spring, and before going into the building I had lunch outside—there are tables and a concession on the west side of the building that does a brisk business. Then I entered through a side door, and the first exhibit I saw was "The Golden Age of Flight." It combined planes, newsreels, and mannequins to tell the story of the era from 1919 to 1939. On a roped-in platform is a reproduction of the Gee Bee Model Z called *City of Springfield,* a black and yellow plane that was, according to information presented here, the first of the "distinctive stubby racers." A plaster pilot in the cockpit, an attendant with a clipboard, and a flight mechanic create a scenario. Against a partition, meant to represent a wall, is a handsome piece of concrete with a stylized design and this legend:

> This historic lintel once graced the hangar door at Bowles Field in Agawam, Mass. Located near Springfield, the hangar was built in the Art Deco style with an aviation motif [another reminder of the human drive to embellish anything and everything]. Constructed in 1929, Bowles Field, which once housed the Gee Bees, was closed in 1935.

Meanwhile, on television screens set into the walls, a newsreel film was playing out President Franklin Roosevelt's victory parade to set the exhibit in time. In another scene the *Polar Star,* a silver polar bear of an airplane with wide wooden skis instead of wheels, has an Antarctic backdrop.

There are also exhibits on vertical flight, even a series of mannequins wearing the uniforms of both pilots and flight attendants: a 1971–72 Northeast Airlines stewardess sports a lime-green hot-pants outfit and, next to her, an elegantly dressed Japan Air Lines stewardess of 1977 wears a flowered kimono.

The history of flight continues to the recent past and includes

all the paraphernalia of space flight. In fact, a cobalt-blue flight suit with the name "Sally" above its pocket was added to the exhibits just three months after Sally Ride, a crew member of the space shuttle *Challenger,* became the first American woman to travel in space. Airplanes of every shape and size are on the floor, hanging from the ceiling, and wherever you look. There is a theater where movies are shown and the sensations and thrill of flying become real.

The entire exhibition is a marvel of invention and can take you all of a day or two, or as much time as you can spend there. Everyone loves it, from small children to senior citizens. And it is accessible to all. Wheelchairs free of charge are available in Gallery 100.

ᑎᕞ African Art ᑎᕞ

NATIONAL MUSEUM OF AFRICAN ART
318 A Street NW
Washington, D.C. 20002
Phone: 202-287-3490
Director: Sylvia Williams
Hours: Weekdays 10:00–5:00, weekends and holidays 12:00–5:00
Directions: The museum is between Third and Fourth Streets, on
 A Street, where it is parallel to Constitution Avenue.

The Museum of African Art could hardly be more inspiring.

Two exhibits were mounted when I was there. On the first floor were art and artifacts from Ethiopia. When that country was opened up to tourists during the 1960s, a great wealth of iconographic paintings was discovered, some from as early as the fifteenth and sixteenth centuries. These works, sophisticated in their simplicity, are also marvelously original in their interpretations of the Madonna and Child.

But it was on the second floor, through the exhibit called "African Mankala," that I was reminded of both the singularity and the universality of humankind. *Mankala* is a game, some say the oldest game in the world, that involves moving a predetermined number of objects (maybe seeds, maybe shells, or maybe even dung balls) from one cup or hole to another on a board, or a reasonable facsimile thereof. The goal is to capture the majority of the pieces.

In one form or another and with a variety of names, *mankala* is played on every continent. The most ancient example of it, found in Egypt, is estimated to be thirty-five hundred years old. Besides re-

minding us that people everywhere have always enjoyed mental as well as physical games, the *mankala* boards also show an irresistible impulse toward embellishment and artistry. The African games are austerely plain and functional or spectacularly elaborate and individual. Consider one polychromed wood board made by the Yorubas of Nigeria. It is supported on the heads of carved figures of people and animals and is devotional in its attention to the spirit of the game. Not many objects speak so eloquently of people's ability to pursue peaceful social pleasures.

The Museum of African Art merged with the Smithsonian in 1979 and in 1986 is scheduled to move from its present location on A Street to a building now under construction along the Mall. On Independence Avenue it will be flanked by other Smithsonian museums, including the Freer Gallery (see page 242).

This is a fine museum, good for children and made accessible to those who must travel in wheelchairs. Moreover, special tours for the blind, deaf, and motor impaired may be arranged by calling in advance (202–287–3490, extension 41, Monday through Friday). I don't know how much space the exhibits will take up in their new quarters, but I'd recommend saving an hour or so.

∾ Textiles ∾

TEXTILE MUSEUM
2320 S Street NW
Washington, D.C. 20008
Phone: 202-667-0441
Director: Patricia L. Fiske
Hours: Tuesday through Saturday 10:00–5:00, Sunday 1:00–5:00
Directions: Heading into downtown Washington from the north,
 both Massachusetts and Connecticut Avenues intersect S Street.
 The museum is on S Street between these two avenues.

This museum is unique in that the collection is made up of textiles produced all over the world and throughout history. (The textile museum in North Andover, Massachusetts, in comparison, is devoted to the history of manufacturing textiles.) Because of the fragile nature of fabrics, displays are not left up for long periods of time; but you can be sure that when you visit you will see representative pieces from the time span covered in the collection—A.D. 300 to the

twentieth century—and everything from richly colored Oriental rugs to bright and outrageous contemporary extravagances. One huge, thick-looped rug in an exhibit called "Country of Origin USA" was shaped as an inviting sofa.

Most visitors to this museum fall into one of three categories: scholars, textile designers, or weavers. The collection is one of the great resources for the study of ancient and ethnographic textiles. The Near and Far Eastern collections are unmatched, and pre-Columbian Peruvian textiles form one of the most extensive such collections in the world. More than a thousand rugs and ten thousand textiles may be studied through photographs if they are not on display. Despite the specialized nature of the resources here, there is much to fascinate one whose interest may be purely dilettantish. You will be able to see avant-garde designs just a few steps away from ancient ones. The building is elegant and, partly because lighting must be controlled, the atmosphere is soothing. A quiet refinement characterizes the setting, which includes a beautiful garden with a dragon fountain that visitors can enjoy.

Don't overlook the location of this museum and, two doors down, the Woodrow Wilson House (see page 250). This section of S Street is called Embassy Row, and passing the stately buildings that house ambassadors from Austria, Laos, and Costa Rica adds a sense of adventure.

I doubt that many young children will enjoy a visit here. I think it might be difficult for wheelchairs to negotiate. The time to spend depends a great deal upon the depth of an individual's interest.

⟶ Making Money, Catching Criminals ⟵

TREASURY EXHIBIT HALL
Main Treasury Building
Fifteenth Street and Pennsylvania Avenue NW
Washington, D.C. 20220
Phone: 202-566-5221
Hours: Weekdays 9:30–3:30
Directions: The museum has a ground-floor entrance just beyond the main entrance to the Treasury Building, which faces the White House on East Executive Avenue. Either Pennsylvania or New York Avenue will take you there, but the street entrance is closed to traffic.

My favorite display in the Treasury Department museum was in the case devoted to the work of the U.S. Customs Service: a stuffed mongoose digging its sharp teeth into a snake that is wound three times around its belly, exotic drug paraphernalia (hookah and various other pipes), and a reminder that customs officials played a major role in identifying the French Connection. And there were several confiscated devices made or adapted for smuggling: a hollowed-out Balinese statue, a hollow leg, and, most intriguing, a cutaway of a good-sized metal tank that has a label warning "Caution, Liquid Nitrogen Only." It was used to smuggle bull semen.

There is a huge coin press like the one at the U.S. Mint in Philadelphia, but of course making money is just part of this department's responsibility. The Bureau of Alcohol, Tobacco and Firearms also comes under its umbrella, and among the displays are various containers that distillers sent to the ATF for regulation of volume measurements. A likeness of John Wayne is on one square bottle, a ceramic statue of Elvis Presley is actually a bottle, and even Martha Washington's likeness decorates a bottle made to hold Kentucky bourbon.

A serious Lefty Luger (plaster), with a serious machine gun ("weapon deactivated," a sign says), guards a beautiful old safe that is opened to reveal gold bricks and coins—behind bars and glass.

The Secret Service also falls under the jurisdiction of Treasury, and there is a mainly photographic display on its work. And a counterfeiting exhibit gives visitors a chance to test their own ability to distinguish real from fake bills.

Four films are shown throughout the day. Children can have fun here and adults will like it just as much. A visit can take up to an hour, or more if you watch the films.

⌘ Woodrow Wilson ⌘

WOODROW WILSON HOUSE
2340 S Street NW
Washington, D.C. 20008
Phone: 202-387-4062
Director: Earl James
Hours: Tuesday to Sunday 10:00–4:00. Closed Mondays and the
 month of January.
Directions: The Woodrow Wilson House is two doors from the
 Textile Museum (see page 248).

The furniture is beautiful, and the decor elegant, but it is some small details that breathe life and character into this house: a Princeton banner, a baseball signed by King George V, the radio microphone through which Wilson spoke to the nation on November 11, 1923, the fifth anniversary of the end of World War I. Wilson enjoyed motion pictures and was able to watch them on his own graphiscope. Particularly evocative is a small portable typewriter with a peculiar circular keyboard. On this Woodrow Wilson wrote his own speeches—no ghostwriters for this world leader. Another interesting detail: the typewriter keys are interchangeably Greek and English. Wilson was the only man with a Ph.D. to have been president.

Woodrow Wilson was the twenty-eighth president of the United States, inaugurated in 1913. He set about establishing the New Freedom platform he'd run on. He pushed for equality of opportunity for all men and for a graduated income tax; he established the Federal Reserve Board and the Federal Trade Commission; and he allowed legalization of unions, peaceful picketing, boycotts, and strikes. When war was inevitable during his second term, Wilson determined to make the world "safe for democracy" and mobilized the nation. His intense efforts to secure world peace won Wilson the Nobel Prize in 1919. But he left the presidency physically worn— he'd suffered a major stroke in 1919—and saw his dream of U.S. participation in the League of Nations defeated.

For just four years he lived in this house as a semi-invalid. He died in 1924. His second wife stayed on and preserved mementos of Wilson's career until she died, in 1961, and left the house and its contents to the National Trust for Historical Preservation, which still administers it.

Mrs. Wilson played piano, and on the music rack of the Steinway is her sheet music—"Oh, You Beautiful Doll" and "Won't You Be My Sweetheart." The kitchen is equipped and furnished as it was during the 1920s, with a cast-iron stove, linen towels, a carpet beater hanging on the back of the door, and, above the stove, my favorite thing—an ice card. It's a piece of cardboard that would be placed in the window to show whether the residents needed 25, 50, 75, or 100 pounds of ice.

Eight rooms of the eighteen-room mansion are open to the public and can be visited during a thirty- to forty-five-minute guided tour. It's not really appropriate for most young children. The house might prove difficult for handicapped people to get around in.

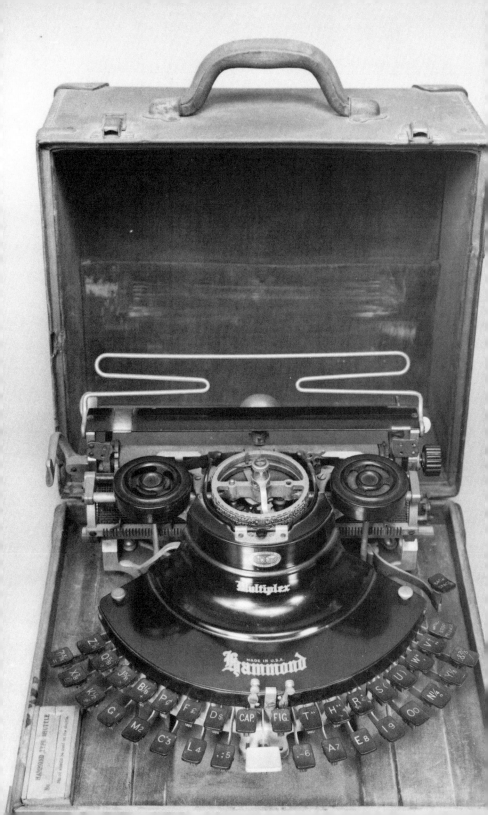

⌘ George Washington ⌘

GEORGE WASHINGTON MASONIC NATIONAL MEMORIAL
Callahan Drive at King Street, P.O. Box 2098
Alexandria, Virginia 22301
Phone: 703-683-2007
Director: E. J. Gondella
Hours: Daily 9:00–5:00
Directions: The Masonic National Memorial is just a mile from the
 Potomac River in Alexandria. Take the George Washington
 Memorial Parkway (Route 1A) to King Street in Alexandria
 and go west on King. You'll have a very difficult time missing
 the memorial, a tall grey tower that looms over all. Route 1 also
 intersects King Street.

His false teeth were porcelain, not wood; he never threw a dollar
across the Delaware (they didn't even make dollars then); and forget
the cherry tree. But he was a Mason, and you can believe that. One
of the most impressive buildings in the Washington, D.C. area,
across the river in Alexandria, is the George Washington Masonic
National Memorial. It stands 333 feet tall, overlooking the nation's
capital and commanding the landscape.

 This stunning memorial to the Freemason's most illustrious
member was built, in 1923, on a site once considered for the capitol
building. The memorial hall is dominated by a seventeen-foot-high
bronze statue of George Washington. Two brightly painted murals
show the laying of the cornerstone of the U.S. Capitol in 1793 (in
another room is a small and beautiful ceremonial silver trowel that
Washington actually used at that event) and General Washington
attending a religious service in 1778.

 Objects on display here are diverse: the president's Bible, the
candle holders that were carried at his funeral, and bleeding instru-
ments used to try to bring him back to health when he was dying are
examples. Some pretty unusual things are here too. An engraving
that shows the site of Washington's tomb is in fact a puzzle. You
can find the hidden profile of the first president if you look very
carefully between the trees. A mourning ring given to Alexander
Hamilton contains a lock of Washington's hair. Another marvelous
memento is Washington's autograph attached to the ribbons of the
very dress a happy lady wore when she acquired that signature. This
is a wonderful collection.

◀ President Woodrow Wilson's Hammond Typewriter
 Woodrow Wilson House, Washington, D.C.

In addition to the memorabilia there are dioramas, small scenes depicting moments in the president's life. One of these is a dramatic model of him and his men in the snowy woods at Valley Forge. But probably the most dramatic item is a mantel clock, plain but elegant, that was forever stopped at 10:20 p.m. on Saturday, December 15, 1799, the moment when the first president of the United States died.

This museum will take over an hour and will certainly impress children and adults of all ages. There are elevators, but people in wheelchairs should probably make arrangements in advance.

⟳ Pharmacy ⟳

STABLER-LEADBEATER APOTHECARY SHOP MUSEUM
105/107 South Fairfax Street
Alexandria, Va. 22314
Phone: 703-836-3713
Directions: South Fairfax Street runs north and south, parallel to the George Washington Memorial Parkway (Route 1A) but on the east side of it, closer to the Potomac River than the George Washington Masonic National Memorial (see page 253).

This museum presents a dilemma. The pharmacy was founded in 1792, and what you will see if you walk in there now is a re-creation of the original drugstore with its collection of more than two hundred hand-blown and hook-necked bottles. The labels are gold leaf, the counters are marble, the incidental woodwork is beautifully carved, and the atmosphere will most certainly give you an idea of what a neat and elegant shop may have been like a hundred and more years ago. But that's not quite where the heart of this collection lies. And that's the rub, because upstairs, where the public is not yet admitted, is a collection so extraordinary that it transports you absolutely to its own era.

"Just think," said the friend who had led me here, "while the Civil War was being waged, they were up here scraping and weighing." On the second floor, above the museum and the antique shop connected to it, is the workplace of the pharmacy, where concoctions were actually assembled. There are ancient chests with drawers that have ceramic knobs and labels reading "Passion Flower" or perhaps "French Berries." Nearby are a table for measuring and mixing the herbs and a drawer with the labels to put on them. There is also a

tray full of small glass bottles with wooden stoppers. They are, to our surprise, bottles designed to contain tooth powder.

Here is the dilemma: the ancient objects and medicinal herbs, powders, flowers, and everything else here are so fragile that there is no way anyone could visit unattended. We were lucky enough to be shepherded by a devotee. How can the museum open the upstairs to the public? It must be done in such a way as to leave the place intact, and however it is done, it will be expensive. But if you have an interest in things like Job's tears, cubeb berries, wicker demijohns, hydrangea root, and all the makings of a drugstore as it was a hundred and more years ago—this is not a reconstruction but a serendipitous discovery—you ought to write in advance and inquire whether you can arrange a visit by special appointment.

This museum is not for children; even the downstairs is quite specialized. It may not even be for the general museum sampler. But for the few who are really interested, it is a fascinating place.

APPENDIX

The museums listed here are either substantial, well-respected museums with membership in the American Museum Association or specialized museums that I could not visit. Remember that hours are subject to change, and weekend hours, especially, tend to be irregular.

<p align="center">*　　*　　*</p>

<p align="center">༄ Maine ༄</p>

MAINE STATE MUSEUM, State Street (Capitol Complex), Augusta, Maine 04330, 207-289-2301. Open: All year.

The natural and cultural history of the state and such industries as lumbering, quarrying, fishing.

ROBERT ABBE MUSEUM OF STONE AGE ANTIQUITIES, Sieur De Monts Spring, Acadia National Park, Bar Harbor, Maine 04609 (mailing address: Box 286, Bar Harbor, Maine 04609), 207-288-3519 or 207-244-7452. Open: Mid-May to mid-October.

A collection of Indian artifacts and tools, some stone implements estimated to be five thousand years old.

BAR HARBOR HISTORICAL MUSEUM, Jesup Memorial Library basement, 34 Mount Desert Street, Bar Harbor, Maine 04609, 207-288-3838. Open: Mid-June through mid-September or by appointment.

In addition to a large collection of early photographs of the resort town, there is documentation of the 1947 fire that ravaged Bar Harbor. This exhibit includes personal accounts and the original *Life* magazine photographs of the disaster.

NATURAL HISTORY MUSEUM, College of the Atlantic, Bar
 Harbor, Maine 04609, 207-288-5015. Open: Mid-June through
 Labor Day.

Special attention to marine life, especially whales. A good museum for children to visit.

BOOTHBAY RAILWAY MUSEUM, Route 27, Boothbay, Maine
 04537, 207-633-4727. Open: Mid-June to mid-October.

Housed in two restored railroad stations are displays pertinent to the steam train era. There are also rides on a narrow-gauge railroad steam train.

BOOTHBAY THEATRE MUSEUM, Corey Lane, Boothbay, Maine
 04537, 207-633-4536. Open: July, August, and usually September.
 Make sure to call for an appointment and directions.

A house with working models of theaters and sets, a rare peepshow from the early eighteenth century, knickknacks, memorabilia, photographs, costumes, figurines, paintings, playbills, even John Wilkes Booth's ivory-handled cane.

GRAND BANKS SCHOONER MUSEUM, 100 Commercial Street,
 Boothbay, Maine 04537, 207-633-2756. Open: June through
 September, weekends in October.

One of the last remaining dory fishing boats. There are tours and a movie on the dory fishing business.

BOWDOIN COLLEGE MUSEUM OF ART, Walker Art Building,
 Bowdoin College, Brunswick, Maine 04011, 207-725-8731. Open:
 All year.

Some experts consider this Maine's finest art collection.

STANWOOD WILDLIFE FOUNDATION, Box 485, Ellsworth, Maine 04605, 207-667-8460. Open: Mid-June to mid-October or by appointment.

The museum contains mounted birds, a collection of eggs, and Ollie, the famous barred owl. There is also a fifty-acre bird sanctuary.

SEASHORE TROLLEY MUSEUM, Log Cabin Road, P.O. Box 220, Kennebunkport, Maine 04046, 207-967-2712. Open: April to October and for some special events.

More than twenty-four historic railway cars; trolley rides.

UNIVERSITY OF MAINE ANTHROPOLOGY MUSEUM, South Stevens Hall, University of Maine, Orono, Maine 04469, 207-581-1901. Open: Weekdays while school is in session.

American Indians, Africa, weapon and tool development, fossils, and special Maine displays.

OWLS HEAD TRANSPORTATION MUSEUM, Route 73, P.O. Box 277, Owls Head, Maine 04854, 207-594-9219. Open: May through October, hours vary.

A collection of spiffy old airplanes and cars that really work, and you can see them in action.

LUMBERMAN'S MUSEUM, Route 159, P.O. Box 275, Patten, Maine 04765, 207-528-2650 (office) or 207-528-2547 (Mrs. Hanson, office manager). Open: Weekends Labor Day through Columbus Day or by appointment.

Nine buildings house collections that preserve a graphic record of the lumber industry of northern Maine.

CHILDREN'S MUSEUM OF MAINE, 746 Stevens Avenue, Portland, Maine 04101, 207-797-5483. Open: Year-round.

A hands-on approach, with exhibits on the arts, sciences, and natural history.

PORTLAND MUSEUM OF ART, 7 Congress Square, Portland, Maine 04101, 207-775-6148. Open: Year-round.

Maine's oldest public art museum has a new addition designed by
I. M. Pei. A wide range of American paintings includes seventeen newly
acquired Winslow Homers. There is also European art.

VICTORIA MANSION, 109 Danforth Street, Portland, Maine
 04101, 207-772-4841. Open: Mid-June through Labor Day,
 Tuesday through Saturday.

One of the finest examples of High Victorian architecture, and the
finest Victorian Italian villa in the French style (to be specific) in the
country. Of special note are a flying staircase, Carrara marble fireplaces,
and frescoed walls and ceilings.

WILHELM REICH MUSEUM, Orgonon, P.O. Box 687, Rangeley,
 Maine 04970, 207-864-3443. Open: Irregular hours.

Austrian-born physician-scientist Wilhelm Reich held theories that
were strange and controversial. He invented an "orgone box" to hold
the biological energy he called "orgone." He died in 1957. Exhibits
show biographical material, scientific equipment, his paintings, and
other memorabilia.

JONES GALLERY OF GLASS & CERAMICS, Douglas Mountain
 Road, off Route 107, Sebago, Maine 04075, 207-787-3370. Open:
 June through October.

A major collection of glass and ceramics.

MOUNT DESERT OCEANARIUM, Clark Point Road, Southwest
 Harbor, Maine 04679, 207-244-7330. Open: Daily, except Sunday,
 9:00–5:00.

Exhibits from lobsters and scallops to the tides, sea salts, and the
weather. You can even find out what you weigh under water. Great for
kids.

WELLS AUTO MUSEUM, Route 1, Wells, Maine 04090,
 207-646-9064. Open: Mid-June to mid-September.

More than sixty antique cars, including a 1907 Stanley Steamer and
a 1909 Buick.

⤜ New Hampshire ⤛

CROSSROADS OF AMERICA, Route 302, P.O. Box 436,
 Bethlehem, New Hampshire 03574, 603-869-3919. Open: June
 through October.

World's largest ⁹⁄₁₆-scale model railroad on public exhibit. Also
models of cars, trains, ships, and planes.

NEW HAMPSHIRE HISTORICAL SOCIETY MUSEUM AND
 LIBRARY, 30 Park Street, Concord, New Hampshire 03301,
 603-225-3381. Open: All year, Monday through Saturday.

Fine and decorative arts and a beautiful Concord Coach.

HOOD MUSEUM OF ART, Dartmouth College, Hanover, New
 Hampshire 03755, 603-646-2808. Open: Call for hours.

Look for the frescoes of Mexican artist José Clemente Orozco, who
flourished in the 1930s.

MONTSHIRE MUSEUM OF SCIENCE, 45 Lyme Road, Hanover,
 New Hampshire 03755, 603-643-5672. Open: All year.

Special emphasis on the natural history of northern New England;
children's activities.

R. A. KEMP'S MACK TRUCK MUSEUM, River Street, Hillsboro,
 New Hampshire 03244, 603-464-3386. Open: During daylight
 hours.

Maybe a hundred trucks.

CURRIER GALLERY OF ART, 192 Orange Street, Manchester,
 New Hampshire 03104, 603-669-6144. Open: All year.

The state's major art museum and one of the finest small art muse-
ums in the country. American and European collections, and look for
the copper weather vane of a merino ram and a large Gothic tapestry.

NEW HAMPSHIRE FARM MUSEUM, Route 16, P.O. Box 644,
Milton, New Hampshire 03851, 603-652-7840. Open: June
through October.

Early agricultural tools, artifacts, exhibits, and a set of connected
farm buildings.

THE GAME PRESERVE, 110 Spring Road, Peterborough, New
Hampshire 03458, 603-924-6710. Open: By chance or
appointment.

If you have better luck than I did, and I tried to call and visit on
several occasions, you may get to see the display of more than 1,000
board and card games that date from 1810 to 1920.

STRAWBERY BANKE, Marcy Street, Portsmouth, New Hampshire
03801, 603-436-8010. Open: Mid-April through mid-November
and by appointment.

A ten-acre outdoor museum, a major venture in historic preserva-
tion with working craftspeople.

ᘯ Vermont ᘯ

FLEMING MUSEUM, University of Vermont, 60 Colchester Avenue,
Burlington, Vermont 05401, 802-656-2090. Open: Tuesday
through Friday, and Sunday.

A wide-ranging collection that includes carved ceremonial figure-
heads from New Guinea, seventeenth-century African bronzes, and Eu-
ropean and American works.

DISCOVERY MUSEUM OF ESSEX, 51 Park Street, Essex Junction,
Vermont 05452, 802-878-8687. Open: Daily, with special summer
hours.

A lively, hands-on museum for children, with displays in the natu-
ral and physical sciences, history, and special exhibits on themes such as
the hospital room or prehistoric life.

HILDENE, Route 7, Box 331, Manchester Village, Vermont 05254,
802-362-1788. Open: Mid-May through mid-October.

A splendid 412-acre estate where Abraham Lincoln's direct descendants lived until 1975. It includes not only the house but also the gardens, nature trails, and a lovely gazebo. The property is on the National Register of Historic Places.

SHELDON MUSEUM, 1 Park Street, P.O. Box 126, Middlebury, Vermont 05753, 802-388-2117. Open: Daily, except Sunday, June through October.

In a nineteenth-century home are early hand-forged kitchen utensils, oil paintings, pewter, clocks, dolls—objects illustrating local folkways and folk art.

৵৹ Massachusetts ৵৹

ADDISON GALLERY OF AMERICAN ART, Phillips Academy, Chapel Avenue (Route 28), Andover, Massachusetts 01810, 617-475-7515. Open: Tuesday through Saturday, Sunday afternoon.

On expert authority, this is an excellent collection of the best American artists.

ASHFIELD HISTORICAL SOCIETY, Howes Project, Route 116, P.O. Box 277, Ashfield, Massachusetts 01330, 413-628-4541. Open: Tuesday, Wednesday, and Thursday.

Alvah and George Howes spent twenty-five years, starting in 1881, traveling from town to town in western Massachusetts and photographing families at home, at work and in school. The brothers provided a historical documentation rare in its scope. The historical society owns more than twenty-three thousand negatives and hundreds of vintage prints of what has become known as the Howes Brothers Collection. At least fifty prints are kept on display and thousands are on microfilm.

BOSTON CHILDREN'S MUSEUM, 300 Congress Street, Boston, Massachusetts 02210, 617-426-8855. Open: Every day except Monday.

An imaginative and exciting museum for children, with constantly changing programs and exhibits.

BOSTONIAN SOCIETY, OLD STATE HOUSE MUSEUM, Old
State House, 206 Washington Street, Boston, Massachusetts
02133, 617-242-5619. Open: Daily.

Boston's history is told here.

BOSTON TEA PARTY SHIP, Congress Street Bridge, Boston,
Massachusetts 02210, 617-338-1773. Open: Daily.

Guides in colonial costumes on a working replica of the eight-
eenth-century square-rigged brig *Beaver*. Also a museum that documents
the Boston Tea Party.

ISABELLA STEWART GARDNER MUSEUM, 280 The Fenway,
Boston, Massachusetts 02115, 617-566-1401. Open: Daily except
Monday.

Built in 1902 in the style of a fifteenth-century Venetian palazzo,
the building is beautiful, the collection of art is fine, and the flowering
courtyard is irresistible.

INSTITUTE OF CONTEMPORARY ART, 955 Boylston Street,
Boston, Massachusetts 01505, 617-266-5151. Open: Daily, but
hours vary.

An important center for today's art and artists.

MASSACHUSETTS STATE ARCHIVES MUSEUM, Archives
Division, State House, Beacon Street, Boston, Massachusetts
02133, 617-727-2816. Open: Monday through Friday.

Some pretty interesting documents, such as the Mayflower Com-
pact and John Hancock's copy of the Declaration of Independence.

MUSEUM OF FINE ARTS, 465 Huntington Avenue, Boston,
Massachusetts 02115, 617-267-9300. Open: Tuesday through
Sunday.

One of the country's major art museums, with collections from an-
tiquity to contemporary times.

MUSEUM OF SCIENCE, Science Park, Boston, Massachusetts 01224,
617-723-2500. Open: Tuesday through Sunday.

◀ Boothbay Railway Museum
Boothbay, Maine

A wide ranging museum that shows how ants build nests, birds fly, and machines work. It has a lot of interactive displays.

CAPE COD MUSEUM OF NATURAL HISTORY, Route 6A,
Brewster, Massachusetts 02631, 617-896-3867. Open: Monday
through Saturday.

A natural history museum with more than 225 acres of trail-crossed salt marsh, wooded upland, and freshwater marsh that serve as an outdoor classroom and observatory. Movies on rainy days.

DRUMMER BOY MUSEUM, Route 6A, Brewster, Massachusetts
02631, 617-896-3823. Open: Mid-May to mid-October.

An unusual documentation of the American Revolution, with gigantic oil paintings. The museum is as large as a football field and you are walked through history by guides.

NEW ENGLAND FIRE & HISTORY MUSEUM, Route 6A,
Brewster, Massachusetts 02631, 617-896-5711. Open: Mid-June
through Labor day, weekends until Columbus Day, and
otherwise by appointment.

Fire-fighting equipment, dioramas of major conflagrations like the great Chicago fire of 1871, and, just in case you're not interested in fire, a substantial collection of apothecary jars.

MARY BAKER EDDY MUSEUM, Longyear Historical Society, 120
Seaver Street, Brookline, Massachusetts 02146, 617-277-8943.
Open: Tuesday through Saturday, and Sunday afternoon.

Mary Baker Eddy was the founder of Christian Science. At this headquarters is a hundred-room mansion holding manuscripts, books, photographs, portraits, and memorabilia of Mrs. Eddy and those associated with her. (There are several other historic sites associated with Mrs. Eddy throughout New England. Information about them is available here.)

FOGG ART MUSEUM, Harvard University, Cambridge,
Massachusetts 02138, 617-495-1910. Open: Daily except July and
August, when museum is closed on weekends.

One of the largest university collections, with more than eighty thousand objects from all historical periods and many countries.

HISTORIC DEERFIELD, Main Street, Deerfield, Massachusetts 01342, 413-774-5581. Open: Daily all year, evening hours extended July through October.

Wrapped in the history of the battle to settle the Connecticut River Valley, this mile-long street of a colonial village has twelve buildings devoted to the life and arts of early America.

MARINE MUSEUM, Water Street, Fall River, Massachusetts 02722, 617-674-3533. Open: Every day.

This two-story building, 100 feet by 90 feet, with 17-foot-high ceilings, is devoted to steamships, with more than 150 steamship models that range from ½ inch to 15 feet in length. There are also paintings, prints, and memorabilia.

DANFORTH MUSEUM, 123 Union Avenue, Framingham, Massachusetts 01701, 617-620-0050. Open: All week, hours vary.

A fine-arts museum with six galleries of paintings, sculptures, and so on. Also changing exhibits.

THE SLEEPER-McCANN HOUSE, Eastern Point Boulevard, Gloucester, Massachusetts 01930, 617-283-0800. Open: Mid-May through mid-October.

This home of an antique collector is now a museum of decorative arts. Twenty-six rooms of carefully chosen objects are arranged to show interesting use of color and light for dramatic effect.

GLOUCESTER FISHERMAN'S MUSEUM, Rogers and Porter Streets, Box 159, Gloucester, Massachusetts 01930, 617-283-1940. Open: All year.

This museum is supposed to be open all year, but it was closed one weekday in midsummer when I stopped by. It's a small, hands-on museum with donations, including the skull of a sixty-foot whale, from local fishermen.

HAMMOND CASTLE MUSEUM, 80 Hesperus Avenue, Gloucester, Massachusetts 01930, 617-283-7673. Open: All year.

John Hays Hammond built his house to look like some of the castles that had impressed him in Europe. It is architecturally interesting and has a good collection of medieval and Renaissance art.

WILLARD HOUSE & CLOCK MUSEUM, Willard Street, Grafton, Massachusetts 01519, 617-839-3500. Open: Tuesday through Saturday.

Eighteenth-century life with period clocks made by the four Willard brothers.

HANCOCK SHAKER VILLAGE, Route 20, Hancock, Massachusetts 01237, 413-443-0188. Open: Summer, until October 31.

This living museum is an outdoor village with twenty restored buildings. The most special building is a round stone dairy barn.

NATIONAL MUSEUM OF PRINTING, Office of the President, 645 East Washington Street, Hanson, Massachusetts 02341, 617-826-5617. Open: Call to find out when the museum will open.

The museum has acquired no less than 280 tons of printing equipment, including about 55 presses and 2200 cases of type, but all are currently in storage. When the staff get set up, they intend to have all the presses in the museum in working order and to be able to print everything from a newspaper to wrapping paper. All they need is a building.

WISTARIAHURST MUSEUM, 238 Cabot Street, Holyoke, Massachusetts 01040, 413-534-2216. Open: Tuesday through Saturday afternoons. Closed last two weeks of August.

A nineteenth-century home, now a National Registry property. Changing art and historic theme exhibits. The wisteria blooms in May.

NATIONAL PLASTICS MUSEUM, Old School House, Route 117, Leominster, Massachusetts 01453. For information call Jack

Galvin (617-537-1751), who is in charge of exhibits, or Richard
Flannagan (617-537-8306), a vice-president of the museum.
Opening: Scheduled for 1987.

Leominster, a small city in central Massachusetts, is the home of
the plastics industry, the first place where plastics were manufactured.
This museum will commemorate industry and show current and future
uses of plastics.

DECORDOVA MUSEUM, Sandy Pond Road, Lincoln,
 Massachusetts 01773, 617-259-8355. Open: All week, hours vary.

A changing program of innovative and unique exhibitions espe-
cially of contemporary art works.

A & D TOY-TRAIN VILLAGE AND RAILWAY MUSEUM, 49
 Plymouth Street, Middleborough, Massachusetts 02346,
 617-947-5303. Open: Daily Memorial Day to Labor Day,
 weekends during the winter.

Train buff alert. You'll want to check this out.

SMITH COLLEGE ART MUSEUM, Elm Street, Smith College,
 Northampton, Massachusetts 01060, 413-584-2700. Open: Closed
 Monday and during June. Open afternoons Tuesday through
 Saturday.

This is probably the leading college art museum in the country
(besides Harvard and Yale), and since it's one of my favorite haunts, I
do recommend it.

BERKSHIRE MUSEUM, South Street (Route 7), Pittsfield,
 Massachusetts 01201, 413-443-7171. Open: Closed Monday except
 in July and August, when the museum is open daily.

From art to aquariums—talk about eclectic! There are some im-
pressive paintings by members of the Hudson River School and an ex-
quisite painting by John Singleton Copley. Sounds worth a trip to me.

PLIMOTH PLANTATION, Plymouth, Massachusetts 02360,
 617-746-1622. Open: Daily April through November.

In this seventeenth-century Pilgrim village the people are in costume and they stay in character. Their dress, speech, character, manner, and attitudes put you in a time warp.

PLYMOUTH NATIONAL WAX MUSEUM, 16 Carver Street, Plymouth, Massachusetts 02360, 617-746-6468. Open: Spring through Fall.

The Pilgrim story is told here. If you like wax museums, this is the only one in America devoted to Pilgrims.

PILGRIM HALL, 74 Court Street, Plymouth, Massachusetts 02360, 617-746-1620. Open: Daily, all year.

Pilgrim furnishings, arms, and other possessions are on display here. You will leave Plymouth knowing a great deal about the Pilgrims.

ESSEX INSTITUTE, 132 Essex Street, Salem, Massachusetts 01970, 617-744-3390. Open: All year. Hours vary.

The Institute is responsible for a number of Salem's notable houses and also witchcraft trial records, historical memorabilia, and ongoing witchcraft exhibits.

THE QUADRANGLE, Springfield Library and Museums Association, State Street, Springfield, Massachusetts 01103, 413-737-1750. Open: Daily.

In addition to the George Walter Vincent Smith Museum (see page 78), there are three other notable museums here: the Museum of Science (which has a planetarium), the Museum of Fine Arts, and the Connecticut Valley Historical Museum.

OLD STURBRIDGE VILLAGE, Sturbridge, Massachusetts 01566, 617-347-3362. Open: All year.

An outdoor, living museum re-creates a country town of the 1830s with its center village, mill neighborhood, and agricultural countryside. Interpretive staff in costume.

AMERICAN JEWISH HISTORICAL SOCIETY, 2 Thornton Road,
Brandeis University, Waltham, Massachusetts 02154,
617-891-8110. Open: Monday through Thursday. (Get a parking
sticker at the main gate for lot E.)

The society is the largest repository in the world for original materials relating to more than three centuries of Jewish life in the New World. The permanent exhibit is "Jews in Colonial America" and there are rotating exhibits.

PERKINS SCHOOL FOR THE BLIND, Watertown, Massachusetts
02172, 617-924-3434. Open: Monday through Friday.

The Perkins School has two unique museums. The first is the tactual museum, with collections of many natural history objects. Perkins students have used it for about 150 years. The second museum is called the Blindiana Collection and is primarily a history of the education of the blind. It contains embossed books, maps, and other historic objects. These items have been on loan to the Smithsonian Institution for a traveling exhibit. Make sure that they are back if that's your interest.

CLARK ART INSTITUTE, 225 South Street, Williamstown,
Massachusetts 01267, 413-458-8109. Open: Check hours.

A deservedly well-known art museum with a wide range of fine works from Rembrandt to Winslow Homer.

WORCESTER ART MUSEUM, 55 Salisbury Street, Worcester,
Massachusetts 01609, 617-799-4406. Open: Tuesday through
Sunday.

A substantial art museum.

๛ Connecticut ๛

BLOOMFIELD FARM IMPLEMENT MUSEUM, 441 Tunxis
Avenue Extension, Bloomfield, Connecticut 06002, 203-242-1130.
Open: Daily.

Antique tools and farm instruments are demonstrated.

MUSEUM OF ART, SCIENCE & INDUSTRY, 4450 Park Avenue, Bridgeport, Connecticut 06604, 203-372-3521. Open: Tuesday through Sunday, afternoons only.

Wide-ranging exhibits, from circus life to antique furniture to energy. The museum tries to make visitors see new and innovative integrations of art and technology.

EDWARD E. KING MUSEUM, 840 Main Street, East Hartford, Connecticut 06027, 203-528-5425 or 203-289-6429. Open: Saturday and by appointment.

The odd combination of tobacco and aviation isn't so strange when you consider that these were two major local industries. Models, tools, implements, and products, and some WPA (Work Projects Administration) murals of laborers of the 1930s.

BRANFORD TROLLEY MUSEUM, 17 River Street, East Haven, Connecticut 06512, 203-467-6927. Open: Summer only.

One hundred classic trolleys, a three-mile shoreline ride, and museum displays.

BIRDCRAFT MUSEUM, 314 Unquowa Road, Fairfield, Connecticut 06430, 203-259-0416. Open: Check for hours.

A small museum with dioramas of Connecticut birds and wildlife and changing displays on the state's natural history. An Audubon Society property, adjoining the museum, is a four-acre bird sanctuary.

U.S. TOBACCO MUSEUM, 100 West Putnam Avenue, Greenwich, Connecticut 06830, 203-869-5531. Open: Afternoons Tuesday through Sunday.

Chinese snuff bottles, snuff boxes, Delftware tobacco jars, tobacco store figures, advertising art, Indian pipes, meerschaum pipes—all kinds of pipes.

CONNECTICUT HISTORICAL SOCIETY, 1 Elizabeth Street, Hartford, Connecticut 06105, 203-236-5621. Open: Year-round, hours vary.

Furniture, costumes, prints, books, manuscripts, tavern signs, quilts, and about six hundred portraits, including works of Gilbert Stuart.

DEWITT COLLECTION OF PRESIDENTIAL AMERICANA,
University of Hartford, 200 Bloomfield Avenue, Hartford, Connecticut 06117, 203-243-4100 (curator Edmund Sullivan). Opening: Scheduled for fall 1987.

This is one of the two great private collections of presidential Americana in the country.

HISTORICAL MUSEUM OF MEDICINE & DENTISTRY, 230
Scarborough Street, Hartford, Connecticut 06105, 203-236-5613. Open: Monday through Friday.

A lively, ten-year-old collection of implements, paintings, prints, pharmaceutical materials.

SLOANE-STANLEY MUSEUM, Route 7, Kent, Connecticut 06757,
203-927-3849. This museum is operated by the Connecticut Historical Commission, 59 South Prospect Street, Hartford, Connecticut 06106, 203-566-3005. Open: May through October, Wednesday through Sunday.

Artist, writer, and tool-collector Eric Sloane donated and organized the collection of early American tools and implements. The site of the museum is where an iron furnace produced pig iron.

WHITE MEMORIAL CONSERVATION CENTER, Route 202,
Box 368, Litchfield, Connecticut 06759, 203-567-0015. Open: All year. Check hours.

The state's largest nature center also has a museum of natural history, which contains an extraordinary three-thousand-species butterfly collection (if that is your particular interest, make sure to call ahead for an appointment to see it).

NEW BRITAIN MUSEUM OF AMERICAN ART, 56 Lexington
Street, New Britain, Connecticut 06052, 203-229-0257. Open: Tuesday through Sunday.

A very fine museum, with the oldest museum collection devoted entirely to American art, ranging from early colonial times to the present. Eighteen galleries.

BEINECKE LIBRARY, Yale University, 121 Wall Street, New Haven, Connecticut 06511, 203-436-8438. Open: Monday through Friday.

This building has thin marble panels that admit light (see Vermont Exhibit, page 36). Exhibits include original Audubon bird prints, medieval manuscripts, and a Gutenberg Bible.

CHILDREN'S MUSEUM, 567 State Street, New Haven, Connecticut 06503, 203-777-8002. Open: May weekends, June through August weekdays.

For children three through eight years, a play village with shops, a hospital, and a restaurant.

YALE ART GALLERY, 1111 Chapel Street, Box 2006 Yale Station, New Haven, Connecticut 06520, 203-436-0574. Open: Daily except Monday, hours vary.

Outstanding collection of art from all periods, both European and American. A sculpture garden, too.

LYMAN ALLYN MUSEUM, 625 Williams Street, New London, Connecticut 06320, 203-443-2545. Open: Tuesday through Sunday year-round.

This museum has beautifully displayed decorative arts and a good collection of drawings and paintings.

AMERICAN INDIAN ARCHAEOLOGICAL INSTITUTE, Off Route 199, P.O. Box 260, Washington, Connecticut 06793, 203-868-0518. Open: Year-round.

A research and education center for the study of prehistoric and historic people in Connecticut and New England. Exhibits include a 12,000-year-old mastodon; an indoor, life-size, reconstructed Indian longhouse; an authentic wigwam; and a simulated dig site.

NATIONAL ART MUSEUM OF SPORT, University of New
Haven, West Haven, Connecticut 06516, 203-932-7197. Open: By
appointment, for the time being. Call the number above.

Paintings of hockey players, jockeys, and downhill racers, a portrait
of Jack Dempsey in the ring, and a bronze diver in the midst of a swan
dive and half-twist—this unusual collection is in the only museum ded-
icated to art and sport.

WEBB-DEANE-STEVENS MUSEUM, 203–215 Main Street,
Wethersfield, Connecticut 06109, 203-529-0612. Open:
Year-round.

Three authentically restored eighteenth-century houses. Owned
and operated by the National Society of the Colonial Dames of
America.

↬ Rhode Island ↬

COGGESHALL FARM MUSEUM, Colt State Park, Route 114,
Bristol, Rhode Island 02809, 401-253-9062. Open: Grounds open
all year.

A restored eighteenth-century working farm. Special programs in
the summer.

NEW ENGLAND WIRELESS AND STEAM MUSEUM,
Frenchtown and Tillinghast Roads, East Greenwich, Rhode
Island 02818, 401-884-1710. Open: June through September or by
appointment.

Early radio, telegraph, and telephone equipment; stationary steam,
hot air, gas, and oil engines.

TOMAQUAG INDIAN MEMORIAL MUSEUM, Summit Road,
Arcadia, Exeter, Rhode Island 02822, 401-539-7213 or
401-539-7795. Open: Tuesday, Thursday, Sunday.

Indian cultural center and trading post.

NAVAL WAR COLLEGE MUSEUM, Founders Hall, Coasters
Harbor Island, Newport, Rhode Island 02841–5010,
401-841-4052. Open Monday through Friday and weekend
afternoons from June to September.

Exhibits on the history of naval warfare and the navy in Narragansett
Bay. Models, maps, works of art, weapons, uniforms, and documents.

The history of naval warfare through art and science. Models, maps, documents, and weapons.

REDWOOD LIBRARY, Bellevue Avenue, Newport, Rhode Island
 02822, 401-847-0292. Open: Monday through Saturday.

The oldest continuously used library building in America, the Redwood Library was used by the British during the Revolutionary War. It now holds a fine collection of paintings.

MUSEUM OF ART, Rhode Island School of Design, 224 Benefit
 Street, Providence, Rhode Island 02903, 401-331-3511. Open:
 Daily except Monday. Hours change seasonally.

An internationally respected collection of art, with treasures from ancient Greece and works by contemporary artists.

ᔕᕒ New York ᔕᕒ

NEW YORK STATE MUSEUM, Empire State Plaza, Albany, New
 York 12230, 518-474-5877. Open: Every day.

Thirteen life-size dioramas show scenes from New York state's history, including a lively tenement street scene from the turn of the century. Exhibit themes range from the New York metropolis to Adirondack wilderness in a fabulous marble-faced building.

THE BROOKLYN CHILDREN'S MUSEUM, 145 Brooklyn
 Avenue, Brooklyn, New York 11213, 212-735-4400. Open: Every
 day but Tuesday.

The world's first children's museum, founded in 1899 with the notion of making the entire setting and all that is in it user-friendly. The museum moved into a new building in 1977 and continues to lead the way with interactive exhibits and authentic, first class collections in the areas of cultural and natural history.

ALBRIGHT-KNOX ART GALLERY, 1285 Elmwood Avenue,
 Buffalo, New York 14222, 716-882-8700. Open: Daily except
 Monday.

An outstanding center for contemporary art: abstract impressionism, pop and op and kinetic art, not to mention minimalism.

BUFFALO MUSEUM OF SCIENCE, Humboldt Parkway, Buffalo, New York 14211, 716-896-5200. Open: Monday through Sunday.

From a monarch butterfly model six times actual size to a real live taxidermist who shows how he works, this is a good science museum. They just happen to have the world's largest collection of eurypterids (fossilized sea scorpions).

VANDERBILT MUSEUM, 180 Little Neck Road, Centerport, Long Island, New York 11721, 516-261-5656. Open: Tuesday through Sunday.

On the grounds are a mansion, a planetarium (one of the dozen largest and two or three best-equipped in the United States), and a Hall of Fishes filled with intriguing marine specimens collected by William K. Vanderbilt during his round-the-world voyages. There are also beautiful gardens.

MUSICAL MUSEUM, Route 12B, Deansboro, New York 13328, 315-841-8774. Open: Every day, April through December.

Wonderful old juke boxes, a mechanical violin, a French hurdy-gurdy, hand-cranked organs, even a forty-three-whistle Tangley compressed-air calliope.

RADIO AND COMMUNICATIONS MUSEUM, East Bloomfield, New York. For information contact Bruce Kelley, Holcomb, New York 14469, 716-657-7489 or 716-244-9519. Open: Irregular hours.

Equipment actually used during the first years of wireless, telegraph, telephone, phonograph, radio, and television.

VANDERBILT MANSION, National Historic Site, New York–Albany Post Road, U.S. Route 9, Hyde Park, New York 12538, 914-229-7770. Open: Every day.

◄ American Museum of Immigration, Statue of Liberty
New York, New York

Yet another opportunity to see how the very, very wealthy lived. Besides the mansion, Frederick Vanderbilt's carriages and automobiles are on display in the coach house. The Renaissance-style gardens have been restored.

AMERICAN MUSEUM OF IMMIGRATION, Statue of Liberty, Liberty Island, New York, New York 10004, 212-732-1236. Open: Daily. The Statue of Liberty is reached by Circle Line Statue of Liberty Ferry, which leaves from Battery Park in lower Manhattan every hour on the hour. (For ferry ticket and schedule information, call 212-269-5755.)

The museum is in the base of the statue. The exhibit combines pictures, first-person accounts of immigration, the statue's original torch (removed during the 1984–1985 renovation), actual objects that accompanied immigrants to the New World. Visits are usually about a half an hour.

AMERICAN MUSEUM OF NATURAL HISTORY, Central Park West at Seventy-ninth Street, New York, New York 10024, 212-873-4225. Open: Every day.

As the brochure says, in one afternoon you can see how life began and how it may end. This is one of the world's major museums. Among the very special items on display in the thirty-eight halls and galleries are an ancient armadillo the size of a pony and the famous Star of India sapphire. There are three thousand artifacts and artworks from Turkey to Japan, Siberia to India.

CENTER FOR INTER-AMERICAN RELATIONS, 680 Park Avenue, New York, New York 10021, 212-249-8950. Open: Tuesday through Sunday.

The purpose of this center, founded in 1966, is to make U.S. citizens more aware and appreciative of the other cultures of the Americas. Changing exhibits have shown a great variety of works—for instance, Peruvian pottery, paintings by Cubans working in New York, and pre-Columbian sculpture.

COOPER-HEWITT, Smithsonian Institution's National Museum of Design, 2 East Ninety-first Street, New York, New York 10128, 212-860-6868. Open: Daily except Monday.

The only museum in America devoted solely to historical and contemporary design. Collections and exhibits include everything from tea-

pots to furniture, jewelry, fabrics, and building design. Exhibits change regularly.

HOLY LAND MUSEUM, Marble Collegiate Church, Fifth Avenue
at Twenty-ninth Street, New York, New York 10001,
212-686-2770. Open: Hours are limited—Tuesdays 10:00–4:00 and
Sunday after church at 12:15.

The subject and collection are unique. Artifacts and ancient costumes from the Holy Land, Palestinian pottery, jewelry, coins, rugs, and musical instruments. Mid-East lamps, flowers, trees, and more.

FRICK COLLECTION, 1 East Seventieth Street, New York, New
York 10021, 212-288-0700. Open: Daily except Monday.

This art museum holds some of the finest works of European masters of the fourteenth to nineteenth centuries. There are also changing exhibits.

SOLOMON R. GUGGENHEIM MUSEUM, 1071 Fifth Avenue (at
Eighty-eighth Street), New York, New York 10028,
212-360-3500. Open: Daily except Monday.

One of the most extraordinary museum buildings in the world, designed by architect Frank Lloyd Wright, the Guggenheim holds important works of modern art. There is an especially extensive collection of works by Marc Chagall. Changing exhibits complement the permanent ones.

JACQUES MARCHAIS CENTER FOR TIBETAN ART, 338
Lighthouse Avenue, P.O. Box 296, Staten Island, New York
10306, 718-987-3478. Open: Weekends.

The largest collection of Tibetan art in the Western Hemisphere.

METROPOLITAN MUSEUM OF ART, Fifth Avenue and
Eighty-second Street, New York, New York 10028,
212-879-0421. Open: Daily except Monday.

One of the largest art museums in the Western Hemisphere and one of the half-dozen greatest. More than three million works of art and

hundreds of world-famous masterpieces. The new American wing is fabulous, and the entire museum is an exciting place.

MUSEUM OF MODERN ART, 11 West Fifty-third Street, New
 York, New York 10019, 212-708-9480. Open: Daily except
 Wednesday.

This is *the* museum of modern art, with drawings, paintings, sculpture, architectural designs, photography, and film prints from 1880 to the present. You can see the history of modern art unfold here.

NATIONAL ACADEMY OF DESIGN, 1083 Fifth Avenue (at
 Eighty-ninth Street), New York, New York 10028,
 212-369-4880. Open: Daily except Monday.

Founded in 1825, before there were art galleries in New York, the academy had as its purpose the promotion of the arts. Selections from the permanent collection are exhibited throughout the year, and temporary exhibits change every month or two.

QUEENS MUSEUM, New York City Building, Flushing Meadow,
 Corona Park, Flushing, New York 11368, 718-592-5555. Open:
 Daily except Monday.

The museum is housed in one of the two buildings that remain from the 1939–40 World's Fair. It was opened in 1972 to provide a cultural center for the two million residents of Queens. There are changing exhibits and one permanent extravaganza: "Panorama of the City of New York," a nine-thousand-square-foot, detail-perfect architectural model of the city's five boroughs (the scale is 1 inch equals 100 feet).

WHITNEY MUSEUM OF AMERICAN ART, 945 Madison
 Avenue, New York, New York 10021, 212-570-3600. Open:
 Daily except Monday.

Major works of major twentieth-century American artists: Georgia O'Keeffe's *White Calico Flower,* for instance, and George Bellows's painting of the prizefighters Dempsey and Firpo. It is the most important public institution devoted to the work of living American artists.

SHAKER MUSEUM, Shaker Museum Road, Old Chatham, New
 York 12136, 518-794-9100. Open: May through October.

Only one other collection of Shaker materials (in Cleveland, Ohio) surpasses this one. In addition to agricultural equipment, furniture, and household items, the museum has more than three hundred baskets and many pre-1840s molds used to make them, textiles, and five thousand tools used in blacksmithing, carpentry, joinery, coopering, box making, and basket making.

ALLING COVERLET MUSEUM, 122 William Street, Palmyra, New York 14522, 315-597-2212. Open: Afternoons, daily June through September.

The largest collection of coverlets in the country. Coverlets, like quilts, were both utilitarian and decorative, with simple, geometric patterns in deep blues, burgundies, and browns.

ROCKWELL KENT GALLERY, State University of New York at Plattsburgh, Plattsburgh, New York 12901, 518-564-2813. Open: Weekdays.

Paintings, drawings, and prints by Rockwell Kent (1882–1971), whose long and varied life included lobstering, ship's carpentry, and dairy farming, as well as his career as an artist, printmaker, illustrator, and political activist.

NATIONAL WOMEN'S HALL OF FAME, 76 Fall Street, Seneca Falls, New York 13148, 315-568-8060. Open: Every day.

A place where America's most outstanding women are honored and a place where many women feel enlightened and even uplifted. The stories of leaders like Susan B. Anthony and Harriet Tubman are told.

GLADDING INTERNATIONAL SPORT FISHING MUSEUM, Octagon House, South Otselic, New York 13155, 315-653-7211. Open: May 30 through Labor Day.

Guaranteed to fascinate fishermen, this museum has one of the largest collections of fishing memorabilia in the world.

EVERSON MUSEUM OF ART, Harrison and State Streets, Syracuse, New York 13202, 315-474-6064. Open: Daily except Monday.

In this impressive new building designed by I. M. Pei are four main galleries with sculpture, paintings, and an unusually fine collection of twentieth-century ceramics.

MUNSON-WILLIAMS-PROCTOR INSTITUTE, 310 Genessee
Street, Utica, New York 13502, 315-797-0000. Open: Daily
except Monday.

Among central New York's leading cultural and arts organizations.
One of the most famous works here is Thomas Cole's four-painting se-
ries the *Voyage of Life.*

U.S. MILITARY ACADEMY MUSEUM, West Point, New York
10996, 914-938-4011. Open: Daily.

A Revolutionary War fort and museum of the U.S. Army.

ᴏⱽᴏ Pennsylvania ᴏⱽᴏ

ANTHRACITE MUSEUM OF ASHLAND, Pine and Seventeenth
Streets, Ashland, Pennsylvania 17921, 717-875-4708. Open:
Tuesday through Sunday all year, and Monday during the
summer.

Focuses on the mining and processing of anthracite.

MORAVIAN MUSEUM, 66 West Church Street, Bethlehem,
Pennsylvania 18018, 215-867-0173. Open: Tuesday through
Saturday afternoons. Closed during January.

The above address and telephone number will enable you to ar-
range a walking tour of Bethlehem's Moravian community and to make
an appointment to see the Apothecary Museum, below. The Moravian
Museum is in a house built in 1741, and was the first place of worship in
America for early Moravian settlers. The collection reflects the life of
members of this religious sect.

APOTHECARY MUSEUM, Rear 420 Main Street, Bethlehem,
Pennsylvania 18018. Open: By appointment only. To arrange a
visit, call 215-867-0173 or write in care of the Moravian Museum
on West Church Street (see listing above).

The Apothecary Museum has retorts, grinders, mortars and pestles,
scales, blown-glass bottles, labels, and a set of Delft jars from the eight-
eenth century.

Pennsylvania Academy of the Fine Arts ▶
Philadelphia, Pennsylvania

BRANDYWINE RIVER MUSEUM, Route 1, Chadds Ford,
Pennsylvania 19317, 215-459-1900. Open: Daily.

An art museum in a century-old gristmill, especially well known for
works of the Wyeths—Andrew, N.C., and James.

MARY MERRITT DOLL MUSEUM, Route 422, R.D.2,
Douglasville, Pennsylvania 19518, 215-385-3809. Open: Daily.

About fifteen hundred dolls, of a collection of five thousand, are on
display, along with more than forty miniature period rooms and a full-
size replica of a Pennsylvania toy shop of the mid-nineteenth century.

FIREFIGHTERS HISTORICAL MUSEUM, West Fifth and
Chestnut Streets, Erie, Pennsylvania 16507, 814-456-5969. Open:
May through October, Saturday and Sunday, irregular hours.

From a 1927 American La France pumper to a large collection of
fire-department arm patches.

ANTIQUE MUSIC MUSEUM, 1675 Pittsburgh Road, Franklin,
Pennsylvania 16323, 814-437-6301. Open: April to December.

Nickelodeons, organs, and all kinds of music boxes.

SWIGART MUSEUM, Museum Park, Route 22, Huntingdon,
Pennsylvania 16652, 814-643-3000. Open: Daily June through
August. Saturday and Sunday, May, September and October.

Antique cars and the world's largest display of nameplates (the
crests and emblems carried on the front of cars). Also a large display of
license plates.

JOHNSTOWN FLOOD MUSEUM, Washington and Walnut
Streets, Johnstown, Pennsylvania 15901, 814-539-1889. Open:
Daily except Monday.

Documentation of the disastrous May 21, 1889, flood.

BUTEN MUSEUM, 246 North Bowman Avenue, Merion,
Pennsylvania 19066, 215-664-6601. Open: Irregular hours; be sure
to telephone.

This museum (five miles west of center city Philadelphia) is the only one in the country specializing in the study of ceramics. It has an outstanding collection—more than ten thousand objects—of Wedgwood.

MIFFLINBURG BUGGY MUSEUM, 523 Green Street, P.O. Box 86, Mifflinburg, Pennsylvania 17844, 717-966-0233. Open: Call for hours.

This museum is organizing a step-by-step view of the technology of buggy making. A variety of Mifflinburg-made vehicles are on display.

ACADEMY OF NATURAL SCIENCES, Nineteenth Street and the Parkway, Philadelphia, Pennsylvania 19103, 215-299-1000. Open: Every day.

The academy has vast collections of biological specimens. One exhibit demonstrates how a dinosaur skeleton is reconstructed, while elsewhere a flock of extinct passenger pigeons roosts in a forest diorama. A display of giant pandas was the first exhibit of these rare Asian animals in the Western Hemisphere. The specimens were brought back from China in the 1930s.

AFRO-AMERICAN HISTORICAL AND CULTURAL MUSEUM, Seventh and Arch Streets, Philadelphia, Pennsylvania 19106, 215-574-0380. Open: Daily except Monday.

The story of the black diaspora unfolds through artifacts, documents, graphic presentations, and multimedia exhibitions. Black history is traced from its African heritage to the present day, and works of black artists are displayed.

AMERICAN SWEDISH MUSEUM, 1900 Pattison Avenue, Philadelphia, Pennsylvania 19145, 215-389-1776. Open: Tuesday through Saturday.

The story of Swedish immigration and settlement is told in a building modeled after a seventeenth-century Swedish manor house.

FRANKLIN INSTITUTE SCIENCE MUSEUM, Twentieth Street and the Parkway, Philadelphia, Pennsylvania 19103, 215-448-1200. Open: Every day.

In addition to an astronomical observatory and a planetarium, exhibits cover mathematical puzzles, fusion, the heart, airplanes and aerodynamics, printing and paper making, illusions, optics, and a great deal more.

NATIONAL MUSEUM OF AMERICAN JEWISH HISTORY, Independence Mall East, 55 North Fifth Street, Philadelphia, Pennsylvania 19106, 215-923-3811.

A permanent exhibition, "The American Jewish Experience: From 1654 to the Present," provides a chronological overview. (You can learn that twenty-three Spanish and Portuguese Jews arrived in New Amsterdam in 1654, for example.)

MUSEUM OF PODIATRIC MEDICINE, Pennsylvania College of Podiatric Medicine, Eighth Street at Race Street, Philadelphia, Pennsylvania 19107, 215-629-0300. Open: Hours are irregular, call to make sure you can tour the halls of the college.

The museum has about five hundred pairs of shoes, including several pairs donated by first ladies, as well as high-fashion footwear and shoes worn by celebrities like Arnold Palmer.

PHILADELPHIA MUSEUM OF ART, Twenty-sixth Street and the Parkway, P.O. Box 7646, Philadelphia, Pennsylvania 19101, 215-763-8100. Open: Daily except Monday.

International collections: Near and Far Eastern galleries with a famous collection of rugs, an Indian temple, a Chinese palace hall, and a Japanese ceremonial teahouse and temple. American galleries are strong in the work of Thomas Eakins.

PENNSYLVANIA ACADEMY OF THE FINE ARTS, Broad and Cherry Streets, Philadelphia, Pennsylvania 19102, and Peale House, 1820 Chestnut Street, Philadelphia, Pennsylvania 19102, 215-972-7600. Open: Daily except Monday.

Important collection of American art. The academy owns Winslow Homer's *Fox Hunt,* one of the most striking of all American paintings. The Peale House Galleries display a rotating series of exhibitions in all media.

UNIVERSITY MUSEUM, University of Pennsylvania, Thirty-third
and Spruce Streets, Philadelphia, Pennsylvania 19104,
215-222-7777. Open: Daily except Monday.

Ancient Egypt, Mesopotamia, Sumer—more than three hundred
expeditions in thirty-three countries on all continents have brought fas-
cinating artifacts to this museum. There are extraordinary collections of
material from China, the Near East, Greece, Africa, Egypt, the Pacific
Islands, and the Americas.

ANTHRACITE MUSEUM OF SCRANTON, in McDade Park, off
Keyser Avenue, Scranton. Write: RD #1, Bald Mountain Road,
Scranton, Pennsylvania 18504, 717-963-4804. Open: Tuesday
through Sunday all year, plus Monday in summer.

Overlooking the city of Scranton, the museum examines the eco-
nomic and social history of anthracite mining.

RAILROAD MUSEUM OF PENNSYLVANIA, Route 741, Box 15,
Strasburg, Pennsylvania 17579, 717-686-8628. Open: Daily except
Monday.

An extensive collection of locomotives, cars, and related railroad
paraphernalia.

TOY TRAIN MUSEUM, Paradise Lane, P.O. Box 248, Strasburg,
Pennsylvania 17579, 717-687-8976. Open: Irregular hours.

The headquarters of the Train Collectors Association has hundreds
of toy trains, three huge operating layouts, a movie, and some rare spe-
cialty toy trains.

DRAKE WELL MUSEUM, Just off Route 6, RD 3, Titusville,
Pennsylvania 16354, 814-827-2797. Open: June, July, August.

A replica of the world's first oil well at its original site. Exhibits
have working models and dioramas, tools and artifacts of the early oil
industry.

ECKLEY MINERS' VILLAGE, Off Route 940 in Eckley. Write: RD
#2, Box 236, Weatherly, Pennsylvania 18255, 717-636-2070.
Open: Tuesday through Sunday all year, plus Monday in
summer.

Certain buildings along the street are being restored and the visitors' center exhibits illustrate the daily life of miners and their families.

HILLENDALE MUSEUM, Freedoms Foundation at Valley Forge, Valley Forge, Pennsylvania 19481, 215-933-8825. Open: Check for hours.

The installation of this exhibit at Valley Forge is not complete as we go to press. I tried to see the museum before it moved from Mendenhall, Philadelphia, but it had closed the day before I arrived. It sounds interesting. As I understand it, a series of displays lets visitors "discover" America as the explorers did. And, of course, Valley Forge is a stop itself.

⚭ New Jersey ⚭

AMERICAN LABOR MUSEUM, Botto House National Landmark, 83 Norwood Street, Haledon, New Jersey 07508, 201-595-7953. Open: Wednesday through Saturday afternoons.

A rallying place for members of the American labor movement at the turn of the century now serves as a museum. Established in 1982, this is the only labor museum in the country.

WHEATON VILLAGE, Millville, New Jersey 08332, 609-825-6800. Open: Every day.

A substantial glass museum. Crafts such as tinsmithing and glass-blowing are also displayed.

MUSEUM OF DENTISTRY, University of Medicine and Dentistry of New Jersey, 100 Bergen Street, Newark, New Jersey 07103, 201-456-4300. Open: Call for hours.

Artifacts from the dark ages of dentistry can only make us grateful for progress and the present.

❦ Maryland ❦

BALTIMORE STREETCAR MUSEUM, 1901 Falls Road, Baltimore, Maryland 21218, 301-547-0264. Open: June through August.

Displays, exhibits, and a ride on a trolley.

H. L. MENCKEN MUSEUM, 1524 Hollins Street, Baltimore, Maryland 21233, 301-396-7997. Open: Wednesday through Sunday.

Journalist and satirist H. L. Mencken lived here. This small, new museum is sure to become a stopping place for fans of the man who explored the American psyche with wit and wisdom.

NASA MUSEUM, Goddard Space Flight Center, Greenbelt, Maryland 20771, 301-344-8101. Open: Wednesday through Sunday.

Exhibits on the American space flight program and a collection of spacecraft and flight articles.

LADEW TOPIARY GARDENS, 3535 Jarrettsville Pike, Monkton, Maryland 21111, 301-557-9466. Open: Call for hours.

Harvey S. Ladew was an ardent fox hunter. Upon entering the grounds, you encounter a rider and a horse taking a fence in pursuit of fox and hounds—all carved of bushes. The hunt theme is discovered throughout the house—for instance, in the intricate carving of a mirror frame—as are other eccentricities and surprises.

COLLEGE PARK AIRPORT MUSEUM, College Park, Maryland. Write: c/o Maryland National Capital Park and Planning Commission, 6600 Kenilworth Avenue, Riverdale, Maryland 20737, 301-779-2011 weekdays and 301-864-1530 on weekends. Open: Friday and weekend afternoons. Call for hours.

The world's oldest operating airport has exhibits showing its history, which includes the development of the first landing and field lights (1911) and the first army aviation school. Antique and experimental planes are also on display.

ᗩᗩ Delaware ᗩᗩ

JOHNSON MEMORIAL, Bank Lane and New Street, Dover,
Delaware 19901, 302-736-4266. Open: Daily except Monday.

Call the number above for information about the several museums
administered by the Division of Historical and Cultural Affairs. One is
the Johnson Memorial, a tribute to Eldridge Reeves Johnson, an inven-
tor and the founder of the Victor Talking Machine Company, known
today as RCA. Another is the State Museum, which documents Dela-
ware's history.

ISLAND FIELD MUSEUM, South Bowers, Maryland 19963,
302-335-4698. Open: March through November, every day except
Monday.

A prehistoric cemetery of native Americans has been dug up and
turned into an exhibit. A strange, controversial, and fascinating en-
deavor.

DELAWARE ART MUSEUM, 2301 Kentmere Parkway,
Wilmington, Delaware 19806, 302-571-9590. Open: Every day.

The museum has more than five hundred works by Howard Pyle,
the father of American illustration and founder of the Brandywine
school of painting, and other major works.

HAGLEY MUSEUM, off Route 141, Box 3630, Wilmington,
Delaware 19807, 302-658-2400. Open: Daily, hours vary.

Hagley, a two-hundred-acre complex, is an indoor and outdoor mu-
seum of nineteenth-century industry and life, with two dozen restored
homes and mills, including a gunpowder factory and gristmill, and a Du
Pont mansion. Elaborate models and demonstrations show the work-
ings of the industrial system and the machinery.

WINTERTHUR MUSEUM, Route 52, Winterthur, Delaware 19735,
302-654-1548. Open: Daily, hours vary. Call or write for tour
information and appointments.

The Winterthur has 178 rooms of incomparable treasures, furni-
ture, and decorative design from the mid-seventeenth to the mid-nine-

◄ First Ladies Hall
National Museum of American History, Washington, D,C,

teenth century. Henry Francis Du Pont started the collection in 1923 with a simple, eighteenth-century Pennsylvania-made chest and continued his acquisition of Americana, including silver, pewter, ceramics, and textiles.

ᴄᴡ Washington, D.C. ᴄᴡ

The Smithsonian Institution was established by an act of Congress in 1846 for "the increase and diffusion of knowledge among men." Today it encompasses the world's largest museum complex—there are thirteen museum buildings in Washington and New York City. A few of them, like the National Air and Space Museum, have been described in earlier chapters at some length. Several other Washington museums are part of the Smithsonian; they are designated with an * after their name.

The Smithsonian Institution Building itself is at 1000 Jefferson Drive S.W., Washington, D.C. 20560. It is often called the Castle and in its Great Hall is the Visitor Information Center and an exhibition area. The information desks are staffed every day from 10:00 to 4:00. Telephone numbers: 202-357-2700 (voice) or 202-357-1729 (TDD telecommunications device for the deaf).

ARTS AND INDUSTRIES BUILDING*, 900 Jefferson Drive SW, Washington, D.C. 20560, 202-357-1481.

The second oldest Smithsonian building on the Mall is devoted to a display of one of the most extensive collections of Victorian Americana.

CAPITAL CHILDREN'S MUSEUM, 800 Third Street NE, Washington, D.C. 20002, 202-543-8600. Open: Daily, hours vary.

A hands-on museum for learning through doing. There are three major exhibits—International Hall, Changing Environments and Communications. In the communications exhibit, for instance, find out how people got messages across long distances in 500 B.C., in 1740, and in 1940.

HILLWOOD, 4155 Linnean Avenue NW, Washington, D.C. 20008, 202-686-5807. Open: Guided tours given daily except Tuesdays and Sundays. They must be arranged in advance.

Hillwood was the Washington residence of the late Marjorie Merriweather Post. You'll find china services and fine glassware used by Catherine the Great, Beauvais tapestries, and a room of icons, gold and silver chalices, gem-studded Easter eggs.

HIRSHORN MUSEUM AND SCULPTURE GARDEN*,
Independence Avenue at Eighth Street SW, Washington, D.C. 20560, 202-357-1300 (Main number), 202-357-1461 (Information desk). Open: Daily.

Mainly nineteenth and twentieth century sculpture, paintings, prints, and drawings. Particularly well known are monumental sculptures by Calder, Moore, Rodin, and David Smith, which are shown in the sculpture garden and on the museum plaza. Painters whose works are here include Degas, Picasso, and Thomas Eakins.

MUSEUM OF MODERN ART OF LATIN AMERICA, 201
Eighteenth Street NW, Washington, D.C. 20006, 202-789-6019. Open: Tuesday through Saturday.

Latin American art and archaeology and monthly exhibits by Latin American artists.

NATIONAL ARCHIVES, Exhibition Hall, Constitution Avenue at
Eighth Street NW, Washington, D.C. 20006, 202-523-3000. Open: Every day.

The original Declaration of Independence, Constitution, Bill of Rights, and changing exhibits in another building designed by John Russell Pope, this one with bronze doors more than thirty-eight feet high weighing 6½ tons each.

NATIONAL GALLERY OF ART, on the Mall, Washington, D.C.
20565, 202-842-6353. Open: Daily.

One of the finest collections in the world. It has the most comprehensive survey of Italian painting and sculpture in the Western Hemisphere, including the only painting by Leonardo da Vinci outside Europe, a portrait of Ginevra de'Benci. A rich, superb collection in a building designed by John Russell Pope; it is one of the largest marble structures in the world.

NATIONAL MUSEUM OF AMERICAN ART*, Gallery Place, Eighth and G Streets NW, Washington, D.C. 20560, 202-357-3176 or 202-357-2700. Open: Every day.

A comprehensive collection of American art with both outstanding masterworks and important works by less-known artists. Look for Albert Bierstadt's dramatic painting of the Sierra Nevada in California.

The Renwick Gallery of the National Museum of American Art, at Pennsylvania Avenue and Seventeenth Street, NW, is a showcase for American creativity in crafts, design, and decorative arts.

NATIONAL MUSEUM OF AMERICAN HISTORY*, Fourteenth Street and Constitution Avenue NW, Washington, D.C. 20560, 202-357-2700. Open: Daily.

"In a very real sense, the Museum guards our nation's memory," wrote the director of this museum. From *the* Star-Spangled Banner to old toothbrushes, unused army boots, permanent-wave machines, and atom-smashers, this place is our nation's closet. It contains the national numismatic and philatelic collections, and divisions for everything from armed forces history to extractive industries, to mechanical and civil engineering, transportation, domestic life—just plain everything.

NATIONAL MUSEUM OF NATURAL HISTORY*, Tenth Street and Constitution Avenue NW, Washington, D.C. 20560, 202-357-2810. Open: Daily.

The nation's largest collection of natural history specimens and artifacts—there are more than sixty-five million specimens of animals, plants, fossils, rocks, and human artifacts, everything from elephant tusks to herbs.

NATIONAL PORTRAIT GALLERY*, Gallery Place, F Street at Eighth Street NW, Washington, D.C. 20560, 202-357-2137. Open: Daily.

Portraits of American villains and heroes, actresses and ballplayers. You'll find that wonderful photograph of Babe Ruth in his

baseball uniform, Mathew Brady's Abraham Lincoln, John Singleton Copley's rather romantic self-portrait, and a portrait of George Washington by Gilbert Stuart.

NAVY MEMORIAL MUSEUM, Washington Navy Yard,
 Washington, D.C. 20374, 202-433-2651. Open: Daily.

More than five thousand artifacts to commemorate the Navy's wartime heroes and peacetime contributions. There are displays of tools, equipment, and personal "accoutrements." The ship model collection is one of the finest in the country. A submarine room has operating periscopes, and moored outside are real ships that can be boarded.

PHILLIPS COLLECTION, 1600 Twenty-first Street NW,
 Washington, D.C. 20009, 202-387-0961. Open: Daily except Monday.

The most famous work in this collection is Renoir's *Luncheon of the Boating Party,* a happy rendezvous of the artist's friends on the Seine in shimmering colors. There are also Bonnards, Cezannes, Rothkos and van Goghs in the newly renovated museum, which claims the title of America's oldest museum of modern art—an interesting time line.

POTATO MUSEUM, 704 North Carolina Avenue, SE, Washington,
 D.C. 20003, 202-544-1558. Open: Call for hours or appointment.

The role of the potato in history and culture, the potato in art, thousands of display items, and even a poster of Marilyn Monroe in a potato sack.

INDEX

↭ Special Collections ↭

*News, updates, features, and notes about unique
collections and special museums*

The museum world is a constantly changing one. Whether curators
are bringing treasures out from storage or acting as host to a trav-
eling exhibit, there is always a chance to find an exciting new
show—if you know where to look. Until now there hasn't been a
single source of information for people who love to visit museums,
from the smallest or most offbeat collection to a major collection at a
world class institution. There are just too many great opportunities
we've missed by not knowing what was happening.

I plan to change that.

Four times a year, (January, April, July, and October), starting in
July, 1985, I will publish a newsletter called "Special Collections," to
keep subscribers up to date on the museum scene. You'll be able to
find new exhibits of anything from maps, ancient amd modern, to
traveling soup tureens; you can find out when the Air and Space Mu-
seum will be repairing and reassembling The Wright Brothers Flyer,
in full view of visitors; you can learn how to track major exhibitions
of art. You'll learn about museum openings, closings, renovations,
special trips, and significant administrative changes.

A year's subscription to the newsletter is $10 and can be ordered
by mail from:

**Special Collections
Box 313
North Amherst, MA 01059**